Le Classicisme Français

MASTERPIECES OF SEVENTEENTH CENTURY PAINTING

To Rossella

'Mon naturel me contraint de chercher les choses bien ordonnées, fuyant la confusion, qui m'est aussi contraire et ennemie comme est la lumière des obscures ténèbres'.

Poussin

Le Classicisme Français

MASTERPIECES OF SEVENTEENTH CENTURY PAINTING

A LOAN EXHIBITION FROM THE LOUVRE
AND FRENCH REGIONAL MUSEUMS AT
THE NATIONAL GALLERY OF IRELAND
30 APRIL — 9 JUNE 1985

Catalogue by
SYLVAIN LAVEISSIÈRE
(Curator at the Department of Paintings of the Louvre)

Foreword by
JACQUES THUILLIER
(Professor at the Collège de France)

The National Gallery of Ireland 1985

THE EXHIBITION. LE CLASSICISME FRANÇAIS — MASTERPIECES OF SEVENTEENTH CENTURY PAINTING HAS BEEN ORGANISED BY THE ASSOCIATION FRANÇAISE D'ACTION ARTISTIQUE UNDER THE AUSPICES OF THE FRENCH MINISTÈRE DES RELATIONS EXTERIEURES.

Catalogue translated by Kim-Mai Mooney & Raymond Keaveney

© Sylvain Laveissière & Jacques Thuillier, 1985

First published, 1985, by
The National Gallery of Ireland, Merrion Square West, Dublin 2.

ISBN 0-903162-25-3

Design, origination and print production by Printset & Design Ltd., Dublin.
Printed in Ireland by Ormond Printing Company Ltd., Dublin.

COVER: Eustache Le Sueur, *Allegory of the Perfect Minister*
Cat. no. 24. Musée des Beaux-Arts, Dunkirk.

Contents

DUBLIN, Le 29th April 1985

It gives me much joy to welcome, at the threshold of this catalogue, all those who visit the exhibition Le Classiçisme Francais – Masterpieces of Seventeenth Century Painting.

Three years ago, as I prepared to leave for Dublin in order to take up my appointment as Ambassador of France in Ireland, I was enchanted to be able to attend the opening, at the Grand Palais, of the exhibition Treasures of Ireland, which the Irish Government offered to France. A remarkable exhibition which met with the greatest success among the French public. A sumptuous and at the same time moving exhibition, for it brought to us French, on the banks of the Seine, the presence of a civilisation sister to ours, the Celtic civilisation of Ireland. At that moment we had in our own Celtic country the very soul of Ireland with her mysteries, her gravity, her innocence, her nobility, her depth, and all those secret interchanges which, although very ancient, are always living, present and make up the affinity of our two peoples.

I immediately expressed my wish that France might reply to this gesture by bringing to Dublin evidence of her identity, so that Ireland might in turn look into the mirror and discover, in the eyes of her sister nation, the soul of France.

Because of the untiring work carried out by the National Gallery of Ireland and the Musées Nationaux de France, with the support of the Irish Department of Foreign Affairs and of our own Ministère des Relations Extérieures, this wish is a reality today. To our Irish friends I express my heartfelt thanks.

From the outset it was essential that our exhibition be significant of French art. Several choices were possible, for the genius of a people includes many facets. Le Classicisme Français – Masterpieces of Seventeenth Century Painting was selected because of the richness and qualities of French art amply illustrated in the painting of that time.

Such occasions are exceptional moments when, beyond the problems of our times, two peoples can for a moment pause in order to recognise one another in their innermost identity and their affinities.

Culture is the foundation and the whole of our individual entity. We are our culture. Whence the utmost importance of cultural exchanges, which unite two countries, in what they possess of intimacy and goodness.

I hope this exhibition will be of interest to Ireland, that it will speak eloquently of France, a country akin to Ireland and Celticism, a country of friendship in and through history.

Jean Batbedat
Ambasadeur de France en Irlande

Preface

For many years and on many occasions the National Gallery of Ireland has been pleased to lend its paintings to exhibitions in France, and in this way it has been our pleasure to share with the French public some of our most cherished pictures by artists including Poussin, Claude, Boucher, Fragonard, Chardin, Jacques-Louis David and others. Now at the National Gallery of Ireland it is our great privilege to receive on loan an entire exhibition of great French paintings of the seventeenth century from the Louvre and other French museums. It is a long time since the Irish people have had the opportunity to view and enjoy such a splendid exhibition of Old Masters, and the Governors and Guardians of the National Gallery of Ireland and myself extend a warm welcome to these important treasures. Our own collection of French seventeenth century paintings is relatively small, but for six weeks there will be the opportunity to see them in the much wider context of a large group of contemporary paintings; and the experience will, I know, be both instructive and rewarding.

In hosting the Exhibition, for which we have retained a French title, *Le Classicisme Français*, we owe a great debt to the museums in France, headed by The Louvre, which have made the loans available. It has been a pleasure to co-operate with the Association Française d'Action Artistique and the Ministère des Relations Exterieures in the planning of the Exhibition and we thank in particular the French Ambassador to Ireland, Monsieur Jean Batbedat and also Christian Cauro and Amanda Jones of the Cultural Section of the French Embassy in Dublin for their generous assistance and advice. The catalogue has been written by Sylvain Laveissière of the Department of Paintings in The Louvre, translated by our Exhibitions Officer, Kim-Mai Mooney and the Assistant Director, Raymond Keaveney and typed by Barbara Goff. To all of them, as well as Janet Drew in the National Gallery, I am grateful.

Le Classicisme Français – Masterpieces of seventeenth century painting brings to Ireland a very important exhibition. It is the hope of the Governors and Guardians and myself that it will not only give pleasure to our visitors but also serve to strengthen the many ties of friendship that exist between France and Ireland.

HOMAN POTTERTON,
Director, The National Gallery of Ireland.

Author's acknowledgements

Our thanks are due to all those who have made this exhibition possible, and particularly to the Mayors of the following towns who have generously agreed to loans requested: Arras, Beauvais, Bourges, Compiègne, Dijon, Dunkirk, Le Mans, Les Andelys, Nancy and Troyes. Special thanks is also due to the President of the Société archéologique lorraine; to the curators of the lending museums: Mme. Davy and her predecessor Mlle. Maison (Arras), Mlle. Salmon (Beauvais), M. Meslé (Bourges), M. Lapointe (Compiègne), M. Georgel (Dijon), M. Kuhnmunch (Dunkirk), M. Nikitine (Le Mans), Mme. Daniel-Blanc (Les Andelys), Mlle. Guillaume (Nancy, Beaux-Arts), M. L'abbé Choux (Nancy, Musée historique lorrain), M. Sainte-Marie (Troyes). Special gratitude is due to M. Laclotte, Inspecteur général des Musées chargé du Department des peintures du Louvre and M. Rosenberg, Conservateur en Chef at the same department as well as to M. Landais, Directeur des Musées de France, for the loans of exceptional importance from the Musée du Louvre.

We have benefited from the efficient help given by the Inspection générale des Musées classés et controlés, directed by M. Pommier, whom we thank along with Mme. Volle, curator.

The restoration of the works was supervised by the Service de Restauration des Peintures des Musées nationaux, directed by Mlle. Bergeon, and the Service de Restauration des Musées de Province, directed by M. Guilly. We also note our gratitude and appreciation for assistance received from Mlle. Cortet, M. Fouace, Mlle. Dijoud, and all the restorers, who worked up to the very last minute preparing the pictures.

Finally, I would wish to thank for their advice, information and assistance rendered at various moments during the preparation of the exhibition: Mme. Beauvais, Mlle. Bernascone, M. Boyer, M. and Mme. Brejon de Lavergnée, M. Chomer, Mlle. Compin, M. Cordellier, Mlle. Coural, M. Cuzin, M. Goetschel, M. Gratte, Mme. Lévy-Lambert, M. Mérot, Miss Montagu, M. Personne, Mlle. Perrin, M. Rosenberg, Mme. Rossi, Mlle. Sahut, Mme. Savina, M. Schnapper, Mlle. Szentkereszty de Zagon, M. Thuillier, Mme. Vasselin, M. Vigne.

Lenders to the Exhibition

Arras, Musée des Beaux-Arts: no. 16.
Beauvais, Musée départemental de l'Oise: no. 18.
Bourges, Musée du Berry: no. 42.
Compiègne, Musée Vivenel: no. 25.
Dijon, Musée des Beaux-Arts: nos. 28, 38.
Dublin, National Gallery of Ireland: nos. 15, 20, 21, 31, 32, 34, 35, 41.
Dunkirk, Musée des Beaux-Arts: no. 24.
Le Mans, Musée de Tessé: nos. 22, 23.
Les Andelys, Musée municipal Nicolas Poussin: no. 36.
Nancy, Musée des Beaux-Arts: nos. 4, 8.
Nancy, Musée historique lorrain: no. 11.
Paris, Musée du Louvre: nos. 1, 3, 5, 6, 7, 9, 10, 12, 13, 14, 17, 19, 26, 27, 29, 30, 33, 37, 39, 40, 43.
Troyes, Musée des Beaux-Arts: no. 2.

Photographic Credits

Agraci: nos. 13, 14, 36 (and colour plate), 42.
Giraudon: no. 16.
Musée de Beauvais: no. 18.
Musée de Dijon: nos. 28, 38.
National Gallery of Ireland, Dublin: nos. 15, 20, 21, 31, 32, 34, 35, 41 (and colour plates).
Musée de Dunkirk: no. 24.
Musée de Troyes: no. 2.
Réunion des Musées nationaux: nos. 1, 3, 5, 6, 7, 9, 10, 11, 12, 16 (colour plate), 17, 19, 22, 24 (colour plate), 25, 26, 27, 29, 30, 33, 37, 39 (and colour plates), 40, 43.
Clichés X: nos. 4, 8, 23.

Foreword

JACQUES THUILLIER

'Classicism' in French Painting of the Seventeenth Century:
from the Reality to the Concept.

Every historian affirms that he offers a true image of the past otherwise, how could he obtain a public audience? And he sincerely believes it: without such faith, how would he have the courage necessary to follow his difficult researches? But deep down in himself every historian knows that he will only ever offer an arbitrary image of the past. From the veritable infinite diversity and number of facts which constitute real life, time has carved and cut away; and in that little which the historian succeeds in retrieving, he proceeds to select criteria which are relevant to his own epoch and to his own interests: creating an image which he simply claims to transmit. Such is the paradox of the historian. For over a century, he has hardly ever ceased to be denounced and criticised, though the prestige of History has never suffered any harm.

The art historian lives this paradox even more profoundly: as, he interests himself not only in facts but also in values. He studies not only a social category, the artists, but a production, the works of art. He requires that his painters and sculptors be at least good painters and good sculptors, and preferably great masters; he requires the works to be beautiful, and if possible even sublime. One can imagine that the imposition of this hierarchy on the work of time also detracts from pure objectivity. Since, within this domaine erudition cannot be separated from criticism, nor the research of facts from the exercise of taste, how then can one boast of simply reproducing the facts? Yet, nonetheless the art historian affirms and believes that the image which he reveals of the art of the past is true. Of a truth that rediscovers, beyond the inextricable compelexity of facts, the significance of great creations.

It is for this reason, that if one is looking for an image which accurately reflects the activity of French painters in the seventeenth century, one should not hope to find it in this exhibition. No one, at that period, imagined that they were painting 'classical' pictures, as our young artists of today claim to create 'conceptual' and 'minimalist' art; and the proposed anthology, would, no doubt, have surprised the collectors. But if one should want to understand some of the fundamental forces which animate the painting of this period, then one would find that Sylvain Laveissière's choice proceeds from an exceptional knowledge of the seventeenth century, of which he proposes one of the more feasible interpretations. Certainly, the most elevated.

Let us explain this a little.

French painting of the seventeenth century, in its concrete reality? No one cares about it very much. And for a good reason: no one can grasp the reality any longer. At best, by relating documents and testimonies, we can succeed in achieving a rough outline . . .

It is first of all a period of immense activity, of disconcerting variety. There is, wrote Michel de Marolles - a bad poet but an excellent witness - in about 1675:

> 'Dans Paris aujourd' huy, dit-on (chose étonnante),
> 'Plus de mille pinceaux, artistes concurrents. . .')
>
> ('In Paris today, it is said — a surprising fact —
> More than a thousand paintbrushes — competing artists . . .')

A thousand living artists? If we include successive generations, we are thinking of three thousand for the entire century. But there is more than just Paris in France: many other towns nurtured their own group of painters, Lyons, Marseilles, Montpellier, Toulouse, Bordeaux, Rouen, Caen, Lille, Nancy, Dijon. . ., and there was hardly a town in the kingdom which did not have two or three. It would not seem an exaggeration to say that there was a total of five to seven hundred for all the provinces (that is, only six to eight for each of the present *départments*. . .) That would mean approximately two thousand for the century. Five thousand painters altogether for the French seventeenth century.

Such numbers have no scientific value, and there are no means of verifying them. But the studies made of certain provinces tend not to refute them, nor the lists which we still possess for a few of the confraternities, nor the numerous French names formerly noted by Jacques Bousquet in the only Roman *'stati d'anime'*. We are only noting them here in order to determine an order of magnitude and to give some idea of this intense artistic production which, at this time, was only rivalled in Italy and the Netherlands. Since an artist would not have been able to earn a living without selling, let us say, approximately six hundred pictures for an average life expectancy, (and even if he was very mediocre, then the more rapid and numerous was his production). Poussin, who started late, and worked slowly, but lived until he was seventy-one, seems to have painted some five hundred canvases; the daubers of paintings at two or three *livres* each must have had a prodigious output. . . French picture production in the seventeenth century must have represented at least three million paintings, and possibly five or more. For a country populated by fifteen to twenty million inhabitants (that is to say about fifty million for the whole century) the figure seems plausible enough. The few studies conducted on a sociological basis - and most notably that of M. Michel Sylvestre, which allows a glimpse at the presence of paintings hanging on the walls of the houses of Nancy during the first half of the century - would invite acceptance of this, at least as a hypothesis.

We have spoken of 'the production', and have guarded against

using the word, art, as there were works of all different qualities. To every Lord every honour: at the top, the great painters, those from Paris, often 'peintres ordinaires du roi' (ordinary painters to the King), and those of the big towns, the Thomas Blanchets at Lyons, the Darets at Aix, the Tournier's or Rivalzs at Toulouse, all painters of great repute and well patronized, reserving for themselves the prestigious commissions, ever careful of their art and ever careful of their glory. At the other end of the scale, are the lowly itinerant painters, too bad to build up a stable clientèle, who travelled from town to town, painting here a Saint Nicholas for a country priest, there doing a portrait of a bride and groom in return for a place at the wedding feast. At the beginning of the nineteenth century there still existed in France some of these daubers, who more often than not did not even possess the charm of naïvety, and it was only the intervention of photography which succeeded in making them disappear. Between these two extremes, imagine all the different levels, this diversity which carrys with it for each region its riches, more or less great, its traditions more or less characterized. But everywhere, from one end of the century to the other, reigned an immense need for images, which went as far as to cover the walls of churches, convents, municipal buildings, castles and private mansions, even slipping them into the most modest of dwellings.

In such a manner as to allow one encounter there all *genres* and all levels. Firstly come the religious works, from the large altarpiece, from now on necessary to every altar, to the 'Magdalens', the 'Saint Josephs', the images of 'Saint Francis', small paintings on wood or copper which were bought at fairs or on pilgrimage days. The portrait was their great rival, from the princely effigy by some famous hand, to the portrait of the father or the wife, whose sentimental function often outweighed the formal value:- an immense production, an easy livelihood for the artist who knew how to reproduce the conventional images and offer the public what they wanted: a flattering souvenir rather than a work of art. This is the greater part of an output devoted to profane painting which was then quite abundant: in other ways romantic subjects were also popular as were *genre* subjects, erotic pictures (which were numerous despite the wrath of the Church), 'droleries' (comical subjects) more or less crude (greatly appreciated and not as much forbidden) and also landscapes and still-lifes, whose popularity never ceased.

Is there any need to say that all the styles expressed themselves there, that all the traditions cut across each other, all the influences and all the tendencies merged together? The study of a precise *milieu* like Marseilles, Nancy or Toulouse, when it is conducted throughout the full duration of a century, shows that the success of an artist and of his studio could just as well sweep along 'followers' and create a 'style' as drive the neighbouring studio towards a completely opposite produc-

tion, and young artists to win over a clientèle by mere novelty To each public its preferences:- though often contradictory. The importance of religious commissions or the presence of a solid bourgeoisie can provoke in such an artist a stern inspiration and an overpolished execution, and in another boldness of thought and of brushwork. And, if it is remembered that France has a long medieval tradition, that it adjoins on the one side Flanders and Germany, and on the other Italy, and that all the roads led to the Parisian melting pot, we can guess that there were no rules, no primacy. Contemporaries sometimes tell us that an artist is of the style of Titian, or of Rubens, or of Le Brun. But living amidst this infinite quantity — of artists — and this infinite diversity — of style — they distinguish only names which, seemed to them particularly worthy to live on in history: they were hardly concerned to place them in schools, groups or movements.

Within this reality, time has dealt ruthlessly. After three hundred years of destruction, there remains, from this century of French painting, only one painting out of every hundred.

For the most part, this should not be overly deplored. The sociologist, the economist, the historian of ideas can in all rightness feel wronged: not the art historian. As a large amount of this production did not consist of art. An enormous part of it varied from a quasi mechanical fabrication to the most lamentable clumsiness. Devotional images, conventional effigies, stereotyped landscapes, copies, more or less awkward, of famous engravings:- this production was destined for 'consumption', and from the start sentenced to a prompt death. Sometimes an example is found, forgotten by fate; and it happens that the centuries make curious that which was once banal, affecting that which was above all clumsy: but more frequently it accentuated the crudeness of the brush and the absence of all inspiration. In the seventeenth century as in our own day, there was doubtlessly not one painter out of ten who merited the name of 'artist' -let alone that of 'petit maître' (little master). . .

The art historian's distress starts when he thinks of those true artists, the great geniuses - La Tour, Poussin, Le Nain - of the very modest talents - du Melezet, Pierre Tassin or Cany. Masterpieces or charming little pictures, time has destroyed without rhyme or reason, somewhat more indulgent here or there, ordinarily systematic and cruel everywhere. Of the production of profane images there survives only meagre remains. Religious production — despite the terrible revolution of 1789 - has survived a little better. But it can be said that no other school of painting in the world has suffered more than that of French painting The contempt of patrimony, the need for innovation, and the concern to be 'up-to-date', characterise the French spirit. The majority of the innumerable interior decors of the hôtels and châteaux have not survived the perpetual mutations of taste, nor family portraits the changes of generations. To the libertine father a devout son: down

through the course of three centuries there has nearly always been a confessor to obtain the destruction of a painting which is somewhat daring, and especially of those large nudes into which the French painters of the seventeenth century had often put the best of their art. But, to the devout father a miscreant son: and it must not be forgotten that French society, more than any other, knew periods of irreligion, sometimes even militant atheism, relegating to the attic those boring and moralising paintings of images of saints, or burning those testimonies to superstition... For a great number of artists, whose celebrity leads one to think they had great merit, we no longer possess a single work. For many others, we are left with only two or three, of which nothing authorises us to believe that these exactly constitute their masterpieces...

From this it is obvious that the slightest affirmation will seem quite rash. How are we to sketch a plausible geography for French art when it is known that the various centres were treated differently, that, for example, Provance has preserved a lot, and yet practically nothing has remained in Bordeaux? How can we retrace the history of a *genre?* Thus, for the portrait, we no longer possess any significant testimony of the Parisian effigies of Vouet, whose influence was paramount; none of the Lyonnaise canvases of Panthot, whom Le Brun himself admired... For the painted galleries, of which Paris possessed at least a hundred, there hardly remains five or six altogether which are intact. As for the interplay of traditions, influences, initiatives, we deduce them by reasoning:- consequently we remain incapable of setting down exactly the choice offered to the artist, of following the correct course of creation. All the more so since the newspapers and correspondance (except for Nicolas Poussin) have also been destroyed:- and — *rari nantes in gurgite vasto* — the few letters of Vignon or Le Brun which have come down to us, make us regret all the more bitterly the loss of these confidences which nothing will ever replace...

A hundred years ago, the art historian proposed, without any anxiety, a clear and logical image of French painting of the seventeenth century. Indeed he was still risking it fifty or forty years ago. Since then, the efforts of scholarship, the attempts made to find again the forgotten artists, to reconstruct their *oeuvre*, the study of archives, and even the success, sometimes surprising, of the quasi archeological researches, have led to cautious prudence. We now conceive all too clearly the narrowness of our knowledge and the immensity of the gaps within it, to claim to have the true and complete picture. The more we know, the less we dare:- we are warned that any scheme which is too authoritarian crudely betrays the reality.

Should we then be content with these scattered remains -without attempting to establish a relationship between them? The historian who is fully aware of his ignorance is always tempted by the list and the dictionary. But their arbitrary nature is even more manifest:- the

alphabetic order itself is also a betrayal. It would be better, using the few solidly established facts, and drawing on all knowledge and every intuition, to choose from amongst the various readings. With confidence. After so many disasters, there still survive some works. In fact a work of art is not a dead object. In contrast to the historic fact, a pure memory, it exists physically. It is in this that it has its great privilege. Present now and placed in the proper light, it is capable of speaking for itself, imparting the sense of its own truth.

M. Sylvain Laveissière has here chosen the point of view indicated by this word 'classicism'. Without ignoring the dangers. In the French tradition, the term is attached to no precise meaning, and whether it is dealing with literature or the arts, no one has succeeded in assigning it a content which is not ambiguous. Hundreds of articles, indeed entire books have been written with this admirable intention and they have achieved nothing except to underline the vagaries of its history and add a new formula, a sense little different from the existing definition.

What agreement is to be found between those who speak of 'classicism' as that period of history which saw spring up the works of Molière and Racine, and those who oppose 'classicism' to 'romanticism' and illustrate this by the confrontation of Ingres with Delacroix, or those who see in it simply the tendency of all art towards order and harmony, or even the moment of equilibrium of more or less short duration, in which the creator possesses the full mastery of his medium. Paul Valéry once observed that the term classicism is *'incompatible avec le précision de la pensée'* ('incompatible with the precision of thought'). On which, Henri Peyre, in a book which is aptly titled 'Qu'est-ce que le classicisme?' ('what is classicism?') and which appeared here some fifty years ago, added: *'Il est un point en tout cas sur lequel l'accord est unanime: le terme est fort mal choisi, et les acceptions si élastiques dont il est susceptible irritent, non sans raison, les esprits friands de précision et de rigueur. Que faire cependant? Le mot existe, il est commode, il est sans cesse employé, et il continuera de l'être. . .'* ('There is in any case one point on which there is unanimous agreement: the term is very poorly chosen, and the accepted interpretations so elastic that it positively irritates, and not without reason, those spirits fond of precision and strictness. What to do however? The word exists, it is useful, it is continually employed and it will continue to be. . .')

Let us not therefore try to start with a definition of 'classicism' drawn from etymology or from formulas borrowed from this or that author. Let us rather look to the works. At the time when La Hyre, Stella, Bourdon, Le Brun were all working in Paris, and Poussin and Claude in Rome, what were they painting in the rest of Europe? In Naples, it was the incisive violence of a Ribera with his *Martyrdom of St. Bartholomew* or his *Flaying of Marsyas*; in Amsterdam, it was a Rembrandt and his dense shadows watching over a timorous or sorrowful conscience, in Seville, a Zurbaran with his ascetic authority, in Antwerp

a Jordaens is lavish to the point of obscenity, at Augsburg, the fragile dream of a Schönfeld. To return to the centres of Paris and Rome, to the works about which the Exhibition revolves, it is after these depths and this violence, these crudities and subtleties, which gripping and rousing force admiration, that we suddenly come upon a zone of light and calm; after so much torment and sublime élan, we come back to the equilibrium between the spirit and the senses from where is born an ease of gesture allied to a lucidity of thought. 'Classicism', perhaps that is what it is?

The influence of Antiquity is often indicated in definitions. It exists alright, but we should not interpret this too narrowly. Though mythology and ancient history offer their themes to the *Bacchanal* of Blanchard (no. 4) and the *Plague of Athens* by Perrier (no. 28), though Roman statuary offers models for the nude, drapery and gestures in the *Pan and Syrinx* by Mignard (no. 26) and the *Coriolanus* of Poussin (no. 30), we also must confess that they offer only a very slight pretext for the landscapes of Claude and La Hyre. And much more, an attitude, the rejection of the styles which the various other European centres proposed, the study of a form of expression tied to the lessons which were those of antique sculpture and the paintings, of he who was considered as having rediscovered the secrets of Antiquity: Raphael.

This meant, more of less, the overt rejection of the pure imitation of reality. Throughout time the spectacle of nature has always been one of the great temptations to the painter. To describe, reproduce, make a double of the real through an image of the real, a fake image since only a copy, but at the same time more true than the real, since it has been extracted at length: it is one of the vocations of the artist, who knows that his actions can magnify the unique and the ephemeral. But there is another attitude. The artist can also reject this confusing spectacle, he can, through the working of the spirit, drawn straight to the essential, detach himself from the mundane, from the innumerable forms which offer themselves to his eye, all different, all imperfect, to concentrate only on the expression of a thought. Félibien tells us that Poussin spoke 'avec mépris' (with disdain) of Caravaggio's *Love Victorious*, now in Berlin and once in the Giustiniani collection, and had said this painter had *'venu au monde pour détruire la peinture'* ('come into the world to destroy painting'). He considered Raphael's figures, which were like the pure incarnation of the ideal. He could not tolerate this nude of a young boy who was just like those who could still be seen bathing on the banks of the Tiber, nor that smile, at once timid and slightly cheeky, which was reminiscent of the chubby faced urchins who were drawn to the painters' quarter to earn a *sous*. Now, that one can look here at *Time Overcome by Love* by Vouet (no. 42) at the *Bacchanal* of Jacques Blanchard (no. 4) and the *Cloelia* of Stella (no. 39): we can note that nothing in the figures in these paintings refers back to the particular traits of an individual, to his particular life. All belong to the one universe of the

artist, where form is first and foremost a language, where actors have only the personality of their role.

But not to the extent of total freedom. The sixteenth century had enthusiastically promoted this concept that painting primarily expresses the 'idea' of the artist, it had confidence in its *'beau feu'* — and was admired for its bizarre creations. From one excess to another, it had arrived right to the point where the spirit was taken over by its own phantasms. That which one calls 'mannerism' drew its prestige from this fact: but in its most extreme formulations, it was confined to the void. One thinks of a Bellange, with his egg-shaped heads topped with dishevelled hairstyles, curiously dressed characters asexual in appearance, which make it difficult to determine whether one is dealing with a holy apostle or a courtesan. Could one have gone further without the image loosing all meaning?

Equilibrium was restored through the powerful call to nature which was launched by the Carracci and Caravaggio. The art of France heard this call. It returned to the normal canon, to forms inspired by the live model; it affirmed that the ideal, to be understood, must make itself visible in a language accessible to all, which could only be that of reality itself. Cézanne once declared that he wished to do *'du Poussin sur nature'* ('do a Poussin on nature'); French art of the seventeenth century, had already wanted to do a Primaticcio on nature. From the *Childhood of Jupiter* of Baugin (no. 2) to the *Plague of Athens* of Perrier (no. 28) or the *Meeting of Anthony and Cleopatra* of Bourdon (no. 6) one finds, more of less intentional, more or less affirmed, this care to preserve the essence of the spirit of Fontainebleau and its seductions, but breaking with everything which could carry forward the artificial and the abstract, gathering the all too languid graces to the solid nourishment of the tangible world.

This language, so distinctive within the century, and, in fact in the history of painting, favours expression of the idea without, however, straying from the imitation of Nature. The sixteenth century had accepted the idea of concealing its thoughts in a complex game of allegories and symbols, caring little to offer the key to this world to the common people: only the erudite and the initiated could penetrate its meaning. The most celebrated example of this was given by Rosso Fiorentino in the *Galerie de François Ier* at the Palace of Fontainebleau. Modern researches have barely been able to partly clarify the mysteries of this over subtle eulogy. The seventeenth century also often gave way to the attraction of this 'mysterious' language, and amused itself in multiplying allegories. But it was aware of a larger audience. Its art, which one denounces as 'learned', sought, on the contrary, to liberate itself from the hold of learned scholars, to catch the attention, if not of the populace, at least of the man of breeding — and ladies, whose interest in painting was on the increase. It knew that to touch the sensibilities was the best way to capture interest and that the mimicry

of the character is an emblem understandable to everyone. It is the gesture which became the principal means of expression for the painter, It was the orchestration of the gesture, through the *mise en scène,* through the play of rhythms, lights and colours, which commanded his greatest attention.

'*Muta poesis*', this celebrated definition of painting should be taken in its strictest sense. One has spoken of a 'theatrical' art and it is in effect an art which to a degree participates in the theatre in as much as that the potential of that artform resides in the expressive play of the actor and the detail of the stage direction. However, it essentially concerns a theatre without words and without duration, where the dialogue is reduced to gesture and the gesture to the moment. Rare were the artists, who, like Poussin, succeeded despite this obstacle, in introducing into their compositions effects which were appropriate to the dynamic action. We find, perhaps, the most striking example of this, in this exhibition, in the *Coriolanus* from Les Andelys (no. 36). This painting may appear cold and devoid of attraction: but it is an austerity which appertains to tragedy. It shows the élan of the general, enraged against his own country, ready to raise his hand against it, but coming up against the supplications of his family, it shows the cornelian character being torn apart at the very moment of decision. And Poussin, no less bold than the Elizabethan authors, has here dared to incarnate the presence of the *Homeland,* drawing up in front of his heroes the figure of a bare-breasted Amazon, of impassive gaze, who is the object of these contrary passions, it is Rome herself; and he interposes between these two antagonists the admirable garland of open arms and imploring hands.

The painter of the *Bacchanals,* is here admirably joined to the tragic author, and under the stoic gravity of the inspiration one perceives deep emotions, especially if one considers that this drama of civil war was painted about 1652-1655 and directly inspired by the troubles and miseries of the Fronde which had just torn France apart. From Rome, where he lived away from all suffering, Poussin did not forget the misfortunes which overwhelmed his country. . . .

Considering the theatricality of such a scene, is it necessary here to talk of theatre or of a poem? Thinking it over, the expression of the idea has broken down the spectacle and its inherant logic, the painter has striven less to achieve a correct *mise-en-scène* to the historic event than to clearly illustrate his thoughts. One thus comes upon strange canvases, for which the narratives provided by Livy and the Bible are nothing but simple pretexts for a poetic meditation, the simplicity of which often conceals the audacious and the profound.

Let us now move to another picture in the exhibition, painted at the same time by La Hyre (no. 16). This *Death of the Infants of Bethel* places the very brief biblical anecdote in a grand, solemn surrounding, mixing the precise ordering of ruins with Nature, and with each attitude

controlled by a director who hardly seeks to conceal his intervention. But, who, like the poet prefers artifice of verse and rhyme to prose. And in effect, what an admirable poem on destiny it makes! The bald prophet had been mocked like a vagabond, the sons of man not recognising the divine under a common guise, and from this blindness there arose death and desolation. The limpid light of morning and the vertical rhythm of the columns contrast cruelly with the dispersed corpses and the grief of the mothers, which the three groups — the woman who has fainted, the woman down on her knees and the woman standing — develop like so many strophes of an ancient choir. If one can imagine this same theme treated in Naples, Antwerp or Amsterdam: one can guess that the artist would have chosen to show Elisha cursing, the murderous bears, the grimaces of the children changing from sarcasm to terror. That was the moment of high drama. Here, La Hyre has chosen the moment when the drama is concluded. Let us return to the painting and dwell for a moment on the detail of the dead youth, to the left, more like a Narcissus at the fountain than a corpse torn by a monster. There is nothing of the anecdotal here, or of the vulgar to disrupt the meditation on human error; and the theatrical aspect rightly banishes that which would have been over emphatic in effect, an over direct appeal to the emotions. Death is evoked in the supreme harmony which is that of poetry, even though its speaks of divine rage and death. The threnody of the sorrow does not shatter the order of rhythms. This art links to the most intimate of sentiments, scenes of divine punishment which the Greeks had once evoked on the façades of their temples. These two masterpieces — one, more austere, the other more Roman, one painted by an artist from Normandy living in Italy, the other, refined like a piece of Attic art, painted in Paris by a Parisian — are sufficient to indicate one of the most lofty aspirations of French painting during their century. They at once justify this exhibition and its title.

Introduction

After Paris[1] and Budapest[2] Dublin hosts the Exhibition of *Le Classicisme Français* and as the Petit Palais and the Szépmüvészeti Museum have done, the National Gallery of Ireland completes the series of 35 pictures sent from France with eight paintings drawn from its collection, paintings which are of an exceptional quality in this domain as in so many others. Though the *Acis and Galatea* of Poussin (no. 34) or the *Juno Confiding Io to the care of Argus* by Claude Gellée (no. 15), both universally renowned, are self-sufficient in themselves, it was instructive to have the opportunity to bring together the sumptuous *tondo* by Vouet (no. 41) and that of *Abundance* (no. 43), to group together *Apollo taking leave of Tethys* (no. 20) by Le Brun and the other two youthful works which figure in the exhibition (nos. 18-19) and to evoke with a large picture (no. 21) the captivating personality of Lemaire, who was not represented at the showings in the other two cities. Also the less celebrated Dublin Poussin's, *The Nymph and the Satyr* (no. 32) and the *Holy Family* (no. 35), which are both assuredly original works, could only benefit by being displayed alongside *The Nurture of Bacchus* (no. 33), contemporary with the former, and the *Coriolanus* and *the Death of Sapphira* (nos. 36 and 37), both slightly later than the second. Finally, the *Assumption* by Poerson (no. 31) which, on account of its large format, has had to be displayed outside the exhibition room, has been included in the catalogue with the intention of recalling, along with the cabinet pictures and those which have come from decorative ensembles, the great religious paintings destined for the churches.

The thirty-five paintings lent by France, which constitute the immutable core of the exhibition common to Paris, Budapest and Dublin, come for the most part from the Louvre (twenty-one in number). Among the fourteen coming from provincial museums, three were on loan there from the Louvre (nos. 22, 25, 42) and two are state loans which date from the beginning of the 19th century (nos. 8, 36). But many masterpieces preserved in the provinces owe nothing to the Louvre: the Baugin (no. 2) was bequeathed to the museum in Troyes in 1918; the museum at Arras was capable of buying, twenty years later, the most moving of La Hyres (no. 16) and only recently, J. Kuhnmunch, then curator at Dunkirk, provided his museum with an admirable Le Sueur (no. 24), which had been discovered by P. Rosenberg. These examples, which one could multiply, testify to the vitality of French museums' which, despite an art market which is becoming more and more out of reach, succeed through judicious acquisitions (nos. 6, 11, 18, 26, 28) to add to their holdings of French seventeenth century paintings, which for the most part date back to the period of the

Revolution. Let us add, that of these thirty-five paintings, for the first time thirteen are being exhibited outside of their own museum (nos. 2, 5, 9, 10, 11, 18, 23, 24, 25, 26, 28, 30, 38), and that ten have been recently restored, for the most part with a view to the present exhibition (nos. 3, 5, 8, 9, 10, 12, 19, 25, 39, 40). Some new attributions are here proposed without reservations (nos. 5, 11, 18, 23, 38) whilst others, traditional though sometimes contested, have been freely reaffirmed (nos. 8, 33).

The fact that many relatively new works have been displayed here for the first time is not simply gratuitous, it takes into account the progress achieved in the history of art in an area which has recently become topical, and which owes so much to the work of scholars and curators, such as A. Blunt, J. Montagu, P. Rosenberg, A. Schnapper, Ch. Sterling and J. Thuillier, who has kindly provided the preface to this catalogue.

That the French seventeenth century is today topical is undeniable. It had been held in high esteem by the artists and *amateurs* of the eighteenth century, even when the totally opposed art of Boucher was triumphant, and it became, with the Antique and the Renaissance, one of the great points of reference for Neo-classicism before encountering, with the coming of romanticism (and despite the admiration of Delacroix) a long century of disaffection. Only Poussin and Claude Gellée maintained an unimpaired reputation. The rehabilitation began with the Paris exhibition of 1934 devoted to the *Peintres de la Réalite* with an appreciation of the values which up to that time were the least known. Organised by P. Jamot and Ch. Sterling, it concentrated on the Le Nain and revealed La Tour. It was necesssary to wait until 1958, however, for an exhibition to be organised, first in London and then in Paris, which presented a vast panorama of the *XVIII° siècle française,* selected by M. Laclotte who drew on the holdings of provincial collections (it is noteworthy that in 1982, P. Rosenberg could treat the same subject with the aid of just American collections). From that time on French painting of this period has had the appearance of a richness and variety undreamt of by the public and many notable exhibitions have clarified its most diverse aspects: *La Nature Morte* (Paris 1952), *Les peintres de Louis XIV* (Lille, 1968) and *Les caravagesques français* (Rome and Paris, 1973-1974). Provincial painting has been the subject of great investigations, giving rise to the spectacular panoramic exhibitions in Marseilles in 1978, in Rouen in 1984 and also exhibitions devoted to a single artist or related artists such as *Les Tassel* (Dijon, 1955), *Jacques de Létin* (Troyes, 1976), *Guy François* (Le Puy and Saint-Etienne, 1974), *Nicolas Mignard* (Avignon, 1979), while Paris celebrated *La Tour* (1972) and the *Les Nains* (1978-1979).

This evolution of taste over a period of fifty years, contemporane-ous with the advance in our knowledge of the period, has allowed us to recognise in the eighteenth century a good many trends and tendencies which not long ago were underestimated. Paradoxically, there remains

to be discovered by the public that which the very contemporaries of Le Nain valued most highly: history painting. Up until the nineteenth century this category held the highest place in the hierarchy of the *genres,* before portraiture, *genre* painting, landscape and still-life. The painter of history subjects had, in effect, to possess all these specialist skills, having in his domain every subject 'emprunté à un texte historique ou littéraire, mettait en scène un ou plusieurs personnages réels ou non' (J. Locquin). 'Taken from a historic or literary text, he placed on stage [in the composition] one or many real or imaginary characters'). Because, though history painting had its obligatory place in the general exhibitions already cited, it has rarely been presented for itself. What would be the glory of Champaigne (Paris, 1952), if he had not been a portraitist and friend to the Jansenists'. And, apart from Poussin (Paris 1960, Rome and Düsseldorf, 1977-1978), only Le Brun has been the subject of a great retrospective (Versailles, 1963). But neither Vouet, who proceeded him as 'Premier peintre du roi' nor Mignard, who succeeded him, nor Le Sueur, who was venerated by artists two centuries after his death, nor La Hyre, whose strange poetry should seduce today, not to mention Stella, Perrier or Bourdon, have yet been accorded this honour. It seems, nonetheless, that the time has come to see this painting for what it is, without employing a historical or literary pretext to justify the exhibition, and without the reassuring support of portraits or still-lifes. This has already been understood in Italy, and the field explored in 1961 with the exhibition *Poussin et son temps* at Rouen, where the catalogue (by P. Rosenberg, with preface by J. Thuillier), sub-titled *Le classicisme français et italien contemporain de Poussin,* leads us to specify our intentions.

The French eighteenth century is commonly called the *'Grand Siècle',* or after Voltaire, the *'Siècle de Louis XIV'.* Born in 1638, the King began his personal reign only in 1661, the year of Mazzarin's death: the first half of the century therefore eludes this qualification. Another term is often frequently met with, that of *'siècle classique'.* In litterature this covers the generation of Descartes (1596) and Corneille (1606) as well as that of La Fontaine (1621) and Molière (1622) together with Boileau (1636) and Racine (1639), the only contemporary of Louis XIV. This designation has passed from literature into the domain of the arts where it is even less evident: the instances cited above, the Caravaggesques and the Les Nains, and also the long survival of mannerism as well as the Rubenist movement towards the end of the century, are sufficient to contradict this.

However, we are forced to recognize the preponderance of this concept, which in spite of everything, has imposed itself on History. Though it is useful to mark its limits, it would be vain to deny its existence. Classicism certainly does not summarize the complete artistic creation of a period such as this, neither does it no less designate the major trend, so well recognised and accepted by contemporaries

who, without actually naming them, endeavoured to establish the rules. At a time when Boileau was paraphrasing Horace, rhyming his *Art poétique* (1674), the members of the Académie Royale de Peinture et de Sculpture, at the instigation of Le Brun, held discources on the paintings in the royal collection in an effort to deduce from them the principles of their art. One can smile at the excess of zeal employed in the interpretation, at certain burlesque debates, such as that which opposed Le Brun and Champaigne in a discussion about the camels absent from Poussin's *Rebecca,* which Colbert was asked to terminate. One can deplore the 'académisme' of the much too rigid precepts which followed: the intellectual process which is that of the Académie is nonetheless one of the most interesting and novel in the history of French art.

On the first of February 1648, twelve artists gathered together, founded an association which, placed under the protection of the regent, Anne of Austria, took the name of Académie Royale de Peinture et de Sculpture. The twelve 'anciens' were the painters Le Brun, Bourdon, La Hyre, Perrier, Le Sueur (all represented in this exhibition), Charles Errard,[3] Michel Corneille le vieux,[4] Henri Beaubrun and Juste d'Egmont, two portraitists, and the sculptors Jacques Sarrazin, Gérard Van Obstal and Simon Guillain. Champaigne, and also the brothers Le Nain, joined them along with others within the year. In no way exclusive of the most diverse of talents, the Académie had at its head, the youngest of its members, Charles Le Brun, aged twenty-nine and only recently returned from Rome.

This association had as its object the aim of having painting and sculpture accepted as liberal arts. Up to that time, in effect, these professions were controlled by the medieval system of corporations (abolished only in 1793). These grouped together the masters of the different trades, titled both masters or wardens, who enjoyed a monopoly. The candidate for 'master' status had to present, after a long apprenticeship, a 'masterpiece' and pay substantial dues. In practice, the corporation of painters was a closed shop, essentially only receiving into its numbers the sons or relatives of masters already members. What's more, it did not make any distinction between the painter of carriages and the painter of portraits and history subjects. This subordination of art to 'mechanical' trades was denounced, no less than the corporate privelege, by artists who, like Le Brun, belonged to the second category. There were only two ways of eluding this system: to work in a *'lieu privilégié'* ('a place of privelege'), such as the Abbey of Saint-Germain-des-Prés, or to obtain a letter of patent as 'peintre du roi': but the multiplication of the latter prompted the masters to bring legal action, which had as a direct consequence the creation of the Académie.

The young institution, protected by royal power, had to struggle for fifteen years against the requirement for 'master' status which was

supported by the Parliament. The corporation, for its part, took the name of the Académie de Saint-Luc and in 1648 had as its head Simon Vouet, who died the following year, then fifteen years later, Pierre Mignard, the great rival of Le Brun. It was only in 1663, thanks to the support of the King and Colbert, that the Académie Royale finally triumphed. It had opened a school where the professors, all chosen from among the painters of history, the only ones entitled to the rank of officers, each came to teach for one month. In 1666 it achieved the setting up of a subsidiary body, L'Académie de France à Rome, intended for the improvement of its most promising pupils (those who won the 'Prix de Rome'), which still exists today. In addition, the Académie gave itself a theoretical vocation, and organised discussions on works of art from 1671 on, a year which also saw the first public exhibition of works by its members (the future 'Salon').

This sudden awareness of the role of the artist, which broadened to rank him with the poet and to be no longer included among the labourers (tradesmen), was contemporary with another change in attitude, namely the aesthetic order.

From Félibien to Louis Dimier, historians concerned with establishing a date for the birth of a 'French School' of painting, (following in this, Vasari's scheme) have put this at 1627, the date of Vouet's return from Italy. And, though there is much evidence to show that French painting was not then quite so anaemic as was once thought, the fact maintained its significance. Wealthy, both economically and artistically, from a prestigious Italian career, Vouet appeared, towards the end of the reign of Louis XIII, as the head of a school which enjoyed an expansive reputation. He brought to a France, in which the mannerist tradition was prolonged (notably in the celebrated studio of Georges Lallmand), the example of a clear, happy style of painting, whose lyricism was equally appropriate to the creation of great altarpieces for the churches and decorations for the palaces and mansions of Paris. Among his many students, who carried his influence far afield and occasionally down through long periods, we list only the most illustrious: Le Sueur, Mignard, Le Brun, as well as Dorigny (no. 12), Dauphin (no. 11) and Poerson (nos. 30, 31). The role of Vouet was considerable: through the impetus which he gave to artistic activity and by imposing, for the first time in France since Primaticcio, a grand style. This style of Vouet (nos. 41-43), of which the young Le Sueur gives a tasteful version, is not 'classic' if one compares it (nos. 22-23) with that of Champaigne (no. 8) or Stella (no. 39), but in relation to the tormented creations of Bellange or the scintillating baroque of Vignon, it must have appeared as a great example of measured expression. More 'pictorial', that of Blanchard (nos. 3-4) more clearly displays a search for equilibrium, which is shared by the delicate Baugin (no. 2).

From the end of the 1630's there began a reaction against the art of

Vouet. Artists such as La Hyre, (nos. 16-17) and Le Sueur (no. 24) who, pupils respectively of Lallemand and Vouet, had up to that time developed an elegant and Roman style, turned to a more exacting conception of painting. It is they who are to be found among the founders of the Académie. Then, no longer, did either La Hyre nor Le Sueur, neither Champaigne (no. 9) nor Patel (no. 27), neither Poerson (nos. 30, 31) nor Corneille, make the journey to Italy. This fact was noted by contemporaries themselves, who saw in it the sign of the maturity of the French school. It has equally been noted that these artists enjoyed a pleasant existence, a bourgeois lifestyle, which contrasts with the adventurous youth of a Vouet, or a Valentin, or even a Poussin. This moment of equilibrium, of measured design, which happily joined rigour to refinement, has been termed 'l'Atticisme parisien' (the 'Parisian Attic style'). To the artists already mentioned must be added Stella (no. 39), who returned from Rome in 1635, attaching himself to the Parisian movement with works of an astonishing 'purism'. This trend seems to have been independent of Poussin and anterior to his Parisian sojourn of 1641-1642. But, though he joined a French anti-mannerist tradition represented in Paris by Pourbus, and in the provinces by Jean Boucher of Bourges, for example, he certainly encountered the taste common to many artists who, during these years returned from Rome: a year after Stella, it was Claude Mellan (1598-1688), in 1636, then around 1639 Remy Vuibert (c.1600-1652) and Lemaire (no. 21) and Charles Errard in 1643.

This was because Rome continued to attract French painters. But there was from now on a dialogue between Paris and Rome, of which Perrier (nos. 28, 29) may be taken as a symbol. His two stays there, before 1629 and from 1638 to 1645, marked respectively, by the influence of Lanfranco then that of Bolognese classicism, alternated with Parisian sojourns which first saw him as an assistant to Vouet and then as a major decorator in the Hôtel de la Vrillière. Bourdon (no. 6) and Tassel (no. 40) were in Rome around 1635, Mignard (no. 26) from 1635 to 1656, Le Brun (no. 18) from 1642 to 1645, Loir from 1647 to 1649, Blanchet (no.5) from 1647 to 1653. From 1634 to 1653 Charles-Alphonse Dufresnoy (1611-1668)[5] was also there: a painter, a friend of Mignard and also one of the first theoreticians of painting in France and also André Félibien (1619-1695), its first historian, who frequented Poussin while there between 1647 and 1649. Noël Coypel (no. 10) there directed the Académie de France in Rome (1673-1675), and Rivalz (no. 38) passed the last years of the century there. Like him, many of the artists were from the provinces: Bourdon, Tassel, Mignard, and it was in Lyons that Blanchet established himself on his return.

Rome, where Dughet (no. 13) was born, and where Claude Gellée (nos. 14, 15) like him, passed his whole career, was also the adopted home of Poussin. Whilst back in Paris the artists were liberating themselves from the supervision of the guild and proclaiming the

dignity of art, Poussin, in Rome, was progressively affirming the independance of the artist and was soon only working for a private clientèle, both Italian and French. A cultured artist, he passionately studied the great models offered by Antiquity and the Renaissance as well as the Bolognese school (especially Domenichino) and, his rational process related to that of an Andrea Sacchi, opposed itself to the baroque of Pietro da Cortona and Lanfranco, he never appeared as simply one Roman painter among others. Meditating with rare intensity the ends and means of his art, he forged a rigorous discipline in which attention to 'decorum' dominated. This word signifies a great deal more than just the absence of all triviality: it is the essential relationship between the idea implied by a given subject and the plastic means employed to represent it. Everything in the painting, composition, the expressions of the characters, costumes, accessories, decor or landscape, must combine to render it clearly readable. The same for colours and rhythms, whether they be joyous, sad or terrible, they must underline its character, following a 'theory of modes' which had been formulated in Antiquity and which Poussin took up again having seen it employed in a treatise on music. Compared to his works from the thirties (nos. 32-34), characterised like those of Blanchard (nos. 3, 4) by the sensuous colouring of Titian, those of the fifties (nos. 35-37) demonstrate to what degree of intellectual and plastic rigours Poussin had advanced his art.

The lesson of Poussin had to be heard. Though it influenced the late period of Bourdon (no. 7), and Blanchet (no. 5), Lemaire (no. 21) and Perrier owed something to it, its mark was to be more profound on a young painter who was destined to render illustrious the second half of the century just as Vouet had dominated the second quarter: Le Brun. The works presented here illustrate this relationship, thanks to a painting recently identified by J. Thuillier (no. 18) , painted under the very eyes of Poussin, whom Le Brun had accompanied to Rome in 1642, with the collaboration of Dughet, Poussin's brother-in-law. Of two others, painted a short while after his return, one (no. 19) illustrates his fidelity to poussinian rhetoric the other (no. 20) heralds the great decorator of Vaux and Versailles.

It is through Le Brun, who became Chancellor of the Académie in 1663, that this institution would adopt the concepts of Poussin (many of whose works were to become the subject of Conferences, in much the same manner as those of Raphael and Titian). One finds echoes of this, together with the influence of Le Sueur, in the works of Noël Coypel (no. 10), and that of Le Brun in the painting which Loir (no. 25) presented as his reception piece to the Académie in 1666. With these two works, which each make allusion to Louis XIV as legislator and protector of the arts, the exhibition theme is made evident. It is the era of Versailles, and the 'querelle coloris' ('conflict over colour') will soon rise up, conducted by Roger de Piles, in relation to the works of Rubens,

which would eventually divide the artists into 'Rubenistes' and 'Poussinistes'.

This exhibition thus retraces, from the first works of Poussin, painted about 1625,° to the *Solon* of Coypel, painted around 1675, a half century of French painting. The scope, as we have said, had been deliberately limited to history painting (and to historical landscapes): a field which covers a vast and astonishing variety of expression. Under the very variety of temperaments, means of expression, from the frozen technique of Stella to the vigorous impasto of Perrier, from the cabinet picture to the altarpiece, from the antique or biblical scene to the allegory, one can recognise a common goal. Starting from completely diffrent experiences, the artists, whether they drew themselves to the bosom of the Académie, or, like Poussin, pursued a solitary quest, they progressed towards a language of clarity, capable, just like poetry, of analysing and expressing human feelings, the 'passions' in their complexity. This was the great ambition of the writers, dramatists and philosophers, of the century which was termed classical. It is not unhelpful to recall that, during this fundamental progress of French culture, painting played, from very early on, a leading role.

Sylvain Laveissière

1. Petit Palais, 30 January — 20 February 1985. Planned initially to be held in the rooms of the Musée d'Art et d'Essai at the Palais de Tokyo, which had later become unavailable, this exhibition was fortunately able to be presented at the Petit Palais, thanks to the help and understanding of Mlle. Thérèse Burollet, the head curator. To both her and M. Gilles Chazal, curator of paintings, we extend our warmest thanks, and indeed to all the staff of the museum, with whom we had the pleasure of working. A booklet published on that occasion, *Le Classicisme Français. Chefs-d'oeuvre de la peinture du XVII° siecle (Petit Palais, Expositions,* no 5, Janvier 1985, 24 pp.), reproduces the French text of the preface by J. Thuillier, and illustrates the thirty-five paintings. They were complemented by another fourteen works from the museum's own collection: six paintings by Claude, Bourdon, Dorigny, Mauperché and Millet, three drawings by Claude and Champaigne, four tapestries after Bourdon and Le Brun and a bas-relief by Duquesnoy.

2. Szépmüvészeti Museum, 5 March — 16 (and not 14) April 1985. The catalogue includes entries for the eleven paintings from the Hungarian Museum written by Mlle. Agnés Szigethi, curator and co-commissioner of the exhibition (Bourdon, Colombel, Dughet, Claude, La Hyre, Le Brun, Mignard, Millet, Vouet) and by Gilles Chomer (Stella); *Le Siècle classique de la peinture française. Tableaux français du XVII° siècle du Louvre, des musées de France et du Musée des Beaux-Arts de Budapest* (in Hungarian), 46 entries, all reproduced.

3. The paintings of Charles Errard (c.1606/1609-1689), which appear to have been very numerous, remain to be rediscovered (cf. J. Thuillier, 'Propositions pour: 1. Charles Errard, peintre', R.A. no. 40-41, 1978, pp. 151-172. The only picture which can be attributed with any certitude *Rinaldo taking leave of Armida,* in the Museum at Bouxwiller, painted in Rome c.1640, is too large (240 × 336 cm) to be included in the exhibition, (cf. J.-Cl. Boyer and A. Brejon de Lavergnée, 'Une commande de tableaux a des artistes français et italiens à Rome en 1639', *R.L.* 1980, no 4, pp. 231-239, cf. pp. 232-234 and, fig. 2).

4. The available works by Michel Corneille (1603-1664) are also too large in size.

5. Cf. J. Thuillier, 'Propositions pour. II. Charles-Alphonse Dufresnoy peintre', R.A., no. 61, 1983, pp. 29-52.

6. Almost certainly retouched at the end of the century, the composition by Coypel representing *Solon* dates to his Roman sojourn, from 1673 to 1675. The other paintings whose dating is certainly later than this *terminus,* are those by Mignard (no. 26), d'Allegrain (no. 1) and Rivalz (no. 38), which perhaps already belong to the eighteenth century. The strong Bolognese references in the first of these and the Poussinesque references in the two latter, appear to us to justify these exceptions.

15 CLAUDE GELLÉE called LE LORRAIN c.1602–1682 **Juno confiding Io to the Care of Argus**, 1660
National Gallery of Ireland, Dublin

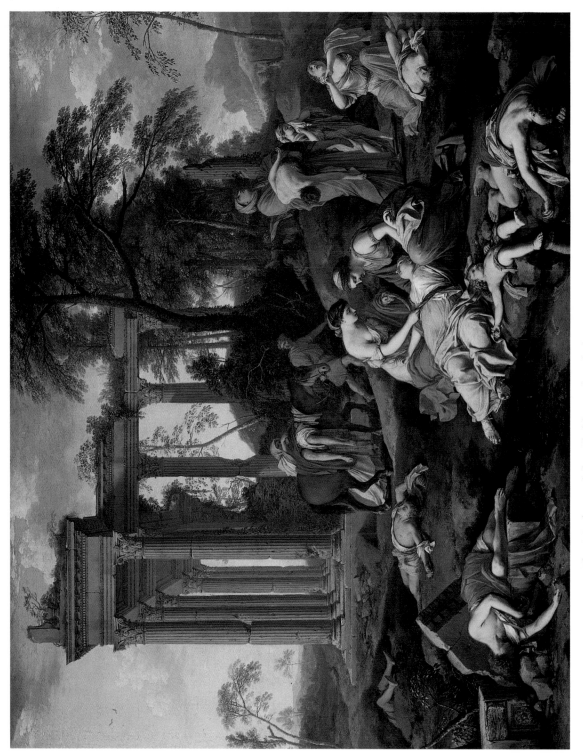

16 LAURENT DE LA HYRE 1606-1656 **The Mothers of the Children of Bethel** 1653
Musée des Beaux-Arts, Arras

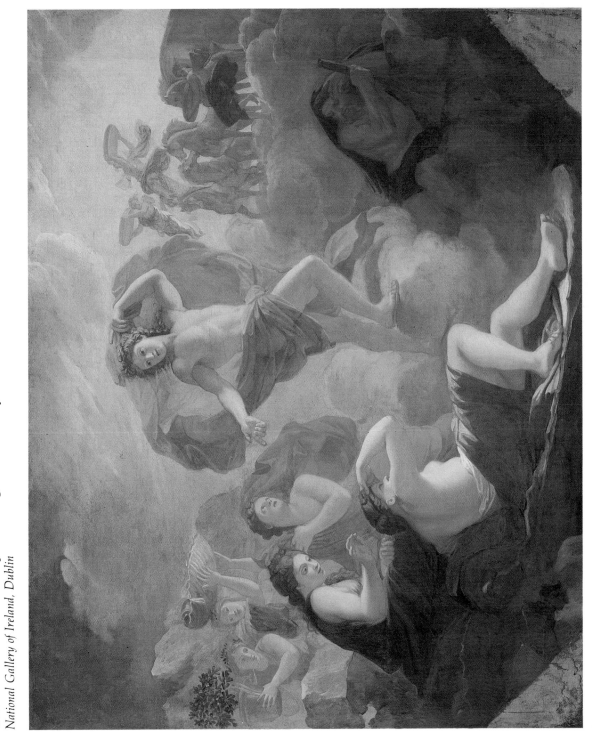

20　CHARLES LE BRUN 1619-1690 **Apollo taking Leave of Tethys**
National Gallery of Ireland, Dublin

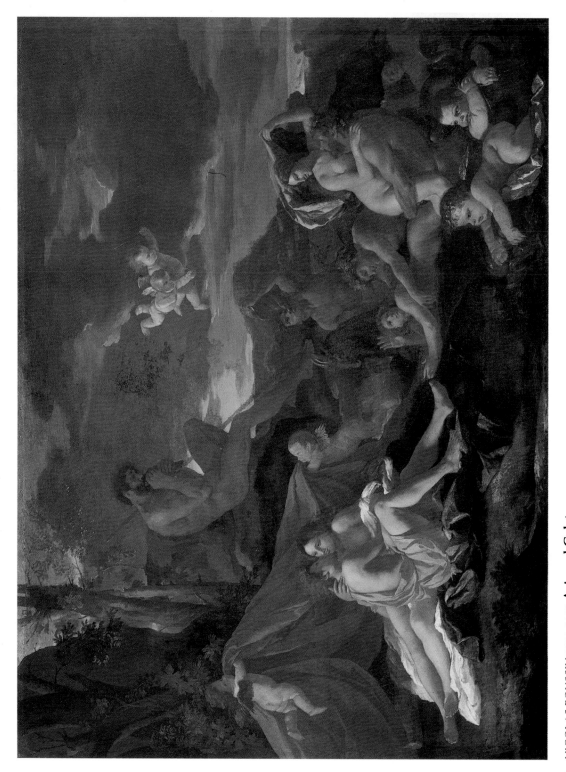

34 NICOLAS POUSSIN 1594-1665 **Acis and Galatea**
National Gallery of Ireland, Dublin

35 NICOLAS POUSSIN 1594-1665 **The Holy Family with Saint Anne, Saint Elisabeth and the young Saint John,** *called* **The Virgin with Ten Figures**
National Gallery of Ireland, Dublin

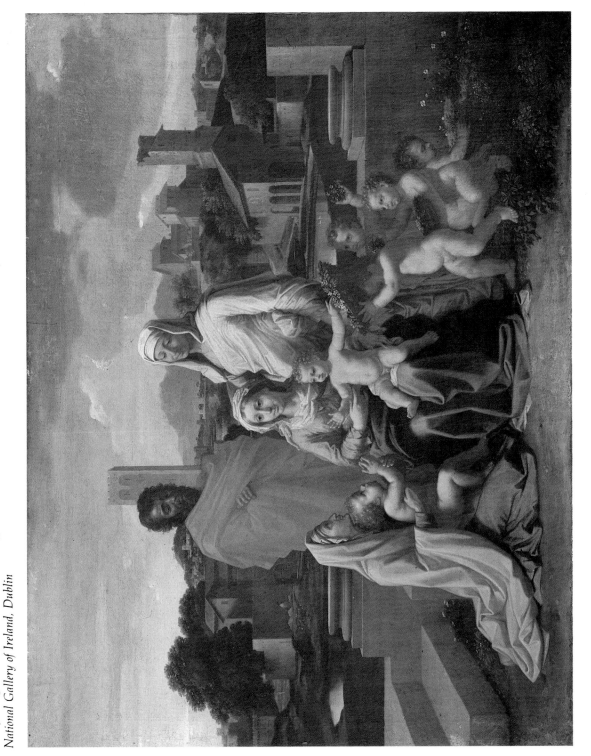

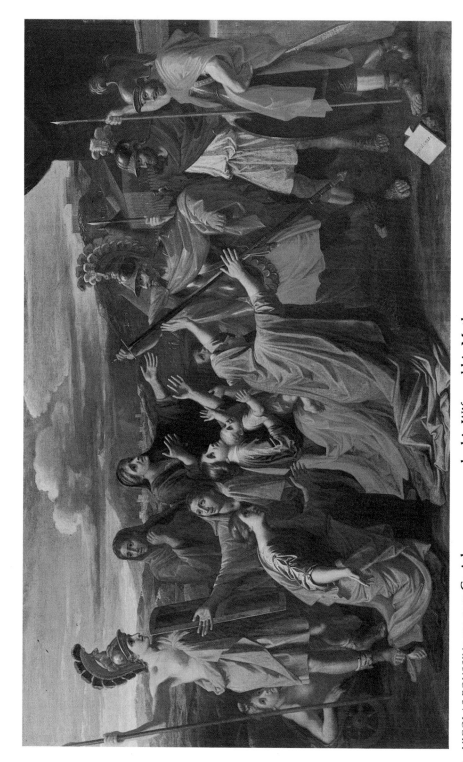

36 NICOLAS POUSSIN 1594-1665 **Coriolanus won over by his Wife and his Mother**
Musée Municipal, Les Andelys

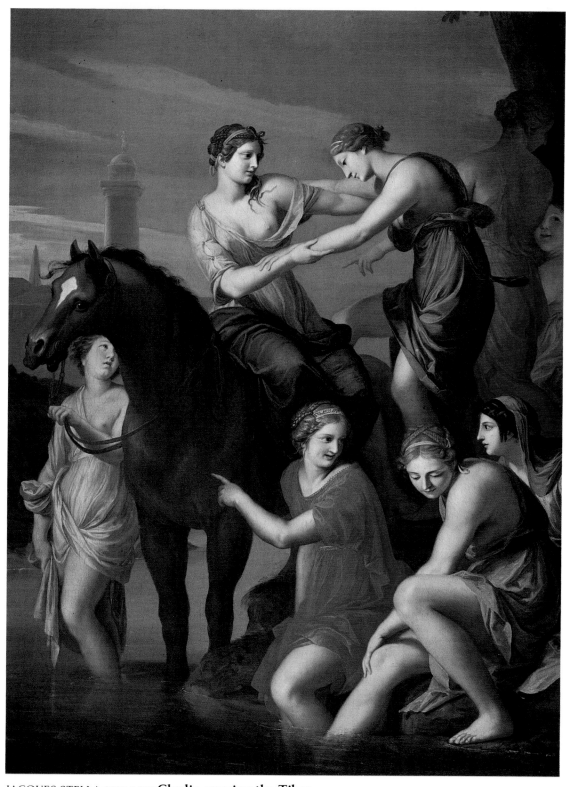

39 JACQUES STELLA 1596-1657 **Cloelia crossing the Tiber**
Musée du Louvre, Paris

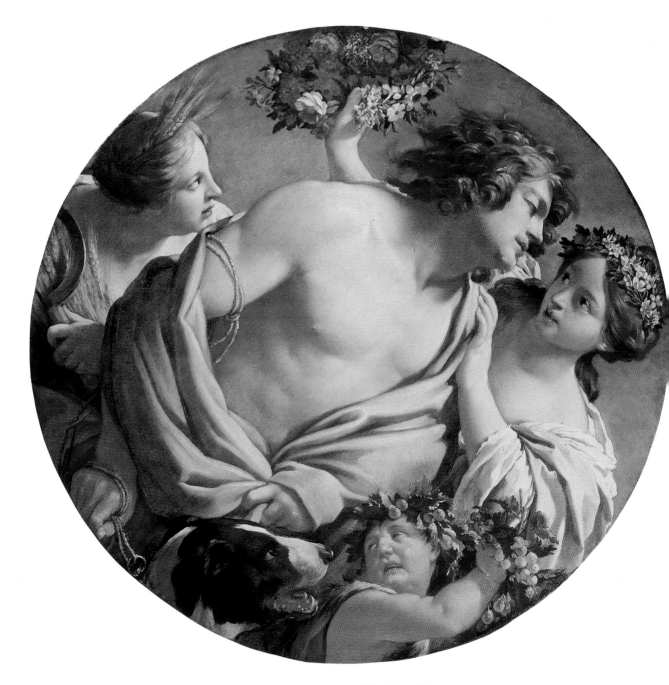

41 SIMON VOUET 1590-1649 **The Four Seasons**
National Gallery of Ireland, Dublin

Etienne Allegrain
Paris, 1644 — Paris, 1736

We know little of this artist who lived to be ninety-two, whose son Gabriel (1679-1748) became a painter, and grandson Christophe-Gabriel (1710-1795) a sculptor. He was received into the Académie in 1677 (his reception piece, a Flight into Egypt *is now lost). Essentially a landscape artist, between 1688 and 1690 he executed a series of lively views of the château and park of Versailles, destined, like those of J. Cotelle and J. B. Martin, for the decoration of the Grand Trianon (in situ; cf. Schnapper, 1967). But it is from the tradition of the composed landscape, proceeding from the works of Poussin and Claude Gellée of the middle of the century, that the landscapes of 1695 and 1700 belong, painted for the same location and the Ménagerie de Versailles. His architecture and figures, which are somewhat spindly, allow us to recognise as his, landscapes which hold erroneous attributions to Poussin, Dughet, van Bloemen or (more likely) to his exact contemporary, Francisque Millet (1642-1679).*

1. Landscape with a River

86 × 136 cm.
Paris, Musée du Louvre, (inv. 2316; Catalogue 1974, no. 2, reproduced).

HISTORY: Acquired in 1822 from M. de Langeac. Collection of Louis XVIII. On loan to Fontainebleau until 1930.

EXHIBITIONS: 1956, France, no. 4; 1960, Paris: *Réserves*, no. 549; 1964-1965, Dijon, Lyons, Rennes, no. 3; 1978, Tokyo, no. 26, reproduced.

BIBLIOGRAPHY: P. Rosenberg, *The Age of Louis XV*, exhibition catalogue, Toledo, Chicago, Ottawa, 1975-1976, under no. 1 (error in the provenance).

Very close in composition to the *Landscape with a Lake* in the Bader Collection, as underlined by P. Rosenberg (1975-1976, no. 1, fig. 10), this luminous landscape, lucidly ordered around the calm mirror of the waters, responds to principles of symmetry and conformity which ensure its balance. It offers a vision of blissful antiquity: three women converse, whilst arranging flowers, with measured gestures which add to the nobility of the evocation. One barely notices that the fourth woman, stretched out on the ground, is weeping: about her, the skeletal wreck of a boat introduces into this idyllic eternal landscape the notion of the frailty of human life. Poussin, who had emphatically incorporated this idea into the *Arcadian Shepherds* (Louvre and Chatsworth), made it the leitmotiv in landscapes, such as the *Orpheus and Eurydice* of the Louvre, which appears to have been Allegrain's chief reference. Thus, in this apparently entirely decorative work, there subsists (even though it is reduced to a picturesque effect) an echo of 'poussinian' rhetoric.

1

Lubin Baugin

Pithiviers (near Orléans), c.1612—Paris, 1663

Received as a master painter into the community of Saint-Germain-des-Prés on 23rd May 1629, Baugin passed many years, from 1636 onwards, in Italy (his wife, Brigitte Dasle, was Roman). Back in Paris in 1641, he entered the Académie de Saint-Luc in 1645, becoming a member of the Académie Royale on 4th August 1651 (at the same time as Vignon and Poerson) during the unification (temporary) of the two institutions. Dismissed on 2nd January 1655 (Ph. de Champaigne replaced him as professor), he was later readmitted.

Initially influenced, like most of his contemporaries, by the School of Fontainebleau, Baugin found the models for his art in Italy: the elegance of Parmigianino, the sweetness of Correggio and the clarity of Guido Reni, the imprint of whose style on his output won him the nickname 'Petit Guide' ('Little Guido').

Creator of large religious paintings (of which eleven were destined for Notre-Dame in Paris, which still retains the Martyrdom of St. Bartholomew and a Pietà) and employed by Vouet to assist with tapestry cartoons, Baugin also excelled (like Stella, Bourdon, Mignard or Loir) in small compositions of the Virgin and Child and Holy Family, which enjoyed great commercial success. One easily recognises the blond colouring of his figures which detach themselves from the blue-tinted landscape, recalling the Madonnas of Raphael. Today there can no longer be any doubt that we must render to the same artist the precious still-lifes signed Baugin (without the christian name), for a long time believed to be by another artist (two in the Louvre, two others at Rennes and the Galleria Spada in Rome).

2. The Childhood of Jupiter

150 × 144 cm.
Troyes, Musée des Beaux-Arts (18.2.4).

HISTORY: Collection of Frédéric-Eugène Piat; bequeathed by his widow in 1918 (as La Hyre). Recognised as Baugin by J. Thuillier (1963).

BIBLIOGRAPHY: J. Thuillier, 'Lubin Baugin', *L'Oeil*, no. 102, June 1963, p. 16-27 and 69-70, cf. p. 25, reproduced in colour p. 24, fig. 19.

The childhood of Jupiter had been treated at least twice by Poussin (Dulwich College and Berlin) who portrayed the infant god suckled by the goat Amalthea on Mount Ida. His mother Rhea had entrusted him to the Curetes and the Nymphs to protect him from his father Cronus (Time): the latter devoured his children at birth, as an oracle had prophesied that one of them would usurp him.

Baugin has here chosen one of the rarer episodes from this story, where the young Jupiter is seen, already accompanied by the eagle and armed with a thunderbolt (he is the master of thunder), chasing after lions and followed by an animated troup of bacchantes playing tambours and cymbals, in the company of the Curetes (demons who also watched over the childhood of Bacchus).

Exceptional in Bauguin's known work, on account of its mythological subject (along with the small *Abduction of Helen* at Dijon, Musée Magnin), this ambitious composition is to be likened to the *Bacchanals* of Blanchard, of 1636 (no. 4) and of Le Sueur (no. 22). If one recognizes in this composition, impressed with a joyous sensuality, the influences evoked above and the characteristic light colouring of the painter, one also finds in it traits

reminiscent of Poussin (the expressive visage, seen in full face, of the Curete placed to the left) and of Le Sueur (as in the young Jupiter) which fully correspond to the ideals of Parisian painting of the 1640's.

Jacques Blanchard

Paris, 1600 — Paris, 1638

After an apprenticeship of five years with his uncle Nicolas Bollery, which began on 30th January 1613, Blanchard departed for Italy in 1620. On the way he stopped in Lyons where he worked with Horace Le Blanc until 1623. He spent only eighteen months in Rome (1624-1626) but delayed two years in Venice (1626-1628), then in Turin. Back in France, he stayed again in Lyons (1628-1629) and passed the last ten years of his short career in Paris. A member of the Académie de Saint-Luc, he was made 'peintre du Roi' in 1636.

His return two years after that of Vouet (1627), was greeted as an event by Félibien who recorded that: these two artists, though working 'de manières bien differentes (...) ont beaucoup contribué à remettre en France le bon goût de la peinture' ('in very different styles (...) have greatly contributed to the return of good taste in French art.' Entretiens..., 4th section, 1685, p. 78).

Of the mannerism of his first master, Blanchard retained principally the inherited elegance of Primaticcio. His Venetian experience, which won him the nickname, somewhat excessive, though revealing of his reputation as a colourist, of 'Titien français' ('The French Titian'), blended happily with a taste for full forms and luminous flesh tints, stemming from Rubens and Jordaens.

The originality of this art, besides being marked by equilibrium and measure, at once sensual and monumental, assured him of a rapid success in the capital, a success moreover in the domain where Vouet enjoyed an almost total monopoly. Around 1631, he painted the twenty-three pictures for the little gallery of the Hôtel Le Barbier and, in 1634, twelve mythological scenes symbolizing the months of the year, executed in three months for the lower gallery of the Hôtel Bullion (where Vouet decorated the Upper Gallery). The same year, he delivered the May de Notre-Dame, *a Pentacost (in situ) which has, for a long time, been considered his masterpiece.*

To the important religious commissions must be added the many devotional pictures painted for collectors: images of saints (St. Jerome, 1633, Budapest), and especially The Holy Family *(Louvre) and the half-length* Virgin and Child *(Clermont-Ferrand), the* Charity *(no. 3) as well as mythological subjects (Danae, Tsarkoié Sélo; Venus and the Three Graces, Louvre; Bacchanal, 1636, no. 4) and legendary subjects (Medoro and Angelica, New York): their success, documented and increased by engraving. Some rare and sensitive portraits (Detroit, Toledo), which make one think of Van Dyck, complete the oeuvre (now better known since the publication in 1961 of Charles Sterling's fine study on the artist) of this fertile and seductive artist, who knew how to add new life to French painting.*

3. ## Charity

110 × 136 cm.
Signed and dated, bottom right: *Jaques / Blanchard / 1633*
Paris, Musée du Louvre (inv. 2610, Catalogue 1974, no. 22, reproduced).

HISTORY: Perhaps in the collection of 'M. de Vaqvieulx, avocat au Conseil privé', to whom is dedicated Daret's engraving after this composition (1636). Collection of Louis XIV since 1683. At Versailles in the eighteenth century (Cabinet des Tableaux, then as an overdoor in the Salon de Mercure). Restored in 1983-1984 (discovery of the signature and the date).

EXHIBITION: 1973, France, no. 1, fig. 9.

BIBLIOGRAPHY: J.-B. de Monicart, *Versailles immortalisé*, 1720, vol. II, p. 376; Dézallier d'Argenville, *Abrégé ...*, 2nd ed., 1762, vol. IV, p. 54; Piganol de la Force, *Description de Versailles*, 1764, vol. I, p. 161; C. P. Landon, vol. I, 1829, pp. 9-10, pl. 1; F. Engerand, 1899, p. 296; A. Fontaine 'Observations sur trois tableaux du Musée du Louvre et de Maisons-Laffitte attribués à Jacques Blanchard', *B.S.H.A.F.*, 1923, pp. 27-31, cf. pp. 27, 28, 30; L. Demonts, 'Deux peintres de la première moitié du XVII° siècle, Jacques Blanchard, Charles-Alphonse Dufresnoy', *G.B.A.*, 1925-II, September-October, pp. 162-178, cf. pp. 166-167; L. Dimier, 1926, p. 39 and pl. XXIX-2; Ch. Sterling 'Les peintres Jean et Jacques Blanchard', *Art de France*, vol. I, 1961, pp. 76-118, cf. pp. 92, no. 52, reproduced in colour, p. 111; J. Thuillier, 1963, p. 206; P. Rosenberg, 'Quelques nouveaux Blanchard', *Etudes d'art français offertes à Charles Sterling*, 1975, pp. 217-225, cf. p. 222, no. 52; Cl. Constans, 'Les tableaux du Grand appartement du Roi', *R.L.*, 1976, no. 3, pp. 157-173, cf. p. 169; J. Thuillier, 'Documents inédits sur Jacques Blanchard', *B.S.H.A.F.*, 1976 (1978), pp. 81-94, cf. pp. 81 and 87 note 1; J. Thuillier and Cl. Mignot, 'Collectionneur et Peintre au XVII°: Pointel et Poussin', *R.A.*, no. 39, 1978, pp. 39-58, cf. p. 47; P. Rosenberg, 1982, under no. 5.

RELATED WORKS: Engraving by Pierre Daret, dated 1636 (cf. *History*); line engraving by Normand the younger, in Landon, 1829.

A *Charity* by Blanchard (approximately 100 × 130 cm.) valued at 150 *livres* in the inventory of Jean Pointel, the friend and patron of Poussin, in

1660, could well correspond to the painting in the Louvre (Thuillier, 1976; Thuillier and Mignot, 1978).

Other painted versions are mentioned in the sales: one with three children, (approximately 57 × 90 cm.) at the Prince de Conti sale on 8th April 1777, no. 562, acquired by 'Silvestre'; another (approximately 70 × 84 cm.) at the Pariseau sale in 1789 (Sterling, 1961, p. 99).

Four other versions are preserved (cf. Rosenberg, 1982): a small version on copper at the Hermitage (18 × 27 cm.; reproduced in *G.B.A.*, 1968-II, p. 126, no. 106); a fragmented painting (106 × 83 cm., dated *1637*) at the Courtauld Institute in London; a painting (108 × 138 cm.) at the Museum in Toledo (Rosenberg, 1982, no. 5). These three works were engraved in the seventeenth century by Antoine Garnier as well as a vertical composition (lost), where the seated woman appears to be a portrait (Sterling, 1961, fig. 53, 56 twice, 58 twice, 59). The fourth extant painting, (131 × 104 cm., dated *163...*); once at the Bob Jones University Museum at Greenville (catalogue, 1968, no. 287) then sold at London (Sotheby's, 11th June 1981, no. 128, reproduced in colour) presents types very close to the Louvre picture.

A drawing (18.7 × 21 cm.), Cambridge, Fogg Art Museum (Sterling, 1961, no. 54) presents another version of a reclining *Charity*.

Among the copies of the Louvre painting, two belong to the Louvre: inv. 2611, on loan in 1876 at La Roche-sur-Yon, and M.N.R. 625 (in reserve and not on loan at Auxerre).

Charity, one of the three theological virtues, along with Faith and Hope, is a subject much used by Blanchard, as is shown by the number of his compositions on this theme. Perhaps the period also had something to do with this: in this respect Ch. Sterling has recalled the contemporary activities of Saint Vincent de Paul for lost children. This theme provided the pretext to paint generously endowed women suckling a group of naked children, a subject whose charm alone would suffice to justify its popularity.

Though recalling the models of the School of Fontainebleau, the Louvre's *Charity* is without doubt the most 'classical' of these compositions, and even if its pyramidical construction can be found again in those paintings in London and Toledo, it is more directly inspired by classical sculpture, most notably the *Sleeping Ariadne* and even more so by the *Nile*, both at the Vatican (Haskell and Penny, 1982, nos. 24 and 65). It is in the recumbant figure of this rivergod, surrounded by children symbolising the branching of the Nile at its mouth, that Blanchard seems to have borrowed the idea, at once sculptural and picturesque, for this painting.

Deprived of the symbolic attributes, displayed in the picture by Champaigne (no. 8), Blanchard's *Charity* is placed within a framework of classical ruins which ennoble the subject, though it equally signifies the vanity of earthly works as opposed to the immortality of spiritual virtue. Following a practice which was dear to him, the artist directs our attention in two opposite directions: to the right to the two children who are

consoling the little girl in tears, one by the use of rational arguments, which he enumerates on his fingers, the other, by a gesture of benediction; to the left, to the close union of the two other figures with their consoling foster-mother.

4. Bacchanal

138 × 115 cm.
Signed and dated to the right: *Blanchard f. 1636* (?)
Nancy, Musée des Beaux-Arts (Catalogue 1909, no. 325, reproduces the signature).

HISTORY: Collection of Jules Renauld; acquired by the Museum in 1884.

EXHIBITIONS: 1958, London, no. 45, album pl. 19; 1958, Paris no. 5, pl. 15; 1959, Berne, no. 5, pl. 5; 1960-1961, Washington, Toledo, New York, no. 48, reproduced.

BIBLIOGRAPHY: (The works already cited in the preceding entry are here abbreviated). A. Fontaine, see above, 1923, p. 30; L. Demonts, see above, 1925, p. 166; W. Weisbach, 1932, p. 57; P. Lavallée, 'Sur un dessin de Jacques Blanchard', *R.A.A.M.*, 1934, I, pp. 183-186, cf. p. 186; M. Laclotte, 1957, p. 45, reproduced p. 41; Ch. Sterling, see above, 1961, pp. 76, reproduced, 82, 93, no. 55; J. Thuillier, 1963, p. 206.

Unique in Blanchard's work, this painting perhaps comes from a series of four *Bacchanals* painted for the *salon* of the Parisian florist Pierre Morin. It is tempting to see, in this particular case, a representation of *Autumn* (though Ch. Sterling remarks that this commission would appear to be prior to 1634).

A magnificent example of the *'peinture claire'* which seduced Paris as much as Rome in the 1630's, this *Bacchanal* recalls the golden colouring of Titian and the joyous vigour of Jordaens. Ch. Sterling compares it with the art of Johann Liss (which Blanchard must have known in Venice, he is known to have owned a *Lute Palyer* by this artist). It inaugurates a French tradition, and its composition, with the large nude laid out in the foreground leaning against a tree where fruits are being picked by children, will be found again in the work of Vouet (*The Earth*, once in the Galerie de Diane at Fontainebleau, engraved in 1744), and in the *Bacchanals* of Dorigny and of Chaperon.

Almost contemporary with Pietro da Cortona's *Age of Gold* at the Palazzo Pitti (1637), composed in the same manner, it too evokes a blissful antiquity where evil does not exist: here Silenus and the Nymphs celebrate the virtues of wine, music and dance, in full harmony with a gracious Nature where even the trees participate in the movement.

Thomas Blanchet

Paris, 1614 ? — Lyons, 1689

'On ne connaît pas assez Thomas Blanchet à Paris pour lui rendre la justice qui lui est due' ('One does not know enough of Thomas Blanchet in Paris to do him the justice that is his due'), Dézallier d'Argenville was already lamenting in 1762 (Abrégé ..., vol. IV, p. 118).

Recent studies have brought to our attention again this most original artist who has remained more famous in Lyons than in his native city. Initially a sculptor, he abandoned this artform for painting, on the advice of Sarrazin, while devoting his talents equally to architecture at the same time. He was in Rome from 1647 until 1653, where he frequented the company of Poussin and Sacchi, who directed him towards high painting. Arriving in Lyons in 1655, he collaborated with Germain Panthot, whom, in 1675, he succeeded as town painter – his principal work being the decoration (extant) of the Hôtel de Ville, from 1655-1672. He also worked for the churches, the convent of Saint-Pierre and the Palais de Justice, besides working on ephemeral decorations designed for festivals. He also opened a school of painting in the town.

Nonetheless, Blanchet maintained contact with Paris. In 1663 he painted the May de Notre-Dame (The Capture of Saint Philip, Arras) and was received into the Académie Royale in 1676; he did not deliver his reception piece until 1681 (Cadmus and Minerva, Semur-en-Auxois), presented in his absence by his friend Le Brun.

If Blanchet can appear as a great 'baroque' decorator, and the major part of his existing oeuvre testifies to this, he also owes a debt to Poussin. Despite its agitation, his Death of Dido (Dijon) recalls the Madonna of the Steps of the latter, and the group of works painted in Rome which have been attributed to him by Jennifer Montagu, (no. 5) give evidence of a study of archaeology and an approach to art close to that of a Dufresnoy or a Lemaire (he would have painted many pictures in competition with the latter according to Dézallier d'Argenville).

5. Alexander at the Tomb of Achilles

97.5 × 133.5 cm.
Paris, Musée du Louvre, (inv. 1290; Catalogue 1974, no. 243, reproduced, as Dufresnoy).

HISTORY: Collection of Jonas Witson at Amsterdam, at the end of the seventeenth century, as Poussin (cf. the engraving of G. Van Houten). 'Collection du chevalier de Pagge' (according to the catalogue of the Chamgrand sale, 1787). Page sale, December 1786 (Lugt, 4116, cites the catalogue after Duplessis); sold for 2600 francs (Smith, 1837). Anonymous sale 'M.M.' (Marquis de Chamgrand, de Proth, Saint-Maurice, Bouilliac), (Lugt, 4162), 20-24th March 1787, no. 185, as Poussin (36 × 50 ins.; cf. Adhémar, 1962); sold for 1,765 francs (Smith, 1837). Collection of Clermont d'Amboise, at Paris, where it was seized as a *'bien d'emigré'* in 1793. On loan at the Palais de Fontainebleau before 1930.

EXHIBITIONS: 1960, Paris: *Réserves*, no. 381 (French School of the seventeenth century); 1979, Paris, Louvre: *L'enlèvement des Sabines de Poussin*, no catalogue.

BIBLIOGRAPHY: C. P. Landon, *Vies et Oeuvres . . . Nicolas Poussin*, vol. IV, 1811, pl. 36 and table of illustrations, p. 9, pl. CXXIV; J. Smith, vol. VIII, 1837, pp. 89-90, no. 167 (Poussin); H. Adhémar, 'Alexandre au tombeau d'Achille', *G.B.A.*, 1962-II, July-August, p. 315, reproduced; A. Blunt, 'Poussin Studies, XIII: Early falsifications of Poussin', *B.M.*, November 1962, pp. 486-498, cf, p. 493, reproduced p. 491, fig. 21, ('Jean Lemaire ?'); J. Thuillier, *Tout l'oeuvre peint de Poussin*, 1974, p. 122, R 52, reproduced (the engraving) p. 121, R 52a (Blanchet or Dufresnoy ?); J. Thuillier, 'Propositions pour: II. Charles-Alphonse Dufresnoy peintre', *R.A.*, no. 61, 1983, pp. 29-

52, cf. pp. 33-34 and 49 notes 31-41, reproduced p. 32, fig. 3; L. Galacteros, *La vie et l'oeuvre de Thomas Blanchet,* unpublished thesis, Lyons, 1982, pp. 950-952, C.P. 63.

RELATED WORKS: Engraving in the opposite direction by Gerard Van Houten (seventeenth century) as after a painting by Poussin, with the dedication: *'Nobilissimo Amplissimo Domino – Dno Jonae Witsen/Republ: Amstelodamensis Secretario, – Picturae cultori eximio olim discipulo nunc Patrono/hanc Poussinii tabulam a se aeri incisam – qua debet observantia D.D.D. Gerardus Van Houten.'* – *'Nic Poussin pinxit –G. van Houten sculpsit'* (reproduced in *Colloque Poussin,* 1960, vol. I, fig. 252, and Thuillier, 1974, fig. R 52a; cf. Smith, vol. VIII, 1837, pp. 89-90, no. 167; C. Kramm, *De leven en Werken ...,* vol. I, 1857, p. 758; Andresen, 1863, p. 77, no. 313).

Line engraving after the latter, by Mme. Soyer, in Landon, 1811.

A painting of the same subject, though larger and higher (approximately 250 × 160 cm.) with its pendant, *The Consultation of the Sibylline Books,* was in the collection of Robert Walpole under the name of Poussin (in 1744) and then under that of Lemaire (H. Walpole, *Aedes Wolpolianae ...* London, 1767, p. 61; cf. E. Waterhouse, 'Poussin et l'Angleterre jusqu'en 1744', *Colloque Poussin,* 1960, vol. I, pp. 283-296, cf. pp. 290-291; the passage concerning this painting is incorrectly illustrated, fig. 252, by the Van Houten engraving mentioned above). Nothing allows us to determine that it had any connection with the painting in the Louvre.

The subject is taken from Plutarch: his *Life of Alexander* (15, 8) states that 'having rubbed himself with oil and run naked, as was the custom, with his companions, he placed crowns' on the tomb of the hero from whom he claimed to be descended. In this scene the artist, faithful to the text, exhibits quite a profound knowledge of archeology, though the roman enseigns to the left appear somewhat incongruous in a Greek scene (an artist as erudite as Dufresnoy, to whom the painting has been attributed, would not have committed such an anachronism). Van Houton's engraving did not indicate the subject and it has been variously interpreted as: *The Sacrifice of Scipio,* in the inventory of Poussin's engraved works from the collection of the Comte de Vence (published by S. Damiron, *Colloque Poussin,* 1960, II, p. 18); *Caesar bringing an offering to the tomb of Alexander* (Kramm, 1857); Landon calls it simply: *Sacrifice near a Mausoleum.*

The hommage paid by Alexander, the Conqueror, to the memory of Achilles, the demigod, is 'commented' upon on one side by the high priest performing a sacrifice, and on the other by the soldiers. In front of the severe frontal plane of the tomb, the three groups form a type of frieze, similiar to the antique bas-reliefs, drawn indefatiguably by the artists visiting Rome. The scene represented on the front of the tomb seems indeed to be, as indicated to us by Jennifer Montagu, the death of Achilles from the arrows of Paris, to whom Apollo had pointed out his victim.

The authorship of this painting has always intrigued: attributed to Poussin in the seventeenth and eighteenth centuries, at the time of its accession to the Museum in 1793 it was catalogued as 'gravé sous le nom de Poussin, attribué à Pietre Teste, mais est de Stella en Italie' ('engraved under the name of Poussin, attributed to Pietre Teste (Testa), but is by Stella in Italy'. Adhémar, 1962). The Musée Royal's inventory of 1832 (M.R. 715), and that of Villot twenty years later (inv. 1290), gave it to Berthollet Flémale (Liège 1614-1675), an attribution which it retained for a long time. Blunt (1962) tentatively proposed the candidacy of Jean Lemaire, while that of Ch.-A. Dufresnoy (1611-1668), put forward about 1930, is still upheld by P. Rosenberg (1974 catalogue) and by J. Thuillier (1983).

Jennifer Montagu, after many years, has reconsidered the work as well as a dozen paintings closely related to it, and proposed, with convincing arguments, to give them to Thomas Blanchet, dating this picture to the period of his Roman sojourn. Though it may not be included among the works of the artists' to whom it has successively been attributed, it in fact, shares many traits in common with Blanchet's surviving paintings which date to after his return to France. The liveliness of touch, the angular draperies

(which do in fact recall Pietro Testa), the eye sockets marked by deep triangular shadows and the hard modelling, are to be found most notably in the sketches for the Hôtel de Ville at Lyons, preserved in the Museum of the same town.

Sébastien Bourdon
Montpellier, 1616 — Paris, 1671

Having departed at a very young age from his native town for Paris, where he made his apprenticeship and which he left at the age of fourteen, Bourdon spent some time in the Military at Toulouse prior to taking up his brushes again. Arriving in Rome around 1634, he studied the great contemporary models: Poussin, Claude Gellée, Andrea Sacchi, representatives of the classical approach. He also looked at Pieter van Laer, called 'Il Bamboccio', whom he imitated very closely in the depiction of popular subjects, and the Genoese G. B. Castiglione, producing pastiches of his celebrated animal scenes.

Threatened with denunciation on account of his religion (he was a Protestant), Bourdon was forced to leave Rome in 1637 and return to Paris, via Venice. Back in Paris, he painted numerous bombacciate, *concurrently his great religious paintings, such as the* Martyrdom of St. Peter, May de Notre-Dame *of 1643 (at Notre-Dame), one of his most baroque works.*

It is from about 1645 onwards that he displays the study of Poussin in his works, in more monumental compositions, stressing the rigour and discipline of vertical and horizontal lines, the clarity of planes, with fresher colours underlining the increasingly noble forms.

*In 1648, Bourdon was numbered among the twelve founders of the Académie, of which he became Rector in 1654. Called to Sweden by Queen Christina, whose portrait he painted, he remained there from 1652 to 1654. On his return to Paris he took over from Le Sueur on the commission to provide cartoons for the tapestries destined for the Church of Saint-Gervais (*The Beheading of St. Protase, *1655, Arras), a series finished by Champaigne.*

The town of Montpellier, to which he returned in 1656-1657, commissioned him to paint a vast Fall of Simon Magus *for the cathedral (in situ) in which there figures a self-portrait of the artist. At the same time he executed the seven compositions representing* The Works of Mercy, *(Sarasota) which he engraved himself and which recall the* Seven Sacraments *of Poussin. From 1663 he decorated the gallery of the Hôtel Bretonvilliers (destroyed), close to the Hôtel Lambert on the Isle Saint-Louis: this included fourteen medallions representing, in the form of allegories and scenes from ancient history, the* Virtues *necessary for 'good government' and the* Arts *which they promote, which were surmounted in the vault with the* Story of Phaeton, *an allusion to the young Louis XIV whose reign had just begun.*

During his later years, the four Discourses *which he read at the Académie between 1667 and 1670, devoted principally to Poussin, the Carracci and to the antique, are a remarkable profession of classicism.*

On account of his amazing facility to assimilate the style of the most diverse masters, great and small, Bourdon has suffered the reputation of being an eclectic copyist, whereas in actual fact he was a fundamentally original artist, whose many talents concealed, or rather revealed a universal curiosity, a boundless love for painting and all its possibilities.

6. **A Scene from Roman History** *called* **The Meeting of Anthony and Cleopatra (?)**

146 × 197 cm.
Paris, Musée du Louvre (R.F. 1979-57).

HISTORY: Sale at Paris, end of 1809 or beginning of 1810, acquired for 480 *livres* (on the advice of Xavier Atger) by 'Rolland', who resold it for 600 *livres* in 1810 to J. J. de Boussairolles (1741-1814), of Montpellier (archives of the de Colbert family). By descent, collection of M. de Colbert,

10

in the twentieth century. Presented by the Société des Amis du Louvre in 1979.

EXHIBITION: 1980-981, Paris: *Patrimoine*, no. 33, reproduced in colour.

BIBLIOGRAPHY: X. Atger, *Considérations philosophiques (...) sur la vie et les ouvrages de Sébastien Bourdon ...*, 1818, p. 9; *R.L.*, 1980, no. 1, p. 45; 'Chronique des Amis du Louvre, février-mars-avril 1980', *R.L.*, 1980, no. 2, p. 1, reproduced; 'La Chronique des Arts', supplement to *G.B.A.*, 1981-I, March, p. 4, no. 15, reproduced; A. Brejon de Lavergnée, exhibition note, 1980-1981; Laclotte and Cuzin, 1982, p. 27, reproduced in colour p. 46.

The subject of this painting has still not been identified. At the time of its sale at the beginning of the nineteenth century, the celebrated collector Xavier Atger, a compatriot of Bourdon, put forward, with some reservations, the *Meeting of Mark Anthony and Cleopatra*, and it is under this title that he refers to it — without indicating its whereabouts — in 1818: '*Cléopâtre recevant, à l'entrée de son palais, Antoine à son retour d'Alexandrie*' ('Cleopatra receiving, at the entrance to her palace, Anthony on his return from Alexandria').

J. Montagu has noted (written communication, 1979) that it is difficult to identify Cleopatra with the uncrowned woman greeting the Roman general and neither can the scene represent the meeting with Mark Anthony (which took place on a boat) no more than that with Julius Caesar (to whom she had 'delivered' herself in a parcel!) nor her meeting with Octavian-Augustus (in the interior of a temple).

Should one see it as 'Coriolanus Entreated by his Family', as is suggested by more than one connection to Le Sueur's painting of the same subject, recently given to the Louvre (illustrated *Revue du Louvre*, 1984, no. 3, p. 219)? But the scene, although possibly in Roman countryside (the start of the inscription on an entablature reads: S.P.Q. [R]) most probably takes place in the Orient as is indicated by the camels and the pyramid. Without this Roman inscription, one could also see it as 'Alexander and the Family of Darius'. However, this 'meeting' evidently takes place after a victory as is indicated by the procession of musicians in the middle ground.

Whatever the subject is, this canvas is one of Bourdon's most ambitious. The sumptuous *mise en scène*, emphasized by the low viewpoint, places 'screen type' figures in the foreground, seen in *contre-jour* these popular figures recall Bourdon's taste for *bamboccliate*, and contrast with the principal protagonists, seen in full light, inclined elegantly in their mutual greeting. The great Venitian tradition dominates this presentation, with its architecture, its steps, its vast sky, and Veronese would not have disowned the negro boy, to the left, holding back his dog. But it is to his contemporaries like Mattia Preti (in Rome during the 1630's) that Bourdon aligns himself in this work, which, while still owing much to the Roman baroque, gives proof of a distinction particular to a Parisian ambience. It seems, in effect, according to P. Rosenberg and J. Thuillier, to have been painted after the artist's Italian visit (quoted by Brejon, 1980-1981), who dates it to about 1645.

7. Christ and the Children

50 × 61 cm.
Paris, Musée du Louvre (inv. 2806; Catalogue 1974, no. 77, reproduced).

HISTORY: Doubtlessly Jean de Julienne sale, 30th March—22nd May 1797, no. 225, 18 × 22½ ins. (approximately 49 × 61 cm.), sold for 650 *livres* 15 *sols* to 'Dumasson' (Fowle, 1970, p. 110). Claude Tolozan sale (1728-1798), 23rd February 1801, no. 4: sold for 1,705 francs to 'St. Martin' for the Louvre.

EXHIBITIONS: 1959, Berne, no. 13; 1960, Paris: *Réserves*, no. 272.

BIBLIOGRAPHY: Filhol and Lavallée, vol. VIII, 1812, 88th issue, pp. 1-3, pl. I, no. 523; X. Atger, *Considérations philosophiques (...) sur la vie et les oeuvres de Sébastien Bourdon*, 1818, p. 8; C. P. Landon, 1829, vol. I, p. 23, pl. 11; Ch. Ponsonailhe, *Sébastien Bourdon, sa vie et son oeuvre*, 1886, p. 287; A. Blunt, 'A Bristol, une exposition d'art français du XVIIᵉ siècle', *Beaux-Arts*, 25th November

1938, p. 3; J. Thuillier, 1964, p. 76; G. E. Fowle, *The Biblical paintings of Sébastien Bourdon*, thesis, University of Michigan, 1970, vol. I, pp. 101-103 and vol. II, pp. 110-115, catalogue no. 36; A. Pigler, 1974, vol. I, p. 303; M. F. Perez, 'Collectionneurs et amateurs d'art à Lyon au XVIIIᵉ siècle', *R.A.*, no. 47, 1980, 43-52, cf. p. 49; E. Brugerolles, exhibition catalogue, *De Michel-Ange à Géricault*, Paris, Ecole des Beaux-Arts, 1981, under no. 90, reproduced.

RELATED WORKS: Engraving by Châtaigner and Villerey in Filhol and Lavallée, 1812. Line engraving by C. Normand in Landon, 1829. Engraving by A. Delvaux.

Drawing of overall design, Paris, Ecole des Beaux-Arts (inv. 612; cf. Brugerolles, 1981, no. 90, reproduced).

Painting, 102 × 134 cm., Chicago, The Art Institute (1959-57), considered by Fowle to be a copy (1970, p. 113), but rather as an original by Rosenberg (1982, p. 346, fig. 8). Painting on copper, dimensions unknown ('a small Cabinet picture, on Copper, highly finished') in the Horace Walpole sale, London, 25th April 1842 and the following 23 days, no. 15 at the sitting of the 9th May 1842.

'Suffer the little children and forbid them not to come to me; for the kingdom of heaven is for such': by these words Christ indicated to his disciples that innocence was one of the most necessary virtues for the salvation of man. More familiar to the Northern Schools, this subject seems to have been rarely depicted in France, apart from by the Protestant Bourdon, whose religion was more attentive to the fate of children. Bourdon takes some liberties with the Scriptures (Matthew, XIX, 13-15; Mark, X, 13-16; Luke, XVIII, 15-17; cf. Réau, II, 2, pp. 329-330 and Pigler, I, pp. 301-303), by placing the action, not in a house, but out of doors.

In comparison to the animated composition of the beautiful drawing at the Ecole des Beaux-Arts the little painting from the Louvre has eliminated all the gestures which linked together the various groups: the apostle to the left who pushes away a child has disappeared, and Christ no longer points to the sky with his right hand.

The large version at Chicago, doubtlessly the original, though somewhat worn, reinforces the sculptural immobility of the present painting.

The massive figures, with their geometrically arranged drapery folds, are placed in a veritable 'landscape of rock', which goes beyond the contemporary research of Poussin (*Christ and the Woman taken in Adultery*, 1653, and *The Death of Sapphira* (no. 37) in the Louvre; *Saint Peter and St. Paul healing the Paralytic*, 1655, New York). It has been agreed that Bourdon's work can be dated after 1650 (1650-1652, according to J. Thuillier; circa 1655, Fowle, 1970, p. 111), in other words, at the time when the artist was turning towards a strict classicism with geometric forms and a strong colouring which were at once both solid and abstract.

Philippe de Champaigne
Brussels, 1602 — Paris, 1674

Educated in Flanders, Champaigne, at the age of nineteen set out for Italy, but he stopped in Paris, en route. Here he entered the atelier of Georges Lallemand, formed a friendship with Poussin and worked on the decoration of the Luxembourg Palace. He never did see Rome. The Flemish were numerous in Paris at this time; Pourbus, Van Mol, and Flémalle were installed there and in Antwerp Rubens was painting the Life of Marie de Medici *for the gallery of the Luxembourg Palace. After a brief sojourn in Brussels, Champaigne returned in 1628 as 'peintre en titre de la reine' and, like his predecessor Pourbus, who died in 1622, played a major role as both a portraitist and painter of religious subjects. Marie de Medici commissioned from him a series of large paintings for the Carmelite Convent in the rue Saint-Jacques (The Presentation in the Temple, 1629, Dijon) and Richelieu, of whom he left many fine portraits (Chantilly, London, Warsaw, Louvre), had him decorate, in company with Vouet, the Galerie des Hommes illustres (The Gallery of Famous Men) in his own palace (Louis XIII with Victory, Louvre). The prestigious career in the service of the Court (decorations for Anne of Austria in the Val de Grâce and at Palais Royal, portraits of Mazarin and Colbert . . .) and, in the service of the city (Le prévot et les échevins de Paris, 1648, Louvre) fitted him to figure among the founders of the Académie in 1648. He laboured intensively supplying works for churches (between 1657 and 1661, three pictures, in the Louvre and at Lyons, for the tapestries of Saint-Gervais et Saint-Protais, two at Arras for those showing* The Life of the Virgin *in Notre-Dame) and the convents, most notably the Carthusians. From 1646, however, he was attracted to the company of those who were associated with the Jansenists of Port-Royal, painting the portraits of the most distinguished members of their group (Robert Arnauld d'Andilly, Louvre). The recovery from illness of his daughter, a religious at Port-Royal, occasioned the moving Ex-Voto of 1662 (Louvre).*

The art of Champaigne owes no less to the knowledgeable skills and solid virtues of the 'realism' of his native country than to the quest for equilibrium and clarity which characterised Parisian painting at the time he settled in France. Like La Hyre or Le Sueur, Champaigne did not feel the need to travel to Italy. In return, his influence, by way of his teaching at the Académie and by his example, worked on the youngest painters as an exemplary lesson in dignity.

8. Charity

157 × 132 cm.

Nancy, Musée des Beaux-Arts (Catalogue 1909, no. 209, reproduced).

HISTORY: State loan, in 1803, to the museum at Nancy, as Champaigne and originating from the Hôtel de Penthièvre (Clément de Ris, 1872, p. 491). It was the painting mentioned in the guides to Paris, throughout the eighteeenth century, above the door of the 'Salle des Colonnes' of this Hôtel (previously called Hôtel La Vrillière, then de Toulouse), as 'école de Van Dyck', and inventoried on the 22nd October 1793: 'présumé de Van Dyck, représentant La

Charité ou l'abondance' (Tuetey, 1902). Taken away on the 24th November, it passed into the depots of the Revolution and then, on the 24th March 1794, to the Museum, where it was sometimes attributed to Lucas Franchoys, and perhaps to Jacques Stella (cf. Thuillier, 1960 and Dorival, 1976).

EXHIBITION: 1952, Paris, no. 15, pl. VII (Champaigne).

BIBLIOGRAPHY: Piganiol de La Force, *Description de Paris, de Versailles (...),* 1742, vol. III, p. 85 (and not 258); A. N. Dézallier d'Argenville, *Voyage pittores-*

que de Paris, 6th ed., 1778, p. 172; Hurtault and Magny, *Dictionnaire historique de la ville de Paris et de ses environs*, 1779, vol. III, p. 272; J.-A. Dulaure, *Nouvelle description des curiosités de Paris*, I, 1st section, 1785, p. 325; L. V. Thiery, *Guide des amateurs et des étrangers voyageurs à Paris . . .* 1787, vol. I, p. 305; Ch. Coligny, 'Les hôtels de Paris, L'hôtel de Toulouse', *L'Artiste*, 1866-1867, no. I, pp. 126-132, cf. p. 128; L. Clément de Ris, *Les musées de province*, 2nd ed., 1872, pp. 305 and 491; E. Tuetey, *Procès Verbaux de la Commission des Monuments*, vol. II, (*N.A.A.F.*, 3rd series, vol. XVIII), 1902, p. 204; B. Dorival, exhibition note, 1952; F. Laudet, *L'hôtel de Toulouse, siège de la Banque de France*, 1952, p. 30; A. Mabille de Poncheville,

Philippe de Champaigne, s.d. [after 1952] pp. 47, 142; J. Thuillier, 'Poussin et ses premiers compagnons français à Rome', *Colloque Poussin*, 1960, vol. I, pp. 72-116, cf. pp. 110-111, note 140; Vergnet-Ruiz and Laclotte, 1962, p. 229; B. Dorival, 'Catalogue raisonné de Philippe de Champaigne', *L'Information d'Histoire de l'Art*, 1973, n° 2, pp. 55-62, cf. p. 60, fig. 7; B. Dorival, *Philippe de Champaigne, 1602-1674*, 1976, vol. II, pp. 306-307; 1698, reproduced A. Sutherland Harris, (review by Dorival, 1976), *The Art Bulletin*, June, 1979, pp. 319-322, cf. p. 322.

RELATED WORKS: A replica in the trade, in New York, about 1973 (Dorival, 1976).

As with Blanchard (no. 3), Champaigne installs his figure of Charity within a framework of antique architecture no longer in ruins but, rather, emphasized by the curtain of velvet and the perspective — the painting was manifestly intended to be viewed from below. The allegory is here embellished with its symbolic attributes, the flame over her head, signifying love, and the pomegranate in her hand, sharing.

Shown at the major *Philippe de Champaigne* exhibition, at Paris in 1952, organised by B. Dorival, who dates the work to 1636-1638 and reproduces it in the catalogue, this picture has since been deleted from the artist's *oeuvre* by the same author (1973 and 1976) in favour of an attribution to the Flemish artist Lucas Franchoys, as suggested by some inventories dating to the Revolution. If this painter did indeed stay in Paris in 1650, nothing in his work allows the *Charity* of Nancy to be attributed to him. On the other hand, the painting is quite closely related to the works definitely given to Champaigne, such as the *Virgin with grapes* in the Museum of Bayeux (Dorival, 1976, no. 90; cf. also no. 91: these two paintings were engraved at the time).

Even though it only appeared in 1803, the attribution to Champaigne has every chance of being correct, and one can even question, as did A. Sutherland Harris (1979), why it was ever doubted. Even while displaying the prestigious Flemish mastery which was Champaigne's, this painting can, with justice, also be included in the art of Paris at the time of Richelieu, uniting as it does the generosity of forms (cf. *Abundance* by Vouet, no. 43) with a delicacy which is reminiscent of Stella (Thuillier, 1960).

9. The Virgin of Sorrows at the Foot of the Cross

178 × 125 cm.
Paris, Musée du Louvre (inv. 1129).

HISTORY: At the Church Sainte-Opportune at Paris in the seventeenth century (Guillet de Saint-Georges, 1842 edition). Accessioned by the Museum in 1792, it was exhibited at the opening of the Museum in 1793 (cat. no. 283), and then sent to the Palais du Luxembourg, first in the Galerie du Senat Conservateur (1804) then in the 'appartements', until 1871. On loan to the Musée de Villefranche-sur-Saône from 1896 to 1981. Restored in 1982-1984.

BIBLIOGRAPHY: Guillet de Saint-Georges, 'Philippe de Champaigne', [circa 1690], in *Mémoires inédits ...*, 1854, vol. I, p. 243; A. N. Dézallier d'Argenville, *Voyage pittoresque de Paris*, 6th ed., 1778, p. 39; J.-A. Dulaure, *Nouvelle description des curiosités de Paris*, vol. I, 1st section, 1785, p. 450; L.-V. Thiery, *Guide des amateurs et des étrangers voyageurs à Paris*, 1787, vol. I, pp. 494-495; *Catalogue des objets contenus dans la galerie du Museum Français ...*, [1793], p. 56; A. Lenoir, [1794], 1865 edition, p. 164; C. P. Landon, *Annales du Musée*, vol. V, 1803, p. 93, pl. 43; *Explication des tableaux ... composant la galerie*

du *Sénat Conservateur*, 1804, p. 7, no. 4; Filhol and Lavallée, vol. V, 1808, 54th issue, pp. 3-4, pl. II (no. 320); C. P. Landon, *Annales du Musée*, 2nd ed., *Ecole Flamande*, 1st section, 1825, p. 30, pl. 19; A. Lenoir, *Archives du Musée des Monuments Français*, vol. II, 1886, p. 19, no. 17 et p. 143; Tuetey and Guiffrey, 1909, pp. 40, 258, 302-303, 395; E. Mâle, *L'Art religieux après le Concile de Trente*, 1932, pp. 291-292; B. Dorival, *Philippe de Champaigne et Port Royal*, exhibition catalogue, Musée National des Granges de Port-Royal, 1957, under no. 60; B. Dorival, 'Recherches sur les sujets sacrés et allégoriques gravés aux XVII° et XVIII° siècles d'après Philippe de Champaigne', *G.B.A.*, 1972-II, July-August, pp. 5-60, cf. pp. 11, fig. 11, 17, 34-35, no. 37; B. Dorival, *Philippe de Champaigne, 1602-1674*, 1976, vol. I, pp. 51, 182, vol. II, pp. 48-49, no. 75, reproduced; A. Roy, *Les envois de l'Etat au musée de Dijon (1803-1815)*, Dijon-Strasbourg, 1980, p. 105.

RELATED WORKS: Sketch or study, B. 52 × 42.5 cm., Leipzig Museum (no. 1685; cat. 1979, p. 36, pl. 290; Dorival, 1976, vol. II, p. 386, no. 2046, *addendum*, reproduced; for its history and another version, cf. Dorival, 1972).

Engraving in the opposite direction by G. Edelinck (reproduced in Dorival, 1972). Line engraving by Normand in Landon, 1803 and 1825. Engraving by Le Villain in Filhol and Lavallée, 1808.

Copy by J.-B. de Champaigne, 195 × 129 cm., for Port-Royal des Champs, subsequently at Port-Royal in Paris (1709), sent in 1803 to the Musée de Dijon which lent it in 1962 to the Musée des Granges at Port-Royal (Dorival, 1957, no. 60 and 1976, vol. II, p. 296, no. 1663, reproduced; Roy, 1980). This copy had as a pendant a *Christ aux outrages* by Philippe de Champaigne, sent in 1803 to the Nancy Museum, which was also lent to the Musée des Granges at Port-Royal in 1963 (Dorival, 1976, vol. I, pp. 42-43, no. 62, reproduced). A copy exists in the Bob Jones Museum, Greenville (id., pp. 293-294, no. 1652).

Alone, seated at the foot of the cross, after the Deposition of Christ (on the ground to the right can be seen, the crown of thorns and the four nails of the Crucifixion; Edelinck's engraving adds tongs) the Virgin cries for the death of her son. This theme of the *Virgin of Sorrows* (which is distinct from the *Virgin of Pity*, the title given to her by Guillet de Saint-Georges, because of the absence of the body of Christ), which goes back to the fifteenth century, is rarely shown in this particular form. The Virgin was often depicted with the seven words piercing her heart, symbols of the 'seven sorrows' (Réau, Vol. II, 2, 1957, p. 108) and more usually she was shown in a shoulder length format.

The moving image portrayed by Champaigne recalls that sculpted in 1585 by Germain Pilon for the royal funerary chapel at Saint-Denis (marble, Paris, church of Saint-Paul, Saint-Louis; terracotta at the Louvre). Here though, the eyes are lifted to the heavens; the palor of the face, where the blood seems to have drained away, is suggested by a bluish tonality beneath the skin, in harmony with the colour of the cloak. The austerity of the background architecture, of Jerusalem, concurs with the general impression of grave sorrow which is implied by the subject: it is because of the extreme coherance of expression and manner of modelling, in which resides the 'classical' perfection of this masterpiece, that this painting should most probably be placed quite late in Champaigne's *oeuvre*.

Noël Coypel

Paris, 1628 — Paris, 1707

Trained at Orléans under Poncet, a pupil of Vouet, then at Paris, where he returned aged fourteen, under Noël Quillerier, Coypel soon became the assistant of Charles Errard, working in the Royal residences, more often than not painting after the latter's designs. After the success of his May de Notre-Dame of 1661 (St. James the Great being led to Execution, Louvre) *he was received into the Académie Royale on the 31st March 1663, where he became Rector in 1690 and later, after the death of Mignard, Director, from 1695 to 1699. In the meantime, from 1673 to 1675 he was Director of the Académie de France at Rome (between the two directorates of Errard) where he took his son Antoine (1661-1722), the future 'Premier peintre du Roi'. The Coypel dynasty also included his second son Noël-Nicolas (1690-1734) as well as the latter's son, Charles-Antoine (1694-1752, made Director of the Académie in 1746). In favour with Le Brun, Colbert, and also the latter's successor Louvois, who had him execute work for the Gobelins tapestry factory, and despite the hostility of the Superintendant Hardouin-Mansart who nominated La Fosse in his place as Director of the Académie, he managed to achieve a considerable output of decorative works: the ceiling of the Parlement de Rennes (1660-1661) and many of the salons at Versailles, of which only one has survived (cf. no. 10), and also salons at the Grand Trianon, at the Louvre, at the Tuileries and Les Invalides.*

Belonging, like N. Loir, to a generation intermediate between Mignard, Le Sueur, Le Brun and that of La Fosse and Jouvenet, Noël Coypel, who neither ignored the Rome of Bernini nor Maratta, nor Venice and Parma, remained faithful to the lessons of Poussin and above all Le Sueur – a unique situation in Parisian painting at the close of the century, which saw the arrival of the 'colourists'.

10. Solon upholding the Justice of his Laws against the Objections of the Athenians

50 × 87.5 cm.
Paris, Musée du Louvre (inv. 3475; Catalogue 1974, no. 184, reproduced).

HISTORY: Acquired by the King (Louis XV) in 1751, from M. Dauthuille Vittement, with the three other paintings of the same series, for 1,600 *livres* (Engerand, 1900). Restored and relined in 1751, in 1753, they were in the Louvre in the atelier of Ch. A. Coypel, who died the year before (id.). Exhibited in the Louvre at the opening of the Museum in 1793 (cat. no. 42). Restored in 1984.

EXHIBITIONS: 1699, Paris, Salon, p. 8 of the catalogue (p. 14 of the Guiffrey edition, vol. II, 1869); 1704, Paris, Salon (p. 12 of the Guiffrey edition, vol. III, 1869).

BIBLIOGRAPHY: C. P. Landon, vol. I, 1829, p. 41 and pl. 28 (captioned as 27); F. Engerand, 1900, p. 610; Tuetey and Guiffrey, 1909, pp. 160, 382; P. Marcel, *La Peinture française au début du dix-huitième siècle, 1690-1721*, 1906, p. 191 note 1; P. Rosenberg, 1966, under no. 17; A. Schnapper, 1967, p. 59.

RELATED WORKS: Engraving by G. Duchange in 1717 (in the chalcographie du Louvre, no. 928; cf. also nos. 929 to 931, engraved without a date, by Ch. Dupuis; cf. *G.B.A.*, 1964-I, May-June, pp. 264-265, nos. 18-21, reproduced). Line engraving by C. Normand in Landon, 1829.

The three other paintings, of the same dimensions and of the same series, also in the Louvre (inv. 3476 to 3478) are: *Ptolemy Philadelphus offering the Jews their Freedom, Trajan holding Public Audiences* and *Alexander Severus distributing Corn to the Roman People.*

It was at Rome, where he directed the Académie de France (1673-1675), that Noël Coypel painted four large compositions, commissioned in 1672, for the Cabinet of the King's Council of State at Versailles, which he exhibited with great success at the Pantheon. The construction of the Galerie des Glaces was later to modify the initial project where the Cabinet occupied the present location of the Salon de La Guerre, and the ceiling was to be placed in the Queen's Guardroom.

The four paintings from the Louvre, of which one is exhibited here, correspond, with a few variations, to these compositions and are most probably those exhibited by the artist in 1699 and 1704; whatever the case, they are certainly the works which were engraved in 1717. Their original destination is not certain. The differences which they present in relation to the decor now at Versailles would appear to have been the result of an intervention by the artist himself at a later date, since one can see beneath the over-paintings an earlier design which conforms to the larger versions. They might thus be sketches or *modelli*, made prior to these last, which Coypel would have subsequently modified, perhaps with a view to presenting them to the Salon. Their style, more rigid, is that of the later works, such as the *Story of Hercules* at the Trianon, painted in 1700, (Schnapper 1977).

The decoration of the Council of State — the most eminent place of all since it was there that the King held his Council and thus where the seat of government was to be found —corresponds to a clearly defined programme appropriate to the gravity of the decisions which took place there. The double theme of *Justice* and *Piety*, whose allegorical figures surround that of Jupiter on the ceiling, is repeated in the angles of the archivolt where four paintings ('sur enduit') represent *Slaves receiving the Mark of their Liberty, Avenging Justice, The Children of Piety offering Fruit* and *Rewarding Justice*. This is also illustrated in the composition of the frieze through the acts of four governors: Solon, Ptolomy, Philadelphus, Trajan and Alexander Severus. The decoration is completed by two paintings: *Jupiter reared by the Corybantes* and on the chimneypiece facing the latter, a *Sacrifice to Jupiter*.

Félibien, who comments at length on this decor (*Description sommaire du Château de Versailles*, 1674, cited by A. Maris, '*Naissance de Versailles*', vol. II, 1968, pp. 298-303), distinguishes among the four subjects in the archivolts, those concerning Justice (Solon, Trajan) and those figuring Piety, in the latin sense of the word (Ptolomy, Alexander Severus).

Solon defending the Justice of his Laws to the Athenians portrays the legislator, who, according to Plutarch, having published his laws (some can be seen posted up to the extreme right of the town), was importuned every day by the citizens of the town who came either to mock them, or to criticise them, or to have them explained.... Thus, this episode illustrates the idea that government should surround itself with advisors and justify its decisions. Le Sueur's allegory (no. 24) has a similar meaning.

Charles Dauphin

Lorraine, c.1620 — Turin ?, c.1677

Still little known, Dauphin was recently brought to recognition thanks to the exhibition Claude Lorrain et les peintres lorrains en Italie au XVII° siecle *(Rome and Nancy, 1982, entries by J. Thuillier and M. di Macco, pp. 375-419). A pupil of Simon Vouet in Paris, around 1640, he was still there when the latter died in 1649. In 1655 he is mentioned in Turin, where he painted a* St. Luke Painting the Virgin *for the chapel of the Company of St. Luke (lost). He was by then eminent among the painters of that city, where he pursued a brilliant career, virtually in an official capacity. Nominated painter to Prince Carignano in 1658, he participated in the decoration of the Royal Palace in Turin, between 1660-1661 and then, before 1663, he executed the altarpiece for the main altar of the church of San Francesco da Paola. Three large equestrian portraits of members of the House of Savoy decorated the* Venaria Reale *of Stupinigi, of which only one now survives in the Palazzo Reale in Turin.*

The Italian career of this French artist has scarcely any relationship with those of Poussin and Claude Gellée. Yet it is an example of the extensive influence of a school, that of Vouet, in an Italy which until that time was visited by Dauphin's compatriots in search of instruction.

11. Time revealing Truth

122.5 × 153.5 cm.
Inscribed on the flaming cauldron to the right:
NIMIA CURA NOCET
Nancy, Musée historique Lorrain.

HISTORY: Private collection, Mont-Saint-Aignan (as Simon Vouet). Sale at Rouen, Palais des Congrès, 21st March 1982, no. 16, reproduced in colour ('atelier de Simon Vouet'). [Galerie Wildenstein]. Acquired in 1982. Restored in 1982-1983.

EXHIBITION: 1984, Nancy, (New acquisitions of the Museum).

BIBLIOGRAPHY: Robert Fohr, 'Pour Charles Dauphin', *M.E.F.R.M.*, vol. XCIV, 1982, no. 2, pp. 979-994, cf. pp. 980-985 and fig. 1-4; *R.L.*, 1982, no. 4, p. 306; P. Rosenberg, 'Tableaux français du XVIIᵉ siecle', *R.L.*, 1983, no. 5-6, pp. 350-357, cf. p. 352 and fig. 6.

Time, Truth, Love: on these three notions, which dominate all human life, the seventeenth century elaborated an inifinity of variations which could illustrate the most diverse philosophical attitudes. Time, the winged old man, can be considered as the destroyer of Love and Beauty: Vouet had painted the victory of these last two over Time (1627, Prado); but he can also be portrayed as revealing Truth: which is the meaning of a painting by Poussin (1641, Louvre). Other allegories of Time by Vouet (no. 42) and Loir (no. 25) are also to be found in this exhibition.

The analysis of Dauphin's painting by R. Fohr (1982, who reproduces two other paintings of similar subjects by the same artist) is based on the latin inscription which he translates as 'Se soucier trop nuit' ('to worry too much [about love] is harmful'): the work shows the antagonism between Love, which presupposes the negation of Time (one of the two *amorini* threatens him with his torch, the other endeavours to hold on to drapery which he is pulling off) and Truth, who only reveals herself with the passing of time. The moral dictated by the inscription, would thus be an incitement to flee the passions, the deceptive charm of appearances (the mask lifted away by Time), and to devote oneself to the search for Truth, most probably by means of study, as designated by the large book on which she is reclining.

18

This picture, which R. Fohr places quite early in Dauphin's output and which is still very close to his master Vouet, must have doubly delighted the seventeenth century collectors, who were both experienced, since college, with the deciphering of 'enigmas' (and perhaps this particular one is open to other 'interpretations') and sensitive to the elegant style of the nude, the charm of the rose and blue colouring and the dynamism of the composition.

Michel Dorigny

Saint-Quentin, 1617 — Paris, 1665

After first becoming apprenticed for five years to Georges Lallemand in 1630, Dorigny entered the studio of Vouet, whose daughter he later married in 1648. An assistant of the latter, he was also, along with the other son-in-law, Tortebat, the principal engraver of his works after 1638. He was received into the Académie Royale on 3rd March 1663 following a royal edict which made it obligatory for every painter to be a member of that body. His sons Louis (1654-1742) and Nicolas (1658-1746) also became painters and engravers.

Though nothing remains of his decorations at the Hôtels La Rivière, Amelot de Bisseuil nor Hesselin, portions of his decor for the Pavillon de la Reine at the Château Neuf at Vincennes (1660) survive in the Louvre and at Vincennes. His works, frequently attributed to Vouet, like the Annunciation *in the Uffizi in Florence, distinguish themselves, nonetheless, from those of his master by their broader handling and more 'metallic' appearance. This same energetic approach is also found in his drawings (cf. B. Brejon de Lavergnée, 'New Light on Michael Dorigny', Master Drawings, vol. XIX, no. 4, Winter, 1981, pp. 445-455). Like Dauphin in Turin (cf. no. 11), he is nothing less than an active representative of the style of Vouet, who, thanks to both, retained his prestige quite late into the century, both in France and elsewhere.*

12. Pan and Syrinx

98 × 131 cm.
Dated, bottom left: *1657*
Paris, Musée du Louvre (R.F. 1949-21; Catalogue 1974, no. 221, reproduced).

HISTORY: Perhaps in the collection of Gédéon Berbier, Sieur du Metz (1626 ? — 1709) to whom is dedicated the engraving published in 1666. Godefroy sale (that of 25th April 1785, postponed to 15-19th November 1785?), no. 37 (as Simon Vouet). M. de La Reynière, 'forestier', sale, November 1792 (brought to 3rd April 1793), no. 1 ('Simon Vouet. Pan poursuivant Syrinx. Belle composition de six figures de fleuves et nayades. Ce tableau est gravé dans l'oeuvre de Vouet (sic) et vient de la vente de M. Godefroi, où il fut vendu sous le no. 37. Hauteur 35 pouc(es) largeur 44 pouces. T.'; noted by C. Bailey, this notice has in fact been related to

Dorigny's painting by B. Brejon de Lavargnée, verbal communication). Galerie Kleinberger, Paris, 1947. Acquired in 1949 by the Louvre from M. Marcel Jonas, Paris.

EXHIBITIONS: 1956-1957, Rome, no. 91; 1960, Paris: *Réserves*, no. 288.

BIBLIOGRAPHY: Ch. Sterling, exhibition note, 1956-1957; G. Isarlo, *La peinture en France au XVII° siècle*, 1960, p. 25, pl. 31; J. Thuillier, 1963, p. 199; A. Pigler, 1974, vol. II, p. 201.

RELATED WORKS: Engraving, in the opposite direction, executed by Dorigny though published 'avec privilège' in 1666, a year after his death, with a dedication to: *Gedeoni Berbier, Domino du Metz'*, royal councillor.

Anonymous copy in the same direction as the engraving, Academy in Vienna.

Taken from Ovid's *Metamorphoses* (I, 689-713, cf. Pigler, II, pp. 199-201) the subject tells of the love of the god Pan for the nymph Syrinx, companion to Diana. The latter, to escape the clutches of Pan, takes refuge with her father, the river Ladon, who transforms her into a reed-bed. Pan was to make himself a pipe from these reeds. This myth of desire sublimated into music, which engenders the art of love, was dear to artists as well as to the philosophers of the seventeenth century, from Poussin (c.1637, Dresden) to Mignard (no. 26). Dorigny worked hard at this composition and *pentimenti* visible on the left bear witness to his hesitations. Through the contrast with the two obliquely perpendicular groups the

violent movement of the figures are as though immobilised at the moment when the race reaches its end.

Dorigny, by means of his handling, rich in contrasts, comes closer here to François Perrier than to Vouet.

Gaspard Dughet
Rome, 1615 — Rome, 1675

Though he passed all his life in Italy, Dughet was born there of French parents. Following the marriage of his sister Anne, in 1630, to Nicolas Poussin, he lived with the latter until 1635; this distinguished relationship gained him the nickname of 'Gaspard Poussin', (he was also known in France as 'Le Guaspre'). Lively in character and rapid in execution, he devoted himself exclusively to landscape painting, a genre to which he was attracted from his taste for hunting, and to which he was encouraged by his brother-in-law. He treated the genre in all mediums, in fresco (Rome, S. Martini ai Monti, c.1647-1651), in easel paintings (numerous examples in Rome, the Doria Pamphili and Colonna Galleries). His reputation in this area was immense, particularly among the English collectors, for whom the name of 'Poussin' for many a long year signified principally Dughet . . . (seven pictures in the National Gallery in London). His basic 'romanticism', which rivalled that of Salvator Rosa, prompted him to portray a Nature which was changeable and dramatic, in a technique which was sound and forceful. Following the example of Poussin, he knew how to create between the landscape and the characters who inhabited it – generally drawing from mythology, the Bible or everyday life – a strong pyschological relationship, confronting the human presence with the world which surrounds it.

13. Landscape with Shepherds

72 × 95.5 cm.
Paris, Musée du Louvre (inv. 1060; Catalogue 1974, no. 246, reproduced).

HISTORY: Collection of Louis XIV from 1683, with its pendant: *Landscape with Three Men and their Dogs* (Louvre, inv. 1059), now at the château of Maisons-Lafitte.

EXHIBITIONS: 1978, Tokyo, no. 25, reproduced; 1979-1980, Paris, Louvre: *Tableaux flamands et hollandais du Louvre: A propos d'un nouveau catalogue* (without numbers or catalogue).

BIBLIOGRAPHY: *Le Musée Français*, vol. III, 1807, 3rd section, text and pl. without no.; Filhol and Lavallée, vol. IV, 1807, 48th issue, p. 7, pl. IV (n° 286); G. F. Waagen, *Kunstwerke und Kunstler in England und Paris*, Berlin, 1837-1839, 3 vol., cf. vol. III, p. 531 (Bloemen); C. Tarral, *Observations sur le classement actuel des tableaux du Louvre et analyse critique au nouveau catalogue*, 1850, p. 35, nos. 210-211; G. Brunet, 'Observations sur les attributions assignées à divers tableaux du Musée du Louvre dans le catalogue de M. Villot', *R.U.A.*, vol. II, 1855, pp. 405-418, cf. p. 414; Ch. Blanc, *Histoire des peintres de toutes les Ecoles. Ecole Flamande*, 1868, fascicule 'Franz van Bloemen', reproduced p. 3; Anonymous, 'Quelques notes sur diverses attributions du catalogue du Musée du Louvre', *R.U.A.*, vol. XXI, 1865, pp. 237-254, cf. p. 239; L. de Veyran, 1877, 9th series, 86th issue, reproduced; F. Engerand, 1899, p. 53; Ph. Erlanger, *Les peintres de la Réalité*, 1946, p. 129; M. Roethlisberger, *Cavalier Pietro Tempesta and his time*, University of Delaware, 1970, no. 12; A. Busiri Vici, *Jan Frans Van Bloemen, 'Orizzonte'*, Rome, 1974, no. R. 13, reproduced; M. N. Boisclair, *Gaspard Dughet: étude de sa vie et de son oeuvre*, thesis, Université de Paris IV — Sorbonne, 1978, vol. II, pp. 126-128, catalogue no. 280.

RELATED WORKS: Engravings by Duttenofer (or Duthenhofer), at Stuttgart in *Le Musée Français*, 1807, re-used in Veyran, 1877 (Boisclair, 1978, p. 315, G. 153), De Saulx and Niquet in Filhol and Lavallée, 1807 (id., G. 149), B. Péringer in 1815 (id., p. 322, G. 191), and by Sargent, in Blanc, 1868.

Having always been considered, since the time of Louis XIV, as a work by Dughet and often engraved under this name, this painting was attributed by Waagen (1837-1839) to the Italianised Flemish artist Jan Frans van Bloemen, called *Orizzonte* (1662-1749), who came to Rome nearly five years after the death of Dughet, whom he sometimes imitated.

This opinion was taken up by F. Villot, who, in his Louvre catalogue, firstly gave the work to Dughet (*Ecole d'Italie*, 1849) and then to Bloemen (*Ecole Flamande ...*, 1852). Although Tarral (1850) protested against this change, it was not until 1969 that M. Chiarini returned it to its true author, who is now no longer disputed. M. N. Boisclair (1978) dates it to 1670-1671.

It is in effect a beautiful example of the work of this artist: the studied landscape, in which the different planes succeed each other, linked by the diagonal lines of the terrain, is here 'enlivened' by a gust of wind, a torrent (it seems to be a pentimento; another one shows that the frightened attitude of the shepherd seen from the back, has been modified). It fits into the arcadian tradition of which masterpieces were made by Poussin, perhaps, as Ch. Sterling (*Colloque Poussin*, 1960, 1, p. 212) has suggested, stimulated by the success of his brother-in-law's, (Dughet), landscapes.

Claude Gellée, called Le Lorrain
Champagne, c.1602 (and not 1600) — Rome, 1682

Claude Lorrain did not live long in his native region, La Lorraine, from whence he gained his nickname. Born most probably in 1602 or a short time after, (cf. M. Sylvestre, in M.E.F.R.M., *XCIV, 1982-2, p. 937), at the age of twelve he moved to Rome where he was to pass the remainder of his life. After a trip to Naples around 1620, he entered the service of the landscape artist Agostino Tassi, then, between 1625 and 1627 he stayed at Nancy, where he was employed by Claude Deruet. On his return to Rome, he led an uneventful life, completely devoted to landscape painting: executing frescoes in the Palazzo Muti (lost) and Crescenzi, and above all producing easel pictures. The influence of Paul Brill (1554-1626) characterized his first period of activity (the oldest dated picture is the* Landscape with Shepherds *of 1629, Philadelphia), which also looks to Elsheimer, to Poelenburg, Breenburgh and Swanevelt, as is evidenced by his* Landscape with man playing a flute, *of 1635 (Nancy).*

With success, testified by a commission from Pope Urban VIII, also came the imitators, to protect himself from which, Claude in 1636 began to compile a Liber Veritatis *(British Museum) in which he kept a drawing of each of all his pictures.*

*Around about 1640, he began to draw his inspiration increasingly from the great classical Italian painters, Annibale Carracci and Domenichino. Working on a larger scale, his mythological and biblical landscapes, in which the figures assume more and more importance, take on a 'heroic' character (*View of Delphi, *Rome, Galleria Doria Pamphili).*

The works of his final years added to this grandeur the charm of a mysterious poetry, and a lyricism which echoes, though in its own distinctive way, that of Poussin, that other Frenchman who made Rome his home.

*Frequently conceived as pendants (*A Morning — An Evening*) the landscapes of Claude are the fruit of an exceptional sensibility to natural phenomenon – particularly light – and of a consummate skill in composition. Locations faithfully reproduced are rare; the artist never hesitated (as Hubert Robert would later) to assemble in the one picture monuments which were in actual fact distant from each other, even going so far as to show the Villa Medici and the Capitol by the seashore! His views of ports at sunrise or sunset allowed him the opportunity of analysing, in an incomparable manner, the effects of light on water, ships and architecture. The stories, recounted by the small figures, which lend their titles to the various pictures, are frequently relegated to the background.*

The art of Claude, however, being so sensitive and poetic goes beyond the simple description of Nature; like the 'history painters' he attempts to justify all the elements of the composition, conceived as a coherent world, in which the hour of the day, the weather, the season, determine the countless aspects of Nature, which he would have observed at length before setting out to reproduce it in his studio.

With Claude, landscape acquires a new importance, which rejects the hierarchy of the genres, becoming completely autonomous. Though he was preceded in this pursuit by Annibale Carracci, the true 'inventor' of the classical landscape, it was to him that posterity, from Turner to the Impressionists, rendered the most consistant homage.

14. Landscape with Paris and Oenone, called Le Gué *(The Ford)*

118 × 150 cm.

Paris, Musée du Louvre (inv. 4724; Catalogue 1974, no. 309, reproduced).

HISTORY: No. 117 of the artist's *Liber Veritatis*. Painted in 1648 for Roger du Plessis de Liancourt, duc de La Roche Guyon (died 1674). Passed with its pendant, *Ulysses restituting Chryseis to her Father, Chryses* (circa 1644, L.V. 80, Louvre, inv. 4718; cf. Russel, 1983, no. 31) in the collection of the duc de Richelieu, who sold them to Louis XIV in 1665. Perhaps exhibited at the Louvre at the opening of the Museum in 1793 (cat. no. 166?). Restored in 1963, the painting, though worn, is presented without the overpaintings made about 1790-1800, most notably in the sky, which were deplored by Lavallée (1810), Villot (in the 1855 catalogue) and Roethlisberger (1961).

EXHIBITIONS: 1964-1965, Dijon, Lyons, Rennes, no. 18, pl. VIII; 1966, Tokyo, no. 6, reproduced in colour; 1967-1968, California, without numbers, reproduced; 1973, France, no. 10, fig. 14; 1983, Munich, no. 18, reproduced.

BIBLIOGRAPHY: Dézallier d'Argenville, *Abrégé ...,* 1762, vol. IV, pp. 61-62; Filhol and Lavallée, vol. VII, 1810, 83rd issue, p. 6, pl. IV, (no. 496); H. Laurent, *Le Musée Royal,* vol. I, 1816, section: 'Paysage', text and plates without numbers; J. Smith, 1837, p. 255, no. 117; V. Cousin, *Du vrai, du beau, du bien,* ed. 1853, p. 247; L. de Veyran, 5th series, 1877, 42nd issue, reproduced; E. Dilke-Pattisson, *Claude Lorrain ...,* 1884, pp. 57-58, 217, 242; F. Engerand, 1899, pp. 356-357; R. Bouyer, *Claude Lorrain,* s.d., p. 62; W. Friedlaender, *Claude Lorrain,* Berlin-Munich, 1921, pp. 70, 240 note 38; P. Courthion, *Claude Gellée,* 1932, pl. 28; Cl. Ferraton, 'La collection clu cluc de Richelieu au Musée du Louvre', *G.B.A.,* 1949-I, June, pp. 437-448, cf. pp. 447-448; M. Roethlisberger, 'Les pendants dans l'oeuvre de Claude Lorrain', *G.B.A.,* 1958-I, April, pp. 215-228, cf. pp. 219, 228 note 14; Id., *Claude Lorrain. The Paintings. A critical catalogue,* New Haven, 1961, p. 292, fig. 205 (and 2nd ed., New York, 1979, vol. I, p. 291-293); Id., 'Nuovi aspetti di Claude Lorrain', *Paragone,* no. 273, November 1972, pp. 24-36, cf. p. 32, pl. 24 (after restoration); Id., *Tout l'oeuvre peint de Claude Lorrain,* 1977, p. 110, no. 185, reproduced; Laclotte and Cuzin, 1982, reproduced in colour, p. 39; M. Roethlisberger, exhibition note, 1983, Munich; H. D. Russel, exhibition catalogue *Claude Gellée dit le Lorrain,* Paris and Washington, 1983, pp. 163-164, under no. 31.

RELATED WORKS: Preparatory drawing, dated 1647, with inscription on verso, London, British Museum (1895, 9.15.899; exhibition *Claude Lorrain, dessins du British Museum,* Paris, Louvre, 1978-1979, no. 66, reproduced). Drawing no. 117 of the *Liber Veritatis,* annotated 1648, London, British Museum (1957. 12.14.123; same exhibition, no. 67, reproduced).

Engravings by J. Geissler in Filhol and Lavallée, 1810, and by C. Haldenwang, in Laurent, 1816, re-used in Veyran, 1877.

The nymph Oenone shows her spouse, the shepherd Paris, the oaths of eternal love which the latter had engraved on the trunk of a poplar tree, swearing that 'when Paris can live without loving Oenone, the waters of the river Xanthe will return to their source'. But Paris deserted her for Helen, and Oenone, who predicted to him the misfortunes and the war of Troy, lamented her fate at the foot of this tree, imploring the river to flow back up its course. ... The story appears in Ovid (*Heroides,* V, 21) and in the *Rape of Helen* a text then thought to be by Homer which was published in the translation of the *Iliad* by Du Souhait in 1634.

It is from this latter work that Claude Gellée has transcribed Oenone's laments, in a long inscription dated October 1647, on the back of a drawing (London, British Museum) which was a first sketch for the present painting. Though the appocryphal narrative had disappeared from modern editions of Homer, it possessed an evocative power strong enough for the painter to want to record it — an exceptional occurence in his work — and to extract from it the argument for one of his most poetic landscapes.

In the cold light of the early morning which shines brightly in the pendant *Seàport with Ulysses restituting Chryseis to her Father Chryses* (Louvre), another Homeric subject, Claude Gellée contrasts the gentle rose and blue of a sunset, on the banks a calm river which herds of cattle and sheep ford on their return to the fold. The three figures of Paris, Oenone and a shepherdess reading the inscription, picked out by a last ray of

light, recall by their bearing the *Shepherds of Arcadia* by Poussin. Though the story thus related is full of tragedy to come, the nature of the painting tells us that the adventures of the human heart cannot trouble the serenity of Nature.

15. Juno confiding Io to the care of Argus

60 × 75 cm.
Signed and dated, bottom, on a boulder:
CLAUDIO IV F. ROMA 1660
Dublin, National Gallery of Ireland (cat. no. 763; Catalogue 1981, p. 24, reproduced).

HISTORY: *Liber Veritatis* 149. Painted in 1660 for a certain Boson (or Bosont, Bason, Botteson) unidentified, whose name figures on the drawing (*L.V.* 150) for the pendant: *Landscape with Mercury and Argus*, dated 1661, (Roethlisberger, 1961, vol. II, no. 150, fig. 247; collection of G. Harward then in a sale in London, Sotheby's, 27th March 1974, no. 63, reproduced in colour in the frontispiece of the catalogue). The two paintings shared the same fate until 1805. Gaillard de Gagny sale, Paris, 29th March 1762, no. 32. Duc de Choiseul sale, 6th April 1772, no. 124. Prince de Conti sale, Paris, 8th April 1777, no. 544, acquired by Langlier. Walsh Porter sale, London, Christie's, 23rd March 1803, no. 44, 700 guineas, acquired by Major Price. R. Heathcote sale, London, Phillips, 6th April 1805, no. 96, acquired by Ch. Hanbury Tracey, later Lord Sudeley (1838). Anonymous sale (Sudeley), London, Christie's, 27th May 1882, no. 94, acquired by Lesser for A. Coats. A. Coats sale, London, Christie's, 3rd May 1914, no. 124, acquired by Sir Hugh Lane, who bequeathed it to the Gallery in 1918.

EXHIBITIONS:1821, London, no. 43; 1832, London, no. 43: 1883, Edinburgh, no. 458; 1918, Dublin, no. 37; 1925, Paris, no. 126; 1962, Bologna, no. 101, reproduced; 1964, Dublin, no. 87; 1964, Newcastle-upon-Tyne, no. 20; 1964, London, no. 31.

BIBLIOGRAPHY: Dunker and Maillet, *Recueil d'estampes (...) du Cabinet (...) de Choiseul*, 1771, pl. 110; J. Smith, 1837, p. 273 no. 149; E. Dilke-Pattisson, *Claude Lorrain ...*, 1884, no. 219; P. Courthion, *Claude Gellée*, 1932, pl. 36; M. Roethlisberger, 'The subject of Claude Lorrain's paintings', *G.B.A.*, 1960-II, pp. 209-224, cf. p. 217; M. Roethlisberger, *Claude Lorrain, The Paintings. A critical catalogue*, New Haven, 1961, vol. I, p. 351-352, no. 149, vol. II, fig. 246 (and not 247; and 2nd ed., New York, 1979); M. Kitson, exhibition note, 1962; M. Roethlisberger; *Claude Lorrain. The Drawings*, 1968, vol. I, p. 311, no. 829, vol. II, fig. 825; J. White, *The National Gallery of Ireland*, Dublin, 1968, pp. 36, 70, pl. 14; A. Pigler, 1974, vol. I, p. 129; M. Roethlisberger, *Tout l'oeuvre peint de Claude Lorrain*, 1977, p. 115, no. 219, reproduced; M. Kitson, *Claude Lorrain: Liber Veritatis*, London, 1978, p. 145, under no. 149, reproduced; H. Quinlan, *National Gallery of Ireland. Fifty French Paintings*, Dublin, 1984, p. 4, reproduced in colour.

RELATED WORKS: Pen and ink drawing, no. 149, in the *Liber Veritatis*, signed and dated: *1660. CLAV*, London, British Museum (1957. 12. 14. 155; Kitson, 1978, p. 145, no. 149, reproduced; Roethlisberger, 1968, vol. I, p. 311, no. 829, reproduced vol. II, no. 829).
Engraving in the opposite direction in Dunker and Maillet, 1771, pl. 110.
Another painting of the same subject, 100 × 136 cm., signed and dated: *1668*, former collection of the Earl of Jersey, destroyed (Roethlisberger, 1961, vol. I, pp. 472-473, no. 209, vol. II, fig. 280).

To remove Io, the daughter of the King of Argus whom he loved, from the jealousy of Juno, Jupiter transformed her into a white heifer. Juno, suspecting the infidelity of her spouse, had him give her the animal as a gift, which she then confided to the care of Argus, whose hundred eyes ensured constant vigilance. Ovid's narrative (*Metamorphoses*, I, 624) was treated on a second occasion by Claude Lorrain, in 1668, in a larger and more structured composition. As in that version, the small Dublin canvas places the scene in a landscape bathed in the morning light (the *Mercury and Argus* which was its pendant is quite naturally an 'evening' scene). More simple and intimate than the 'heroic' version of 1668, it places the accent on the blue-tinted freshness of the dawn, just before the sunrise whose first rays gild a narrow strip of land, between the blue of the mountains and the ancient town whose outline is visible just beyond the river.

The protagonists of this mythological scene are Juno who, with an authoritative gesture, addresses Argus — a simple shepherd who goes down on one knee before the goddess and whose monstruous ophthalmological peculiarity the painter has refused to record ..., she leans on a white, soft-eyed, heifer, which is so small that she easily rests an elbow on its backbone. The charm of the work derives equally from the delicacy of the atmospheric notations and the bonhomie of the characters portrayed.

Laurent de la Hyre

Paris, 1606 — Paris, 1656

Son of the painter Etienne de La Hyre, and the eldest of eleven children (of whom half practised painting), Laurent de la Hyre travelled to Fontainebleau to study the frescoes of Rosso and Primaticcio before entering, for a few months only (c.1624), the studio of Georges Lallemand (c.1575-1636), at that time the most famous atelier in Paris. His earliest works reflect this mannerist training: the two small paintings on copper in the museum at Rennes (Abraham and Melchizadech *and* Elijah nourished by the Angel), *the two versions of* Theseus discovering the Arms of his Father *(Caen 1634, and Budapest), of which one is most likely the painting of this subject executed for Richelieu, and the series depicting* The Story of Pentheus, *of which two canvases are known (Montluçon and Chicago, cf. Rosenberg, 1982, no. 31), give evidence of a taste for legend in accord with the 'precious' literature of the day. After 1630, however, he displayed the large and sombre* Pope Nicolas II at the Tomb of St. Francis *(Louvre), painted for the Capuchins in Paris, an aspiration towards classicism (in association with a use of lighting effects which were almost Caravaggesque) which one finds again in the first of his two* May de Notre-Dame, St. Peter healing the Sick by his Shadow *(1635, Notre-Dame, Paris, and also in the second,* The Conversion of St. Paul, *1637, which has more movement).*

The 1640s saw the confirmation of this tendency. Paris, which La Hyre never left, continually ignoring the lure of Italy, was then the focal point of an anti-baroque reaction, which led painting in a direction completely opposed to that of Vouet, who was then at the height of his fame. La Hyre, with Stella, Le Sueur and Champaigne, was one of the principle representatives of this 'atticisme parisien' (Parisian 'Attic' style) as it was termed by J. Thuillier (1964, pp. 65-69). Opposed to excesses of virtuosity, to painting for effect, which seduces instantly by its movement and brilliant handling, they proposed a less facile art, more considered, in which the clarity of composition, the respect for proportions and perspective (of which Abraham Bosse, a friend of La Hyre's, was an ardent defender), imposed on the artist a demanding discipline. The sojourn of Poussin in Paris (1640-1642) could not but confirm them in this path.

The 1640's was a decade rich in masterpieces: The Rest of the Holy Family, *1641 (Nantes),* The Rape of Europa, *1644, (Houston),* Cornelia refusing the Crown, *1646 (Budapest),* Laban searching for his Idols, *1647, (Louvre). The* Job *of Norfolk (Virginia, U.S.A.), and the* Peace of Westphalia *date from 1648, the year the Académie Royale was founded, in which La Hyre occupied the rank of one of the twelve 'anciens' (ancients).*

Though he did not, as a rule, unlike Vouet or Blanchard, produce large scale decorations, La Hyre designed a cycle depicting the Liberal Arts *for the Hôtel Tallement (some of the pictures on this theme, dated 1649 and 1650 in New York, Dijon, London, Heino and Orléans may have come from there; those in Toledo and Baltimore are most likely by his brother Louis). At this time he painted the great* Entry of Christ into Jerusalem *(Paris, Church of Saint-Germain-des-Prés) and in 1654 the city officials commissioned from him their collective portrait (lost), while at the same time the collectors avidly fought over cabinet pictures, such as* Mercury and Herse *of 1649 (Epinal).*

During his last years, one notices, as with Poussin, a growing attraction for landscape, for, this man who loved the hunt as much as he loved geometry, had a genuine feeling for Nature. His Landscape with Shepherds *(1649) and* Landscape with Bathers *(1653, no. 17, both in the*

Louvre) together with those at Montpellier (1647), Montreal (1648) and Lille, place him, along with Patel, not far from Claude Gellée in his sense of quality and poetry of vision.

At the same time the moral content of his works deepened: The Mothers of the Infants of Bethel *(1653, no. 16), the* Alliance of Peace and Justice *(1654, Cleveland) touched on questions which were then topical in a country which had just come through a civil war (La Fronde), and where religious problems were the subject of passionate debate. It was for the Capuchins at Rouen that he painted, in 1655, a large and dramatic* Descent from the Cross *(Rouen). Already ill, he died the following year aged fifty.*

For a long time forgotten, La Hyre is better known today, thanks to the writings of J. Thuillier and P. Rosenberg. His works, often signed and dated, have survived in great numbers, and allow us to measure the stature of this artist at once severe and graceful, of a sound and delicate technique, who knew how to develop a new language, which more than a century after his death, was to inspire the generation of Neo-classicism.

16. The Mothers of the Children of Bethel

104 × 141 cm.
Signed and dated, bottom, towards the left: *L. de La Hyre in et F. 1653*
Arras, Musée des Beaux-Arts

HISTORY: Painted in 1653 for M. Héliot, conseiller au Châtelet. Collection of Abel Poisson, Marquis de Vandières, de Marigny and then de Ménars (1727-1781, 'Directeur général des Bâtiments du Roi' from 1751 to 1773), from 1765 (Dandré-Bardon, 1765). The latter's sale, 18th March-6th April 1782, no. 51 sold for 5,710 francs. Collection of the Marquis de Vaudreuil (Thiery, 1787, who quotes the provenance of the Marquis de Ménars). M. [de Vaudreuil] sale, 26th November 1787, no. 41, sold for 5,500 francs to Lebrun. (?) Laborde de Méréville sale, 1802, sold for 4,100 francs. (?) Lucien Bonaparte sale, 1805. Collection of Moreau. Acquired from M. Moreau at Paris, in 1938, by the Arras Museum.

EXHIBITIONS: 1951, Amsterdam, no. 64; 1958, London, no. 141, *Album*, pl. 38; 1958, Paris, no. 57, pl. 33; 1959, Berne, no. 37, pl. 17; 1960-1961, Washington, Toledo, New York, no. 51, reproduced.

BIBLIOGRAPHY: Dandré-Bardon, *Essai sur la sculpture, suivi d'un Catalogue des artistes les plus fameux de l'Ecole française*, vol. II, 1765, p. 122; Buchanan, *Memoirs of Painting*, London, 1824, vol. II, p. 292; Guillet de Saint-Georges, 'Laurent de La Hyre' [circa 1690], in *Mémoires indédits ...*, 1854, vol. I, p. 109; Mariette, *Abecedario ...*, ed. Chennevières and Montaiglon, 1851-1860, vol. III, 1854-1856, p. 48; E. Bonnaffé, 1884, p. 137; *Mireur*, vol. III, 1911, p. 517; L. Réau, II-1, 1956, p. 361; Th. Augarde and J. Thuillier, 'La Hyre', *L'Oeil*, no. 88, April 1962, pp. 16-25, 74-75, cf. p. 23, reproduced in colour, pp. 24-25; Vergnet-Ruiz and Laclotte, 1962, pp. 52, 241, reproduced fig. 50; J. Thuillier, 1964, pp. 58, 72; M. Laclotte, *French art from 1550 to 1850*, New York, 1965, p. 227, reproduced p. 226; P. Rosenberg and J. Thuillier, 'The Finding of Moses by La Hyre', *Bulletin of the Detroit Institute of Arts*, vol. 49, no. 2, 1970, pp. 27-31, cf. p. 28, reproduced; A. Pigler, 1974, vol. II, p. 182; J. Thuillier, 'Laurent de La Hyre', *Annuaire du Collège de France*, 1979-1980, pp. 743-749, cf. p. 749.

RELATED WORKS: Engraving by Petrini.

According to the second Book of Kings (II, 23-24), the prophet Elisha while travelling to Bethel, was mocked for his baldness by some young boys from this town, 'And looking back, he saw them, and cursed them in the name of the Lord; and there came forth two bears out of the forest, and tore of them two and forty boys' Guillet de Saint-Georges, who recalls this episode taken from the bible, informs us that M Héliot, dont la piété et celle de son épouse ont été trés connues, fit faire un tableau à M. de La Hyre, où il peignit un sujet pris dans le 2e chapitre du IVe livre des Rois *(sic)*, y représentant les mères des enfants de la Ville de Béthel, lorsqu'elles viennent chercher et reconnaître les cadavres de ces enfants ...' ('M. Héliot, whose piety together with that of his wife were renowned, had

commissioned a painting from M. de la Hyre, who painted a subject taken from the 2nd chapter of the IV Book of Kings (sic), representing the mothers of the children from the town of Bethel, when they came to collect and identify the bodies of these children ...').

The subject, which expands on the biblical narrative without, however, featuring in it, is quite rare (Réau quotes only this example) and it is likely that it was specified by Héliot. Can this choice be explained? It has been accepted since the Middle Ages that the Old Testament may be read as a prefiguration of the New. In this respect the derision of Elisha by the children prefigures the derision of Christ during his Passion, and likewise the prophet's *baldness* evokes mount Calvary, the place of the Crucifixion. One can believe that M. Héliot, known for his piety, wanted to have depicted in this picture an example of divine punishment against the 'Libertines', that is to say in the seventeenth century, the atheists. The image, in the religious climate of the period, could thus be interpreted in this manner and strike the spectator as a warning. If the picture still moves us today, it is because of the poignant description of human suffering, expressed by the women weeping over the death of their children.

Antiquity had, on this theme, produced one of its more fascinating works, which La Hyre, without going to Rome, could have known through engravings, notably that of François Perrier (*Segmenta ... 1638*). It consists of the Hellenistic group of the *Niobides*, representing Niobe and her children succumbing to the arrows of Apollo and Diana. These statues, discovered in 1583 (Haskell and Penny, 1982, no. 66) were set out in a *Loggia* in the garden of the Villa Medici in Rome, and grouped according to an installation which attempted to recreate the original arrangement. (Since the end of the eighteenth century they have been at the Uffizi in Florence, displayed there individually). The century of Poussin had to admire this complex work, a unique testimony preserved from a great 'scenographic' composition of antiquity in which the expression of the passions, through the struggle against death, reaches its paroxysm without altering the beauty of the figures. La Hyre manifestly recalls this moment.

It is superfluous to insist on the incomparable dignity of La Hyre's style, on his intentional coldness which embodies pathos without excluding emotion. Human drama is inscribed in a landscape bathed in a limpid atmosphere where the delicacy of the trees answers to the rigorous scanning of fine corinthian columns, where the tones, vivid in the foreground, merge in the distance; to the right, the funeral procession taking away the young victims, can barely be distinguished. The painting was much admired, and in the eighteenth century passed through two of the finest collections, that of the Marquis de Marigny — the brother of Mme de Pompadour — and that of the Marquis de Vaudreuil. It has been discovered, a significant insight into the stylistic relationship between La Hyre and the Neo-classical painters, that in the latter's collection, according to Thiery (1787), the work was placed side by side with a small version of the *Oath of the Horatii* by David. ...

17. Landscape with Bathers

66 × 87 cm.
Signed and dated, bottom right: *L. De La Hire in. et F. 1653*
Paris, Musée du Louvre (inv. 5363; Catalogue 1974, no. 392, reproduced).

HISTORY: Prince de Conti sale, 8th April 1777, no. 579, sold to Claude Tolozan, for 3,400 francs; Claude Tolozan sale, 23rd February 1801, no. 45, sold for 3,103 francs to the Museum. On loan to the château of Maisons-Lafitte from 1912 to 1943 and from 1948 to 1967. Restored in 1956.

EXHIBITIONS: 1934, Paris: *Réalité*, no. 42, pl. XVI; 1937, Paris, no. 81; 1949-1950, London, no. 16; 1967-1968, California, without a number, reproduced.

BIBLIOGRAPHY: *Le Musée Français*, vol. III, 1807, 3rd section, text and plates without no.; Filhol and Lavallée, vol. X, 1815, 111th issue, pp. 7-8, pl. V

(n° 665); L. de Veyran, 10th series, 1877, 92nd issue, plate; H. Mireur, vol. III, 1911, p. 517; Brière and Communaux, 1924, p. 310, no. 135; Ch. Sterling *La peinture française au XVIIe siècle*, 1937, pl. 46; R.-M. Langlois, *Le Musée national et le château de Maisons*, 1963, p. 52, fig. 19 (incorrectly said to have come from the Hôtel Lambert and acquired by Louis XIV); J. Thuillier, 1964, p. 57; M. F. Perez, 'Collectionneurs et amateurs d'art à Lyon au XVIIIe siècle', *R.A.*, no. 47, 1980, pp. 43-52, cf. p. 49.

RELATED WORKS: Engraving by Châtaigner and Niquet, in Filhol and Lavallée, 1815. Engraving by F. Schroeder in *Le Musée Français*, 1807, re-used in Veyran, 1877.

A painting entitled *The Bathers* figured at the Trouard sale, 22-27th February 1779, sold for 3,000 francs (Mireur, 1911).

Painted in the same year as the preceding picture (no. 16), this painting appears to be the antithesis of the former. The subject here is quite simply an amusing one, depicting the games and dances of young girls bathing. No mythological pretext was employed to ennoble the scene, the bathers are peasant girls and not nymphs and La Hyre does not hesitate to multiply the realistic details. There are, however, reminiscences of the School of Fontainebleau, most notably the landscapes of Nicolo dell'Abate, in this *scene champêtre* which must equally have pleased the contemporaries of Watteau and of Boucher.

Charles Le Brun
Paris, 1619 — Paris, 1690

Though Le Brun dominated his epoch, this was not solely due to his position as leader – the head of the Académie and all artistic enterprises of the reign of Louis XIV, the monarch whose glory seemed indissociable from his own: these responsibilities and privileges dedicated the genius and talent for organisation of an exceptional artist, towards whom posterity has showed itself somewhat unjust.

The son of a sculptor and very precocious, Le Brun was a pupil of François Perrier at thirteen. A short while later he entered the studio of Vouet and copied the King's Raphaels at Fontainebleau. As early as 1641 he painted a picture for Richelieu (Hercules and Diomedes, Nottingham). Admitted to the Corporation des Peintres in 1642 – of which he later became a fierce adversary – he painted for them a Martyrdom of St. John (Paris, Church of Saint-Nicolas-du-Chardonneret; reproduced in colour by Thuillier, 1964, p. 96), a work, rich in the skills learned from his first masters, which also reveals an adventurous spirit. The Chancellor Séguier, who was his protector for ten years, sent him to Rome in 1642. He accompanied Poussin (who had left Paris for good) on the journey there and frequented his studio during his sojourn in Rome, sometimes imitating the master (no. 18). In Rome he also made the acquaintance of Dufresnoy and Mignard, his future rival. His admiration, as much for the antique, Raphael and Annibale Carracci, as for contemporaries such as Pietro da Cortona and Andrea Sacchi, confirmed and enriched the lessons of Poussin, which he made the basis of his doctrine, which in turn became that of the Académie.

Having learned all that he could in Rome, of which his Presentation in the Temple, painted in 1645 for the Hôtel-Dieu at Lyons (Detroit) sums up contemporary tendencies, he cut short his stay and returned to France in 1646, passing through Lyons on the way, where he painted The Death of Cato (Arras), a strikingly Caravaggesque creation.

His Parisian career started brilliantly with the Mays de Notre-Dame of 1647 and 1651 (The Martyrdom of St. Andrew and The Martyrdom of St. Stephen, in situ) and the founding of the Académie of which he was the first among the 'anciens' (1648) – though he was later ousted for a number of years by Charles Errard towards 1655. There soon followed a series of decorative projects for private dwellings: the Hôtel Nouveau, Hôtel La Rivière (1653) and above all the Hôtel Lambert, for which, in 1649, he painted the Galerie d'Hercule. Nicolas Fouquet, the powerful Superintendant of Finance commissioned him to decorate his château at Vaux (1658-1661), where his role was not limited solely to painting but also to supervising the sculpture, tapestries and festivities, a role he was to repeat later at Versailles.

Passing into the service of Louis XIV he began the decoration of the Galerie d'Apollon in the Louvre (1661). In 1663 he became Chancellor of the Académie and Director of the Gobelins Tapestry Factory, and was established as 'Premier peintre du Roi' in 1664.

For more than twenty years he reigned over the arts in France, directing numerous teams of artists and workers, seeing no lessening of his influence until 1683, which saw the death of Colbert, his principal supporter. Colbert's successor, Louvois, supported his rival Mignard, who had returned from Italy and had allied himself with the painters of the Corporation against those of the Académie.

To this period belong the great creations, including the Queens of Persia (1661,

Versailles), a magisterial illustration of his researches into the expression of the passions, a subject he wished to codify scientifically and which was the source of Louis XIV's personal admiration for the artist. Louis in fact watched him paint this particular work. Also included are the four immense canvases depicting the Story of Alexander (from the 1670's, Louvre) together with projects for the Chapel at Versailles (unrealised), L'Escalier des Ambassadeurs (1674-1678, destroyed), and finally the Galerie des Glaces (1679-1684) for the same location. These enterprises did not absorb all of Le Brun's energies and he also continued to paint pictures for churches and convents (The Resurrection 1674-1676, Lyons; The Descent from the Cross c.1679, Rennes) as well as portraits (The Entry of Chancellor Séguier, Louvre), as well as providing drawings for engravings and tapestries and the organisation of festivities. . . . His prodigious activity can only be compared to that of a Raphael or a Rubens.

Overshadowed by the growing influence of Mignard, who was already attracting the more important commissions, the last years of Le Brun saw a return to the production of easel pictures which included The Story of Moses (1687, Modena), and the series showing The Life of Christ, painted for the King (1683-1689, Louvre, Troyes, Saint-Etienne) which led to the moving Adoration of the Shepherds (1690, Louvre) which he painted for his wife, his last work, a homage to Poussin.

If Vouet was the chief influence in the greatest Parisian Atelier of his day, then Le Brun, as David was later to become, was the head of a 'school' and that at a time when France held the most eminent position in Europe. The Art of Versailles ruled over the courts of Europe, which were then already attempting to attract French artists and whose academies were modelled on those of Paris. The Académie itself, in 1666 established the Académie de France at Rome, where virtually all the great French artists, from Antoine Coypel to David and Ingres, finished their studies. This shows the importance of the aesthetic choices of this painter, who being both at the head of the great institutions as well as leading in the creation of the most important artistic projects of his day, knew how to be, at the same time, the follower and inheritor of both Vouet and Poussin, and who, while defending the primacy of drawing over colour, could also see fit to encourage artists such as La Fosse who claimed to draw on Rubens.

18. Allegory of the Tiber

53.5 × 64.5 cm.
Beauvais, Musée départemental de l'Oise.

HISTORY: Painted in Rome between 1643 and 1645 with figures by Le Brun and landscapes by Dughet (Nivelon, circa 1700). Passed through a sale in the nineteenth century under the name of Poussin (?). Acquired at a sale in Paris, Hôtel Drouot, 13th July 1944, for 1,500 francs, by the artist Maurice Boudot-Lamotte (1878-1958). Presented by his daughter, Marie-Josèphe Boudot-Lamotte, to the Musée de Beauvais in 1979.

EXHIBITION: 1979-1980, Beauvais, no. 39, reproduced p. 46 and a detail on the cover.

BIBLIOGRAPHY: Clàude Nivelon, Vie de Charles Le Brun et description détaillée de ses ouvrages, manuscript (circa 1700), Paris, Bibliothèque Nationale, Ms. Fr. 12.987, p. 22; H. Jouin, Charles Le Brun et les arts sous Louis XIV, 1889, pp. 52, 54, 515; J. Thuillier, exhibition catalogue Charles Le Brun, 1963, Versailles, pp. XXXXVI (sic) and 15, under no. 5 ('perdu'); J. Thuillier, introduction to exhibition catalogue, 1979-1980, Beauvais, pp. 10-11; M.-M. Aubrun, entry on the painting, same catalogue, p. 47, no. 39; 'Chronique des Arts', supplement to G.B.A., 1981-I, March, p. 4, no. 21, reproduced p. 5; Museum Guide, 1981, p. 47, reproduced.

Having arrived in Rome at the end of 1642, accompanied by Poussin, Le Brun became very friendly with the latter's brother-in-law, the landscapist Gaspard Dughet. This painting, recently identified and given to the Musée de Beauvais, is a precious testimony to their

collaboration, which Nivelon, Le Brun's confident and biographer, specifically confirms was painted 'dans le même goût fier de M. le Poussin, et dont le Guaspre voulut par amitié peindre le paysage' ('In the same proud way of M. Le Poussin, and in which le Guaspre [Dughet] wanted, out of friendship, to paint the landscape'). The strong influence of Poussin is also evidenced — combined in this case with Perrier's influence — in a *Deification of Aeneas* (Montreal; exhibition 1963, Versailles, no. 5, reproduced) where a river god, quite similiar to this one, is also seen.

The Tiber stands for both Rome and Antiquity. The celebrated statue of the divine River, once in the Vatican, in the courtyard of the Belvedere and in the Louvre since 1803 (Haskell and Penny, 1982, no. 79), directly inspired Le Brun who has here slightly modified its pose and has added an urn under the right arm. This classical group had been engraved by his master François Perrier — whom he met again in Rome — in 1638 (*Segmenta ...*, pl. 92).

Romulus and Remus are here seen suckled by the she-wolf under the left leg of the God; a trophy is attached to a tree. To these symbols of the origin and prosperity of Rome, taken from the Antique, Le Brun adds a few new ideas which Nivelon develops: the trophy alludes to the 'ancient glory of Rome', while Victory and Fame with the two trumpets are reclining signs of 'la langueur et léthargie où elle est présentement' ('the langour and lethergy of her [Rome] present state').

Le Brun, who copied Raphael and Guido Reni for his protector, the Chancellor Séguier, was only in Rome for six months when he urged the latter to allow him return to Paris. He repeated his demand on many occasions from July 1643, mentioning the difficulties which the French had at Rome and the small glory he would get from this stay. He ended by returning to France without Séguier's consent. Could this painting, with its anxious Tiber of fixed expression (no longer directed to infinity, as in the statue) and the allusions to idleness and to dormant glory, be a reflection of the personal distress of the young artist impatient to succeed on another stage.

19. Moses striking the Rock

114 × 153 cm.
Paris, Musée du Louvre (inv. RF 1947-2; Catalogue 1974, no. 436, reproduced).

HISTORY: Perhaps the *'Moïse touchant le Rocher'* of Le Brun valued at 800 *livres* by P. Mignard in the posthumous inventory of Hugues de Lionne in 1671 (Jouin, 1889, p. 746). Seen by Grautoff in 1912 at the Galerie Barbazanges, who offered it in vain to the Minneapolis Museum in 1924, and then sold it to Charles Pearson, as by Poussin (Bertin-Mourot, 1947, p. 56, note 1). Presented by Mme. Pearson, 1947 (attributed to Poussin).

EXHIBITIONS: 1960, Paris: *Réserves*, no. 313; 1960-1961, Recklinghausen, no. D. 68, reproduced; 1961, Rouen: no. 44, pl. 25 ('Lebrun ?'); 1963, Versailles, exhibited but not entered in the catalogue; 1965, Jerusalem, no. 36.

BIBLIOGRAPHY: C. Nivelon, *Vie de Charles Le Brun et description détaillée de ses ouvrages*, manuscript, (circa 1700), Paris, Bibliothèque Nationale, Ms. Fr. 12.987, p. 40; Dézallier d'Argenville, *Abrégé ...*, 2nd ed., 1762, vol. IV, p. 126; H. Jouin, *Charles Le Brun et les arts sous Louis XIV*, 1889, pp. 97 (note),

464, 746 *(addenda)*; Th. Bertin-Mourot, 'Moïse frappant le rocher', *Bulletin de la Société Poussin*, 1st *cahier*, 1947, pp. 56-65; S. Ernst, 'Deux dessins de Poussin pour Moïse frappant le rocher', *Bulletin de la Société Poussin*, 3rd *cahier*, 1950, p. 86; Th. Bertin-Mourot, *Poussin Inconnu, (Bulletin de la Société Poussin)* 1957, pp. 2-3, reproduced; A. Schnapper, 'De Nicolas Loir à Jean Jouvenet', *R.L.*, 1962, no. 3, p. 121 note 21; J. Montagu, 'The unknown Charles Le Brun. Some newly attributed drawings', *Master Drawings*, vol. I, no. 2, 1963, pp. 40-47, cf. pp. 43 and 46, note 19; A. Blunt, *The Paintings of N. Poussin. A Critical catalogue*, London, 1966, p. 170, no. R 13 ('certainly by Lebrun'); J. Thuillier, *Tout l'oeuvre peint de Poussin*, 1974, p. 118, no. R 15 (Lebrun, before 1650).

RELATED WORKS: Five preparatory drawings in the Musée du Louvre (inv. 27969, 28480 recto and verso, 28484 and 28532; Guiffrey and Marcel, vol. VIII, 1912, no. 8123, 8008 recto and verso, 8091 and 6966). A drawing of this title at the Musée de Chartres (inv. 3449; catalogue

1931, p. 26, no. D. 80). A drawn copy of this title, anonymous, after Le Brun, 'à la plume, lavis d'encre rehaussé de blanc sur papier gris; h. 7 pouces; 1. 6 pouces' in the collection of Paingnon Dijonval (Bernard, *Cabinet de M. Paingnon Dijonval,* 1810, p. 120, under no. 2751).

The group of three figures to the right in the foreground are identical to those in Le Brun's *Roman Charity,* recently acquired by the Musée de Caen (engraved by L. Desplaces; *G.B.A.,* 1965-II, July-August, p. 27, no. 160, reproduced; already reproduced by Bertin-Mourot, 1947, p. 64).

Jennifer Montagu (1963) has decisively put an end to the uncertainties concerning the authorship of this painting, for a long time wrongfully attributed to Poussin, and which can no longer be seen as the picture painted in the style of Poussin of about 1665-1668 executed by the young Jouvenet (A. Schnapper, *Jean Jouvenet,* 1974, p. 183, no. 1, now lost). Apart from the testimony of the five preparatory drawings now at the Louvre, the work was actually mentioned by Nivelon (circa 1700), who admitted to have only seen 'un petit dessin à la plume qui est très précieux mais beaucoup différent du tableau que l'on m'a dit être peint comme le précédent', ('a small ink drawing which was very precious but very different to the painting which I have been told was like the previous one'). The painting which he refers to before this one is the *Brazen Serpent* (95 × 133 cm., Bristol, City Art Gallery), dated to about 1649 by J. Thuillier (exhibition catalogue, 1963, Versailles, no. 14).

The two paintings, both most probably contemporary and both devoted to episodes from the Life of Moses as related in *Exodus* (17, 5-6), are equally inspired by Poussin, whom Le Brun had often met in Rome beforehand. His model is obviously *The Fall of Manna*, the famous composition painted between 1637 and 1639 for Paul Fréart de Chantelou (Louvre), and which Le Brun could have seen in Paris. Like Poussin, Le Brun analyses the diverse attitudes of humanity (the Hebrew victims of thirst) faced with the manifestation of divine grace (the water bursting forth from the rock under Moses' rod). The expression of the passions, which was to be Le Brun's major interest throughout his career, finds in this youthful work (he was in his thirties) one of its first applications.

20. Apollo taking Leave of Tethys

102 × 132 cm. (surface originally painted in an octagonal form)
Dublin, National Gallery of Ireland (cat. no. 4197; Catalogue 1981, p. 16; reproduced: 'Attributed to Bourdon, *Phaeton*').

HISTORY: Sold at James Adam & Sons, Dublin 1946 or 1947 where purchased by Dr. Françoise Henry by whom presented to the National Gallery of Ireland in 1977.

BIBLIOGRAPHY: J. Montagu, 'Oeuvres de Charles Le Brun', in *La donation Baderou au musée de Rouen* (*Etudes de la Revue du Louvre*, no. 1), 1980, pp. 41-44, cf. pp. 42-44, 43 fig. 8; P. Rosenberg, 1981-1982, p. 52, under np. 65, reproduced p. 53.

RELATED WORKS: Drawing of the same composition with variations, 41.6 × 44.7 cm., Rouen, Musée des Beaux-Arts (975.4.647; Montagu, 1980, p. 43, fig. 7; Rosenberg, 1981-1982, no. 65, pl. 27; Exhibition: *Choix de dessins français du XVIIᵉ siècle, collection du musée*, Rouen, 1984, no. 58, reproduced).

Initially attributed to Bourdon by J. White, then to Le Brun by A. Blunt, P. Rosenberg and J. Montagu, this painting is, as the latter has demonstrated, the sketch for a ceiling painted by Le Brun in 1650-1651 for the Hôtel of Jérôme de Nouveau, Lord of Fromont and Fiennes, Superintendant General of Posts (c. 1613-1665), situated in Paris, in the Place Royale (now no. 12, Place des Vosges).

H. Jouin (Charles Le Brun, 1889, pp. 104-107, 676-677) who has published the memoirs of Le Brun relative to this commission, confused this, now lost decoration, executed in 1653, with that of the adjoining mansion belonging to the Abbé La Rivière

(now no. 14, Place des Vosges), which is today preserved in the Musée Carnavalet. J. Wilhelm has since re-established the truth ('Les Decorations de Charles Le Brun à l'hôtel de La Rivière', *Bulletin du Musée Carnavalet*, 2ᵉ Année, no. 2, October 1949, pp. 6-15; 'Les Décorations de l'hôtel de La Rivière Nouveaux Documents', *ibid.,* 16ᵉ Année, no. 2, November 1963, pp. 2-19).

The first of the three documents published by Jouin (which then belonged to Anatole de Montaiglon), is dated 3rd August 1650; it is the 'prix des ouvrages de peinture qui se doivent faire chez Monsieur de Nouveau' ('the price of the paintings which must be done at the home of Monsieur de Nouveau'). It lists first 'le grand tableau rempli d'ouvrages ainsi qu'il est porté dans le devis et selon le dessin que j'en ai montré, le prix de 1,500 livres', ('the large painting filled with works as mentioned in the quotation and described in the drawing which I have shown of it [almost certainly the drawing at Rouen], the price of 1,500 *livres*'). It is added further on that the painting would measure twenty-two feet long by twenty feet wide (650 × 713 cm.). Further listings follow: 2nd the border to the painting; 3rd the four corners, decorated with golden chariots etc., 4th the cornice and the frieze; 5th the chimney; 6th the panelling, 7th the doors; 8th the shutters. All adding up to 6,900 *livres,* though this figure is reduced without any reason, in the same document, to 4,650 *livres* and the delivery date fixed for the end of November 1650. According to the second document, of 24th August, Le Brun undertook to reduce the sum by 600 *livres* if he had not finished by 15th December, and on the 26th of August he acknowledged the receipt of 1,162 *livres* and 10 *sols,* in payment of the first quarter, which indicates that the work had already commenced. Finally, on the 1st of July 1651, he acknowledged the receipt of three other payments of the same amount on the 8th of October and the 15th of December 1650 and the 1st of July 1651. The imposed delays therefore had been more than six months, without, however, the anticipated reduction in price.

It is to be noted that the subject of the 'grand tableau' was not specified (it was to be included in the 'quotation' already cited, though now unfortunately lost), and Jouin takes it upon himself to suggest *Mercury and Hebe,* which is a poor interpretation of the subject of one of the ceilings from the Hôtel La Rivière, representing *Mercury transferring Psyche to Mount Olympus* (cf. Wilhelm, 1949, p. 9, reproduced). While Nivelon, Le Brun's biographer, and all the eighteenth century guides to Paris, give lengthy descriptions of the decorations in this Hôtel, none make any mention of those in the Hôtel de Nouveau. However, Guillet de Saint-Georges (c. 1693, in *Mémoirs inédits ...,* 1854, vol. I, p. 12) writes of the latter 'M. Le Brun y peignit dans un plafond le Soleil levant, avec toutes les circonstances dont l'histoire poétique embellit ce sujet. Les chûtes des gorges du plafond sont aussi ornées de bas-reliefs feints, où il a représenté un Triomphe de Thétis, un Enlèvement de Proserpine et la Métamorphose du jeune Stellion, changé en lézard', (M. Le Brun has there painted, on the ceiling, the rising sun, embellished with all the circumstances with which the poetic account endows it. The base of the corner mouldings of the ceiling are decorated with fictive bas-reliefs, in which are represented the Triumph of Thetis, the Rape of Proserine and the Metamorphosis of the young Stellion changed into a lizard'.

The subject of the ceiling (which was octagonal, like the drawing and sketch, as is also testified by the reference to the 'four corners' in the contract), is therefore, as shown by J. Montagu (1980), Apollo taking leave of Tethys. She, a Titanide, a woman of the Ocean, was represented as an old woman, but the resemblance of her name with that of the Nereid Thetis, like her, a deity of the sea, though the wife of Peleus and mother to Achilles, very quickly gave rise to confusion which artists exploited, to portray Apollo rejoining in the evening and then leaving in the morning, a young and beautiful deity. Tethys is here shown reclining in the foreground, protecting her eyes from the rays of the rising sun. A Nereid appears to pick something invisible from her hair (both in the sketch

and the drawing), though it must be the branches of coral which she gathers in her left hand. One of her companions draped in a large veil, seems to arouse herself, while another two carry, one a small shrub planted in a vase, the other a cockle shell full of pearls and coral, symbolizing the riches of the earth and the sea. The bearded god covered with a dark cloak, shown resting and leaning on a staff, appears to be Nereus, the old man of the sea and father to the Nereids. In the background, the chariot of the sun is hitched to four horses who have just been fed by the three, winged Hours.

Such a subject was appropriate, not to the glorification of Louis XIV, who was not yet the Sun King in 1650, but to the charge of Jérôme de Nouveau,'Surintendant des Postes et Relais' (Jouin had noted in this respect the chariots depicted in the corners). This important personage was, on the contrary, connected to the party of the Fronde and to Fouquet, and thought poorly of by Colbert and Mazzarin, whose correspondence he instructed to be opened (cf. E. Vaillé, *Histoire générale des postes françaises,* pp. 38-53).

The Dublin sketch, with its clear tones, gives some idea of the effect produced by the lost ceiling. Its composition should thus correspond to the drawing at Rouen. J. Montagu, who has studied both works (1980), has observed that on the one hand, the proportions of the ceiling and drawing correspond to each other and that they are of a squarer format than those of the sketch, and that on the other hand, the drawing displays a more advanced stage of the composition, more elegant, eliminating certain elements such as the Nereids to the left. It must therefore be deduced that the sketch was painted before Le Brun knew the dimensions given to the ceiling by the architect.

This sketch, nonetheless, remains the most potent memory of one of the first great civil decorations of Le Brun, contemporary with the *Martyrdom of St. Stephen* painted for Notre-Dame, and most probably with the Galerie d'Hercule in the Hôtel Lambert, which seems to have been painted around 1650. As in the two ceilings at the Hôtel La Rivière (in one of which Le Brun again took up the theme of the *Rising Sun*), the vault of the Hôtel Lambert develops a more ambitious decorative plan, in which the flying figures play with the fictive architecture. But Le Brun remains faithful to a moderated system of perspective, rejecting the total illusionism dear to mannerism and to baroque Italy (cf. J. Montagu, 'The early ceiling decorations of Charles Le Brun', *B.M.,* September 1963, pp. 395-408); a single drawing, depicting lions, is mentioned in connection with the Hôtel de Nouveau).

Jean Lemaire, called Lemaire-Poussin or le Gros Lemaire

Dammartin, 1598 — Gaillon, 1659

Reaching Rome while still very young, he is recorded there in 1613, Jean Lemaire formed quite a close friendship with Poussin, after the latter's arrival there in 1624 (in March of the same year he is found along with other French artists in the house of Simon Vouet) and was living with him in 1630. He was back in Paris by 1639, when he was recorded as 'peintre du roi' and staying at the Tuileries. He took part in the decoration of the Grande Galerie at the Louvre in 1641-1642 under the direction of Poussin. According to Félibien it was with Poussin that he returned to Rome in 1642, 'but he did not remain there for very long' before returning to Paris, then retiring to Gaillon, close to Les Andelys, Poussin's native town.

Among the few rare references to him, particularly interesting is the remark made by Mariette, in the eighteenth century, according to whom he is responsible for painting the architectural background to Poussin's Theseus Discovering the Arms of his Father, *known in two versions, at Chantilly and the Ufizi, (the latter exhibited in Rome, 1977-1978, no. 21), dated by Thuillier to about 1633-1634.*

21. **The Childhood of Bacchus,** *also called* **The Childhood of Romulus**

163 × 140 cm.
Dublin, National Gallery of Ireland (cat. no. 800; Catalogue 1981, p. 95, reproduced).

HISTORY: Bequeathed by Sir Hugh Lane, 1918.

BIBLIOGRAPHY: Th. Bodkin, 'Nicolas Poussin in the National Gallery, Dublin, I', *B.M.*, April 1932, pp. 174-185, cf. pp. 174 and 175, pl. I ('School of Poussin'); A. Blunt, 'Jean Lemaire: painter of architectural fantasies', *B.M.*, October 1943, pp. 236, 240-246, cf. pp. 242, 245 and note 8, 246 and 240, pl. II.C ('Jean Lemaire'); A. Blunt, 'Poussin Studies IX. Additions to the work of Jean Lemaire', *B.M.*, December 1959, pp. 438, 440-443, 445, cf. p. 443; A. Blunt, *The Paintings of Nicolas Poussin, A Critical Catalogue*, London, 1966, p. 174, no. R.65; 1974 J. Thuillier: Tout l'oeuvre peint de Poussin; D. Wild, *Nicolas Poussin*, Zurich, 1980, vol. II, p. 249, no. R.15, reproduced.

Entered into the Dublin Gallery, as part of the Lane collection, under the unsustainable attribution to Poussin (as is also that to Sustris, proposed in an old catalogue of the collection) this large architectural landscape was linked by Friedlaender (letter in Gallery files) to Ch.-A. Dufresnoy (and not Duquesnoy, the sculptor, as Bodkin had written in 1932), and eventually given to Jean Lemaire by Blunt (1943). It is, in effect, characteristic of this still little known master, the catalogue of whose works, begun by Blunt (1943 and 1959), is encumbered with paintings which one day will have to be rendered to Blanchet (cf. the present no. 5) or to Le Pautre.

Highly impressive, the monumental landscape mixes antique, real and imaginary architecture. The double colonnade, to the right, reproduces fairly faithfully the first two storeys of the *Septizodium*, erected in 203 A.D. by Septimius Severus at the foot of the Palatine, destroyed in 1588, but known from numerous engravings, which Lemaire represented 'restored' in his painting of the *Lictors* in Montreal (Blunt, 1959, fig. 25). However, though the tomb encircled with columns and placed on a square base could recall the Mausoleum of Halicarnassus, the sarcophagus surmounted by a reclining

couple is pure fantasy, even though he has here and there integrated quotations of antique fragments.

Regarding the figures, which, despite the opinion of Blunt (1943, p. 245, note 8), are certainly by Lemaire, they represent to the right, an infant crowned with a vine wreath whom a female figure helps sit astride a goat, who appears to be Bacchus (Blunt) rather than Romulus (Bodkin). To the left is a reclining shepherdess listening to another shepherd playing a set of pan pipes. These two groups, as Blunt has remarked, are found in two other works by Lemaire: that to the right, in the painting sold in 1924 (Blunt, 1959, p. 443, fig. 28) and that to the left, including the two dogs and the sheep, in a painting exhibited in London in 1908 (Heim Gallery, *Summer Exhibition,* no. 11, reproduced). This latter presents a view of the *Colonnacce* still standing in the forum of Nerva, for which view there is a drawing by Lemaire preserved in the Kunstbibliothek in Berlin (Hdz. 3845, reproduced in *Berliner Museen,* 1969, p. 27, fig. 5).

The manner in which Lemaire organises these various elements, the interchangeable character of which has already been underlined, is nonetheless grand and coherent. The simple geometry of the architectural elements, whose plunging perspective draws the eye into the distance, creates equally a foreground element which is rigorously frontal, into which are cut two views to the clump of trees. This 'architectural caprice', which plays on the poetry of grandiose urban ruins, is, as noted by Blunt, the setting and the antithesis of a purely pastoral scene, and, as noted by Blunt (1943, p. 246), close in sentiment to the creations of Hubert Robert in the following century.

Eustache Le Sueur
Paris, 1616 — Paris, 1655

Few artists have known a posthumous glory such as that of Le Sueur. Dead at thirty-nine, only just older than Raphael, he was soon compared to the latter, as much for his short and uneventful life as for his measured and reflective art. The fact that he never knew Italy (no more than La Hyre or Champaigne), must have reinforced the almost miraculous feeling for perfection which French painting achieved with his art.

A pupil and collaborator of Vouet, from these beginnings he developed with brilliance the lyrical and seductive art of his master, which is testified by the series The Dream of Poliphilo *(no. 22), to such an extent that it is often difficult to distinguish it from that of his master.*

Le Sueur was a member of the corporation des peintres, the Académie de Saint-Luc (for which he painted, in 1645, a St. Paul healing the Possessed, *lost) a body he left in 1648 for the Académie Royale, of which he was one of the twelve 'anciens'. Between these two dates he executed the decoration of the Hôtel Fieubet (The Story of Tobias, Louvre, Grenoble, etc.), and more importantly the twenty-two paintings of the* Life of St. Bruno *(Louvre) for the Carthusian cloister at Paris. Rapidly accomplished (1645-48), this considerable undertaking allowed the painter to deploy, in a spectacular work accessible to the public, all the resources of his talent and earned him immense renown down through two centuries. With its construction it offered to contemporaries the example of a clear pictorial language – supported by a rigorous respect for perspective – together with its expression of feeling, its drawing, always noble, and its use of light, the effects of which were never exaggerated, with the colouring, simple and harmonious.*

Le Sueur worked mainly on large church pictures such as St. Peter Resurrecting Tabitha *(1647, Toronto) and* St. Paul Preaching at Ephesus *(May of 1649, Notre-Dame, Paris), recognised as his masterpiece, as well as on the decoration of private mansions, of which the best known was the Hôtel Lambert where he executed the* Cabinet de l'Amour *(1647-1650), the* Cabinet des Muses *(1652-1655) and the* Cabinet des Bains).

The Queen, Anne of Austria, entrusted him with the decoration of her winter apartment in the Louvre (c.1653: related drawings in Budapest; paintings at the Dayton Museum and the seminary in Venice). In 1652 he began the vast scenes devoted to the Martyrdom of St. Gervase and St. Protase, *cartoons for the church of the same name, for which he executed only one of the pictures (Louvre), the second (Lyons) was completed by his brother-in-law Thomas Goussé, while the rest were entrusted to Bourdon (1655, Arras) and Champaigne (1658 and 1661, two in the Louvre and one in Lyons).*

His last works, four paintings for the Abbey of Marmoutiers (1645), are divided between the Louvre and the museum at Tours.

Starting from the baroque of Vouet, Le Sueur, through the study of the works of Raphael, which he would have known through his acquaintance with the King's collection and through prints, as well as the study of Poussin, set himself on the path towards a classicism which by degrees became more and more purified while at the same time directing his investigations of form towards a 'pre-raphaelite' synthesis: his work was consequently to become, for over two centuries, one of the most influential touchstones of French painting.

22. Poliphilo and Polia assisting at the Triumph of Bacchus

93.5 × 156 cm.

Le Mans, Musée de Tessé (inv. 18.20; Catalogue 1982, by E. Foucart-Walter, no. 78, reproduced).

HISTORY: 'Récupération artistique' after the Second World War. Allocated by the Office des Biens Privés in 1950 to the Musée du Louvre (M.N.R. 34). On loan to the Le Mans museum in 1957. Identified by M. Laclotte (1958).

EXHIBITIONS: 1958, London, no. 46, *Album*, pl. 36; 1958, Paris, no. 98, pl. 16.

BIBLIOGRAPHY: [See Foucart-Walter, 1982, who quotes notably:] M. Laclotte, exhibition notes, 1958; P. Rosenberg, 1966, p. 80, under no. 66; A. Salz, *Eustache Le Sueur and Hypnerotomachia*, Harvard University, manuscript, 1977, pp. 11-13, 34, 49, reproduced; M. Sapin, 'Contribution à l'étude de quelques oeuvres d'Eustache Le Sueur', *R.L.*, 1978, no. 4, pp. 242-254, cf. p. 243, reproduced p. 242 fig. 1; P. Rosenberg, 1982, under no. 50; E. Foucart-Walter, *Le Mans, Musée de Tessé: Peintures françaises du XVIIe siècle* ('Inventaire des collections publiques françaises', 26), 1982, pp. 97-99, no. 78, reproduced p. 98. Since: A. Merot, in the catalogue of the exhibition: *Simon Vouet, Eustache Le Sueur, dessins au Musée de Besançon*, Besançon and Rennes, 1984, under no. 35.

RELATED WORKS: Two studies for the woman marching at the head of the procession with a basket on her head, Vienna, Albertina (11.661) and Besançon (D. 1821) (Sapin, 1978, p. 243, reproduced p. 242, fig. 2 and 3; Mérot, 1984, no. 35, reproduced).

The *Dream of Poliphilo*, a novel attributed to the dominican Francesco Colonna, was published in Venice in 1499, with illustrations, under the title *Hypnerotomachia Poliphili*; translated into the French by Jean Martin in 1546 and by Beroalde de Verville in 1600, it still knew great success in the seventeenth century. It tells of the dreams of Poliphilo and his mistress Polia, pretexts for long and erudite archeological descriptions.

Simon Vouet, who had received the commission for eight paintings illustrating this story, destined to be made into tapestries by Commans, entrusted these paintings to his pupil, Le Sueur, for whom this was the first major undertaking. It must have taken many years to complete, over the period from 1635 to 1645, as the five paintings now known betray a very marked evolution. The two earliest, *The Triumph of the Sea Gods* (Malibu, cf. Rosenberg, 1982, no. 50, reproduced) and the *Triumph of Bacchus* (Le Mans, here no. 22) are still quite close to Vouet. *Poliphilo at the Baths of the Nymphs* (Dijon, Musée Magnin; reproduced in colour in Thuillier, 1964, p. 85) is of an elegance close to La Hyre, while Le Sueur's own classicism asserts itself in *Poliphilo before Queen Eleutherida* (Rouen; cf. Rosenberg, 1966, no. 66, also reproduced a detail in colour on the cover) and *Poliphilo welcomed by Philtronis and her nymphs* or *Poliphilo before the Three Doors* — (Salzburg, Residenzgalerie), published while it was in the Czernin Collection at Vienna by A. Blunt who linked it, along with the painting at Dijon, to that of Rouen ('The Hypnerotomachia Poliphili in Seventeenth Century France', *Journal of the Courtauld and Warburg Institute*, 1937-1938, pp. 117-133, pl. 14a). Two other subjects: *Poliphilo and Polia beside the Sea* and *Poliphilo and Polia in an Orchard* are only known from the tapestries which reproduce them.

Le Sueur, who must have been inspired by the illustrations of the 1600 edition, here depicts the scene where Poliphilo and Polia (to the right) assist in the procession of Bacchus: even though the God does not appear in the painting, we can distinguish his chariot drawn by tigers, Silenus, the nymphs, maenads, fauns, satyrs, and the woman marching 'furiously' ahead, a basket (for winnowing) on her head: all the characters listed by Colonna.

The intentions of the novel — and of the painting — are too complex to be summed up here; one notes especially how strong, during the years 1630-1640, was the taste for novels evoking antiquity, such as the *Dream of Poliphilo*: and the work of Le Sueur, still displaying the influence of mannerism, aptly shows how the classical heritage was still perceived, by his contemporaries, through the litterature of the Renaissance.

23. Cincinnatus returning to his Chariot

130 × 98 cm.

Le Mans, Musée de Tessé (10.81; Catalogue by E. Foucart-Walter, 1982, no. 80, 'attribué à Lesueur', reproduced).

HISTORY: With its pendant (*Cincinnatus leaving his Chariot*, Le Mans, 10.80) probably in the Marquis de Montesquiou sale, 9th December 1788, no. 189 ('Le Sueur'), sold for 160 francs to 'Lenglier (?)'. Collection of the Comte de Saint-Morys (1743-1795), who emigrated in 1790. Seized from this collection in 1797, as 'Simon Vouet, dits de Poerson', they were sent to Le Mans in 1799 as 'Poerson' and figured in the catalogue of this Museum without an attribution from 1799 to 1829, and then as La Hyre from 1839 to 1852, finally from 1864 to 1932 as Charles-François Poerson, due to a confusion with his father Charles.

BIBLIOGRAPHY: See E. Foucart-Walter, 1982, who quotes notably: J. Lejeaux, 'Charles Poerson, 1609-1667 and the Tapestries of the life of the Virgin in the Strasbourg Cathedral', *G.B.A.*, 1946-II, July, pp. 17-29, cf. pp. 26-27, reproduced p. 25, fig. 8 ('here tentatively attributed to Charles Poerson'); P. Rosenberg, 1966, pp. 146-147, under no. 147; E. Foucart-Walter, *Le Mans, Musée de Tessé. Peintures françaises du XVIIe siècle*, 1982, pp. 99-103, no. 79 and 80.

The story of Lucius Quinctius Cincinnatus, a Roman of the fifth century before our era, is related by Titus-Livy (*Roman History*, III, 26-29): he was working the earth when the Senate came to offer him the Dictatorship, for six months, in order to direct the war against the Aequi. His task completed, after sixteen days, he discarded the purple and renounced all honours. His exemplary disinterest has led to the expression in current French usage: 'retourner à sa charrue'.... The two paintings at Le Mans, the second of which is exhibited here, illustrate, one the moment when the Senators appeal to the hero, the other, the moment when Cincinnatus, whose wife removes the toga symbolic of his power, refuses to assume this power any longer and returns to his agrarian activities. The origins of these works, obviously stemming from Vouet's circle, has long remained hypothetical. A return to the attribution listed at the Montesquiou sale, in 1788, which presented them as by Le Sueur, has recently been proposed (Foucart-Walter, 1982, who quotes Rosenberg's opinion in favour of this). The attractive hypothesis of J. Lejeaux (1946), based on references dating to the period of the Revolution, which sees them as the work of Charles Poerson (cf. here no. 30), apparently can neither withstand criticism nor comparison with the anonymous *Adoration of the Shepherds* at Rouen (Rosenberg, 1966, no. 147). On the other hand the relationship with Le Sueur's *Coriolanus* at the Louvre (see no. 36) and even with the *Triumph of Bacchus*, also at Le Mans (no. 22), seem to 'speak' in favour of Le Sueur's name: the profile of Poliphilo and that of the Roman addressing Cincinnatus are virtually superimposable, and the drapery, modelling and landscape, just as the preference for the low viewpoint, all seem characteristic of the young Le Sueur. The broad handling with its beautiful impasto, takes away nothing from the gravity of the scene, which by its very nature must be a simple and eloquent treatment of a 'virtuous' theme which experienced a new popularity during the Neo-classical period.

24. Allegory of the Perfect Minister, *or* The Minister of State, *or* Counsel accompanied by Wisdom, Prudence and Silence.

84.5 × 71 cm., oval.

Dunkirk, Musée des Beaux-Arts (P. 83.3).

HISTORY: This is one of the 'tableaux de cheminée' painted for M. Planson in Paris, probably in 1653 (Florent Le Comte, 1700), the other being *Marcellus Curtius qui paraît se précipiter dans un gouffre de feu* (lost, known from a drawing for the complete composition in the Louvre and two figure studies in Budapest and Montpellier; cf. P. Rosenberg, 'Dessins de Le Sueur à Budapest',

Bulletin du Musée hongrois des Beaux-Arts, no. 39, 1972, pp. 63-75, cf. pp. 74-75, fig. 57-60). Collection of 'MM. de La Curne de Sainte-Palaye, d'où il est passé chez M. Randon de Boisset', (Thiéry, 1787). Randon de Boisset sale, 27th February 1777, no. 171, 10,000 francs. Collection of the Duc de Chabot (Thiéry, 1787); his sale 10th December 1787, no. 60, sold for 8,901 francs. Collection of the Marquis de Montesquiou; his sale, 9th December 1788, no. 188 (which cites the two previous sales). A. Mérot (1982) doubts that the painting passed through the collection of La Curne de Sainte-Palaye, whose name, however, figures on the bottom of the print by Tardieu and in Thiéry, believing that this collector would have been content to have this painting engraved at his own expense though he did not own the work himself. Mérot also indicates that it could have formed part of the Potier collection before entering that of Randon de Boisset. Acquired in Great Britain in 1983 by the museum.

EXHIBITION: 1983-1984, Dunkirk no. 12, reproduced in colour on the cover.

BIBLIOGRAPHY: F. Le Comte, vol. III, 1700, 1st section, p. 99 (reprinted, 1982, p. 292); L.-V. Thiéry, 1787, vol. II, p. 494; L. Dussieux, 'Nouvelles recherches sur la vie et les ouvrages de Le Sueur', *A.A.F., Documents . . .,* vol. II, 1852-1853, pp. 32 (text by Guillet de Saint-Georges) and note 2, 97 (catalogue of drawings by A. de Montaiglon) and 116 (list of paintings, after F. Le Comte); Guillet de Saint-Georges, 'Eustache Le Sueur' (1690), in *Mémoires inédits . . .,* 1854, vol. I, pp. 168-169; Ch. Blanc, *Histoire des peintres . . . Ecole Française,* vol. I, 1857, p. 361; E. Bonnaffé, 1884, p. 256; G. Rouches, *Eustache Le Sueur,* 1923, pp. 50-51; L. Dimier, 1927, p. 6; J. Thuillier, 1964, p. 84; P. Rosenberg, 1981-1982, pp. 58-59, under no. 73 (reproduced p. 59, the photograph of the painting, then unlocated); A. Merot, 'La renommée d'Eustache Le Sueur et l'estampe', *R.A.,* no. 55, 1982, pp. 57-65, cf. p. 60 and notes 49-52, reproduced p. 60, fig. 6; J. Kuhnmunch, exhibition note, 1983-1984; P. Rosenberg, 'Tableaux français du XVIIe siècle', *R.L.,* 1983, no. 5-6, p. 354, reproduced fig. 15; A. Merot, *Eustache Le Sueur,* unpublished thesis (1984).

RELATED WORKS: Drawing for the complete composition, squared, with indications for the oval form, Louvre (30.665; reproduced in Rosenberg, 1981-1982, p. 58). Study for *Counsel,* Rouen (822.1.82; Rosenberg, 1981-1982, no. 73, reproduced pl. 20).

Engraving by Nicolas Tardieu (1674-1749), in the opposite direction, of rectangular form, with the reference: 'Cabinet de Mre de la Curne de Ste Palaye'; plate in the Chalcographie du Louvre (no. 1172); reproduced in Mérot, 1982, p. 60, fig. 7. The catalogue of the Montesquiou sale, 1788, refers to 'l'Estampe gravée par Gérard Audran; (in error ?).

In this painting Le Sueur has summarized, in the form of an allegory, the principal virtues which the 'perfect minister' should have, and has underlined the necessity of their close union by the gestures of each of the symbolic figures: under the gaze of *Silence* — or *Secrecy* (an infant who, in the shadow, puts its finger on its mouth) — *Knowledge* — or *Counsel* — (a majestic, bearded, old man, draped in red and holding an open book) leans his arms on *Minerva - Wisdom* or *Merit* — while leaning on his knee is *Prudence,* identified by the mirror. These images were clear to a man of the seventeenth century, and it is regrettable that we know nothing of the duties of 'M. Planson' for whom Le Sueur invented this allegory, which evidently applies to a man of State.

To these four figures, he had intended to add a flying Mercury pointing his caduceus at the book, as portrayed in the drawing at the Louvre. This gliding figure was not retained in the painting, which thus gains in gravity. It is not, however, absent of charm, and the youthfulness of *Silence* and even of *Minerva,* the graceful feminine poses and the discrete poetry of the grove of trees, temper the severity of the figure of the old man, and recall the contemporary *Muses* of the Hôtel Lambert (Louvre).

Le Sueur, who was never so close to Raphael as in the *Saint Paul at Ephesus* of 1649 (Notre-Dame, Paris), had taken his leave of him in 1653; this entirely intellectual and abstract passage, one of the most beautiful of all of French classicism, reveals a poetic universe of which he is entirely the master.

Nicolas Loir

Paris, 1624 — Paris (?), 1679

A pupil of Vouet and later of Bourdon, Loir's trip to Italy between 1647 and 1649 put him into contact with Poussin. On his return to Paris he painted the May *of 1650 (St. Paul and the Prophet Elymas, Notre-Dame, Paris). Proposed for membership of the Académie Royale from 1655, he was received into that body in 1663, though he only delivered his reception piece (no. 25) in 1666. In the same year he was made a professor there and became assistant to the Rector in 1673.*

Loir participated in the decoration of the Palais des Tuileries and of the Château de Versailles ('grand appartement de la reine', destroyed during the construction of the Galerie des Glaces), as well as numerous Parisian mansions, (La Ferté-Senneterre, Guénégaud, Monnerot ...). He also supplied designs for the Gobelins Tapestry Factory and practised engraving (his brother Alexis was a celebrated engraver). Collectors fought over his Virgin and Child, *which he took the trouble to engrave himself, as much as they battled over those of Mignard, whom they appreciated as a portraitist.*

According to Dézallier d'Argenville (1762) two qualities distinguished his work: his 'préférence pour le coloris' and his 'grand talent ... de peindre les femmes et les enfants' ('preference for colouring, and his great talent ... for painting women and children').

25. The Progress of the Graphic Arts under the Reign of Louis XIV

141 × 185.5 cm.
Compiègne, Musée Vivenel (Catalogue by J. Blu, s.d., no. 33).

HISTORY: Reception piece at the Académie Royale de Peinture et de Sculpture, presented on the 2nd October 1666. Collection of the Académie. Reserved for the Museum in 1793. On loan at the Palais de Compiègne from 1827 to 1832. At the Louvre (inv. 3048) in 1852 (Duvivier, 1852), then on loan in 1872 at the Musée Vivenel at Compiègne, as 'Ecole de Le Brun'. Indentified by G. Brière (1924). Restored in 1984.

BIBLIOGRAPHY: N. Guérin, *Description de l'Académie royale*, 1715, pp. 99-100, no. 35; A.J. Dézallier d'Argenville, *Abrégé ...*, 2nd edition, 1762, vol. IV, pp. 162, 164; A.N. Dézallier d'Argenville, *Description sommaire des ouvrages de peinture (...) exposés dans les salles de l'Académie royale ...*, 1781, p. 3; Guillet de Saint-Georges, 'Nicolas Loir', in *Mémoires inédits ...*, 1854, vol. I, p. 341; L. Duvivier, 'Sujets des morceaux de réception ...,' *A.A.F. Documents ...*, vol. II, 1852-1853, p. 378; N. Guérin, *op. cit.*, republished, Montaiglon, 1893, pp. 47-48; *Procès verbaux de l'Académie ...*, vol. I, 1875, p. 308; A. Fontaine, *Les collections de l'Académie ...*, vol. I, 1875, p. 308; A. Fontaine, *Les collections de l'Académie royale ...*, 1910, pp. 111, 217; Brière and Communaux, 1924, pp. 318-319, no. 166; A. Schnapper, 'De Nicolas Loir à Jean Jouvenet. Quelques traces de Poussin dans le troisième tiers du XVIIe siècle', *R.L.*, 1962, n° 3, pp. 115-122, cf. pp. 115-117, reproduced p. 116, fig. 1; Vergnet-Ruiz and Laclotte, 1962, p. 243; P. Georgel and A. M. Lecoq, *La peinture dans la peinture*, Dijon, musée des Beaux-Arts, 1982-1983, p. 12, reproduced fig. 12.

RELATED WORKS: The sketch (38 × 52 cm.), with numerous variations (Minerva, Time, the portrait of the King left without an effigy), was lent by the Louvre (inv. 308, 'attribué à Luca Giordano') in 1957 to the Musée de Perpignan (Schnapper, 1962, p. 118, fig. 3: 'copy ?'). There exists a mediocre copy (47 × 56 cm.) at the Musée de Rouen (07.1.25; id. p. 117, fig. 2, 'd'après N. Loir', and Rosenberg, 1966, no. 80), where the portrait of the aged Louis XIV, indicates a date much later than 1666. This one could well correspond to a painting 15 × 20 ins. (approximately 45 × 54 cm.) seized in 1797 at the home of the *émigré* Forter, 'aux galeries du

Louvre' (Schnapper, 1962, p. 117, note 8). The reference (noted by D. Cordellier) of a painting 'de Minerve et des Arts de peinture et sculpture, de 18 pouces de large (approx. 48 cm.), de la main de Loir avec sa bordure . . .' valued at 25 *livres* in the inventory of Charles Perrault in 1672, during Loir's lifetime (*G.B.A.*, 1956-II, p. 184) would be more appropriate to the sketch at Perpignan.

Engraving by Alexis Loir (Schnapper, 1962, p. 116, note 47), in the opposite direction, after the definitive painting (though without the portrait of the King, replaced by a shield), and dedicated to Charles Perrault who, as we have seen, possessed the sketch for it.

The series of 'reception pieces' offered to the Académie Royale by artists on the occasion of their election and as proof of their competency, is nowadays dispersed between the Ecole des Beaux-Arts, the Musées du Louvre, Versailles and many other towns throughout France. Still little known despite Fontaine's book (1910), these paintings, numerous and generally well dated, constitute so many chronological landmarks tracing the history of French painting, and are often the surest testimony to the art of numerous painters now forgotten.

One of the first to be preserved is that of Nicolas Loir. Received as academician in March 1663, on the recommendation of Le Brun and also the King, he delayed in giving his painting, of which the subject was to be *The Capture of Dunkirk*. Eventually he submitted it on the 2nd October 1666, along with the painting shown here, representing 'Painting and Sculpture revealed by Time, accompanied by Minerva who presents Them with a Portrait of the King, as the Subject of their Work'. The figures of Painting and Sculpture 'unies comme deux soeurs inséperables' ('united like two inseperable sisters'. Guérin, 1715), revealed by Time, to the great terror of Ignorance (with ears of a donkey as is clearly visible on the engraving), look at Minerva who personifies France, and shows them the King's portrait 'comme l'objet qui doit les occuper et dont le grand nom doit illustrer et éterniser leurs ouvrages' ('as the subject which should occupy them and whose great name must render illustrious and eternal their works'. Id.) Fame, one of the most beautiful figures in the painting, with her profile in *contre-jour,* holds the portrait of Louis XIV, whose glory she proclaims.

An obvious allusion to the foundation of the Académie Royale (Georgel and Lecoq, 1982-1983) — or rather to its recent restoration in 1663 — glorified as the instrument of the renaissance of the arts. The allegory affirms at the same time the close link which unites the institution to the royal power, the young sovereign's renown (then aged twenty-eight) and that of the arts placed under his protection being intimately linked together. A. Schnapper, who published (1962) this long forgotten painting, has noted references to Poussin (the landscape and children) and to Le Brun (Fame): a double parentage, entirely natural for a painting intended for the Académie.

Pierre Mignard
Troyes, 1612 — Paris, 1695

The great rival of Le Brun, his junior by seven years, Mignard like the latter spent seven years in the studio of Vouet, who wanted to make him his son-in-law. His stay in Italy, an exceptionally long one, from 1635 to 1656, gained him the nickname 'Mignard le Romain' (Mignard the Roman).

An assiduous study of the Carracci (whose Farnese Gallery he copied c.1644) marked his style, the severe correctness of which was later lessened by the influence of Francesco Albani, whom he met in Bologna following a sojourn in Venice. A learned painter, attentive to the erudite lessons of his friend Dufresnoy, he can be seen as the heir to Domenichino: his St. Charles Borromeo, painted c.1647 (Le Havre; cf. J. C. Boyer, R.A., no. 64, 1984, pp. 23-24) like his St. Cecilia of 1691 (Louvre) confirm his fidelity to Bolognese classicism.

His reputation as a portraitist, which never ceased to grow, dates to this period: Pope Urban VIII posed for him, and, in Paris in 1650, Poussin could see no one but him capable of painting his portrait which had been ordered by Chantelou. Mignard also produced countless Virgins in half-length, soon known as 'Mignardes' which made the fortunes of the likes of Sassoferrato.

On his return to France in 1656, called back by the King, of whom he has left many portraits, there was the inevitable confrontation with Le Brun, who occupied the top position. Mignard became the head of the Académie de Saint-Luc, the rival of the Académie Royale and was appointed official painter to Philippe d'Orléans, the King's brother, for whom he decorated between 1677 and 1680 the gallery of the Château de Saint-Cloud (destroyed in 1870). The Paradise which he painted for the Queen on the cupola of the Val-de-Grâce (begun 1663), based on the examples to be found in the churches of Parma, Rome or Naples, is the only surviving example of his work as a decorator on a monumental scale, all his other projects having been destroyed, both in the various Parisian mansions as well as in the small gallery at Versailles (1685). That particular project was his first intrusion into the domain reserved to Le Brun, who had just lost in Colbert his chief protector. Supported by Louvois, Colbert's successor, Mignard brought his rivalry with the 'Premier Peintre' before the King himself, to whom he offered, in 1684, a Christ carrying the Cross and for whom, in 1689, he painted a Family of Darius, a picture intended to compete point for point with comparable works by Le Brun. Even his Self-Portrait (Louvre) is a response to the portrait of Le Brun painted by Largillière in 1686 (id.).

The death of Le Brun in 1690 made available to him the position of 'Premier Peintre'. The last five years of Mignard's life, who succeeded Le Brun in all his many capacities, was therefore very busy indeed: the project for the cupola of Les Invalides, the ceiling for the King's small gallery at Versailles and religious pictures. His last work, in which he depicted himself alongside St. Luke painting the Virgin (Troyes, on loan from the Louvre) is a direct homage to Raphael.

26. Pan and Syrinx

116 × 90 cm.
Paris, Musée du Louvre (R. F. 1979.19).

HISTORY: Painted before 1690 and intended for Charles, the son of Pierre Mignard, in the posthumous inventory of the artist (1695; Boyer, 1980). Probably (with its pendant *Apollo and Daphne*) in the sale of Lafontaine and various others, 10th January 1816 (42 × 34 ins.; Boyer, 1980, p. 155, note 4). Posthumous sale of Eugène Féral, 22-24th April 1901, no. 53. Kleinberger collection, then Sulzbach. Acquired in a public sale at Paris, 30th March 1979, no. 15 ('Attribué à Nicolas Mignard', reproduced), by the Louvre.

BIBLIOGRAPHY: *R.L.*, 1979, no. 4, p. 313, fig. 2; J.-Cl. Boyer, 'L'inventaire après décès de l'atelier de Pierre Mignard', *B.S.H.A.F.*, 1980 (1982), pp. 137-165, cf. p. 156, no. 162; J.-Cl. Boyer, 'Un chef-d'oeuvre retrouvé de Pierre Mignard (1612-1695): *Pan et Syrinx*', *R.L.*, 1980, no. 3, pp. 152-156, reproduced; J.-Cl. Boyer, *Pierre Mignard*, thesis (in preparation).

RELATED WORKS: Large painting of the same subject painted for the king of Spain, with its pendant: *Apollo and Daphne*, both lost (Boyer, 1980). Broader painting of the same composition, with two nymphs to the left, Paris, private collection (Boyer, 1980, p. 154, fig. 2, and an engraving by Jeaurat, after this version, fig. 3).

Painter of innumerable portraits and religious pictures, Mignard hardly broached mythology except in his great decorative projects, now lost. The chief one, at the Château of Saint-Cloud, depicted the *Four Seasons*, *Parnassus* and *Leto and the Peasants of Lycia*, compositions which were engraved and translated into tapestries at the Gobelins Factory.

A 'cabinet' painting, the Louvre's *Pan and Syrinx* had as a pendant an *Apollo and Daphne* bequeathed to the artist's other son, Rodolphe. The two works (which seem to have been reunited at the sale of 1816) were thus dear to the artist who kept them until his death. In intending his sons to have these two paintings illustrating the theme of disappointed love, perhaps he wished to give them one last moral lesson, as is suggested by Boyer in his fine analysis of the work (1980, p. 154).

Equally distant from the vivacity of Dorigny (no. 12) and the meditations of Poussin on the same subject (Dresden), Mignard's painting takes its source from Bolognese art, combining the severity of Domenichino with the nacreous execution of Albani. His tight, dramatic composition, has the simplicity of the great classics: the brutality of Pan, the fear of Syrinx, the protection offered by the river Ladon are 'commented' on by two *putti*, while in the background Love extinguishes its flame.

Pierre Patel, called the Elder or Father

Picardy ?, c.1605 ? — Paris, 1676

Of the same generation as Claude Lorrain, Patel, like his son Pierre-Antoine (1646-1707) was exclusively a landscapist. A pupil of Vouet, he was received into the community of painters of Saint-Germain-des-Prés after 1632, the year of his marriage, and into that of St. Luke in 1635, though he never became a member of the Académie Royale, despite the fact that he was a signatory to the act which joined the two bodies. It seems he never visited Italy.

Patel worked on the decoration of the Cabinet de l'Amour in the Hôtel Lambert (1647-1650) where his landscapes flanked those of Swanevelt, and where, in the Cabinet des Muses, he also painted the background to the celebrated Muses *of Le Sueur (1652-1655). In 1660 he assisted with the decoration of the apartment of Anne of Austria in the Louvre. He must also have produced a great number of easel pictures, of which the finest are the two landscapes at Orléans. One must also attribute to him a* General View of the Château de Versailles *(1668, Versailles), the composition of which was repeated twenty years later at the Trianon (see Allegrain).*

Along with La Hyre and Henri Mauperché (c.1602-1686) Patel is one of the most refined of French landscape artists: Mariette saw him as the 'Claude Lorrain de la France . . .'.

27. Josabeth exposing Moses on the Nile

96 × 86.5 cm. (previously oval in form).
Signed and dated, bottom right: *P. PATEL 1660*
Paris, Musée du Louvre (inv. 7126; Catalogue 1974, no. 619, reproduced).

HISTORY: Painted, as was its pendant: *Moses burying the Egyptian* (Louvre, inv. 7127), in 1660 for the Summer apartment of the Queen Mother, Anne of Austria, at the Louvre, where they decorated two over-doors (Engerand, 1899). Attributed to Dughet in the 1709 inventory (id.) and then to P.-A. Patel the younger in 1737 (Engerand, 1900). Exhibited at the Louvre at the opening of the Museum in 1793 (cat. no. 137 and 428). On loan to Compiègne with its pendant (Filhol and Lavallée, 1815) and then on its own at Fontaine-bleau, under the name of Bloemen (Engerand, 1899). Sometimes incorrectly said to have come from the Hôtel Lambert (exhibited again 1960; cf. Méjanès, 1967).

EXHIBITIONS: 1929, Maisons-Lafitte, not in catalogue ?; 1949, Paris, no. 296; 1957, Nancy, no. 58; 1960, Paris: *Réserves*, no. 346; 1960, France, no. 55; 1964-1965, Dijon, Lyons, Rennes, no. 27.

BIBLIOGRAPHY: Dézallier d'Argenville, *Voyage pittoresque de Paris*, 1749, p. 34, 2nd ed. 1752, p. 39; *Le Musée français*, vol. III, 1807, 4th section, text and plates without no.; Filhol and Lavallée, vol. X, 1815, 120th issue, p. 7, pl. V (no. 719); L. de Veyran, 1877, 10th series, 91st issue, reproduced; F. Engerand, 1899, pp. 53-54 (Dughet); F. Engerand, 1900, p. 629 (P.-A. Patel); Chr. Aulanier, *Histoire du Palais et du Musée du Louvre* (I), *La Petite Galerie. Appartement d'Anne d'Autriche*, 1955, p. 28; J.-F. Méjanès, in *Le Cabinet d'un grand amateur, P. J. Mariette*, exhibition catalogue, Paris, Louvre, Cabinet des Dessins, 1967, under no. 252; N. Coural, *Pierre Patel*, thesis (in preparation).

RELATED WORKS: Engravings by M.-G. Eichler 'à Ausbourg', in *Le Musée français*, 1806, re-used in Veyran, 1877; by Pillement and Duparc, in Filhol and Lavallée, 1815.

The summer apartment of Anne of Austria, mother of Louis XIV, in the Louvre was situated on the ground floor of a wing joining the old Louvre to the North with the Grande Galerie to the South, on the floor of which was established the Petite Galerie, burnt in 1660 and then replaced by the present Galerie d'Apollon. Facing east, it was

cooler than her previous lodgings, decorated by Le Brun and Le Sueur, on the ground floor of the wing adjacent to the old Louvre which opened to the South on to the Seine and which subsequently became the winter apartment.

Consisting of a series of seven linked rooms, it was decorated from 1655 to 1657 by Giovanni Francesco Romanelli (about 1610-1662), whose frescoes on the ceilings of four of the rooms, for the most part preserved, have just been restored. The last room to the south, called 'petit cabinet sur l'eau', as it looks onto the Seine, would have been decorated as early as 1655 according to Aulanier (1955), but D. Bodard (in *B.S.H.A.F.*, 1974 [1975], p. 50, note 11) argues that perhaps the work was not completed in 1657, the date of a description of Romanelli's frescoes by Ascano Amaltea, who does not mention this room. It is, however, in 1657 that Romanelli decorated it with seven paintings on canvas relating the Life of Moses, of which four only are now preserved at Compiègne and at the Louvre (inv. 575 to 578).

Dated to 1660, the two landscapes painted by Patel for the overdoors complete this series with two episodes from the Life of Moses: his exposure on the banks of the Nile by his mother Josabeth and the burial of the Egyptian whom he killed. The importance, unusual for him, which Patel gives to the figures is justified by the concern for relating these two compositions to Romanelli's decorative cycle.

The two artists already had an occasion to work together on another Parisian project, that of the Hôtel Lambert (1647, Cabinet de l'Amour), with Le Sueur, Perrier, Flémalle, Juste d'Egmont and the landscapists Mauperché, Asselyn and Swanevelt. In the same style as this decor, that of the Louvre must have offered a striking dialogue between the decorative power of the Italian and the atmospheric subtlety, which is of northern origin, evidenced in the delicate landscapes full of nuances by Patel.

Francois Perrier

Franche-Comté or Burgundy, c.1590/1600 — Paris, 1650

Trained in Lyons, perhaps (like Blanchard) in the studio of Horace le Blanc (c.1580?-1637), Perrier, during the 1620s, passed his first stay in Rome, where he collaborated with Lanfranco (1582-1647), one of the masters of the Roman baroque, whose style made a deep impression on his art. Back in Lyons by 1629, he reached Paris in 1631 where he painted, following the designs of Vouet, the chapel of the Château de Chilly. The young Le Brun was his pupil for a while before entering Vouet's studio. It appears that the virtual monopoly maintained by the latter left little room for him to exercise his talents and forced him to make his way back to Rome where he remained until 1645.

In Rome he decorated, most notably, the gallery of the Palazzo Peretti (formerly Fianò Almagià), and produced two important collections of engravings based on antique sculptures, which were published simultaneously in Rome and Paris: in 1638 the Segmenta nobilium Signorum et Statuarum*. . . . Dedicated to Roger du Plessis de Liancourt (cf. no. 14, history), these reproduced in one hundred plates the most celebrated statues in Rome described in vibrant etching which envelopes each with a landscape surround full of life. This he published along with the* Icones et segmenta *. . ., dedicated to bas-reliefs, in 1645, which constituted for a long time an abundant repertoire of forms much used by artists. This second Roman sojourn, despite the noticeable influence of Pietro da Cortona, was marked by an evolution towards classicism which is evidenced by the two pictures in the Capitoline Museum in Rome (*Moses striking the Rock *and* The Adoration of the Golden Calf*) and the* Plague of Athens *at Dijon (no. 28). The antique style of Raphael (whose decorations at the Farnesina he engraved) together with Poussin were his new models.*

His most important undertaking after his final return from Rome in 1645, was the decoration of the gallery of the Hôtel La Vrillière where he painted the vault, (destroyed but replaced by a copy) which included a scene showing Apollo on his Chariot, *placed between* Aurora *and* The Night, *and* The Four Elements. *Along the walls, were ten paintings which recounted Roman history painted by Poussin, Guercino, Guido Reni, Turchi, Pietro da Cortona and Carlo Maratta.*

*Perrier is found among the painters employed between 1646 and 1647 on the decoration of the Cabinet de l'Amour of the Hôtel Lambert (*Aeneas fighting the Harpies – *Louvre) and in numerous other sites in Paris and its environs. In 1648 he figured among the founders of the Académie Royale.*

Though his reputation as an engraver has never been forgotten, his fame as a painter, considerable in the seventeenth century, has, (as often happens), suffered a long eclipse. His paintings, dispersed among the museums of Leningrad, Cincinnati, Rheims and Montauban, testify to a vigorous artistic temperament, perceptible even in his mature works, rich in subjects and boldly coloured. This very personal art had, apart from its own particular qualities, the merit of opening the eyes of a number of younger painters, such as Le Sueur, Poerson and Dorigny, to the art of the Roman baroque, which at that time was likewise represented by the luminous examples of Romanelli, also available in Paris.

28. The Plague of Athens

72 × 97.5 cm.
Dijon, Musée des Beaux-Arts (4902).

HISTORY: London, Pulitzer Gallery (as La Hyre). Acquired in 1969 by the Museum.

BIBLIOGRAPHY: 'La Chronique des Arts', supplement to *G.B.A.*, February 1971, p. 7, no. 28, reproduced; J. Thuillier, 'Deux tableaux de François Perrier', *R.L.*, 1972, no. 4-5, pp. 307-314, cf. pp. 308, 310, 312, 313, p. 312 fig. 8.

RELATED WORKS: Three anonymous drawings after lost drawings by Perrier for various figures in the painting, Louvre 'Album Perrier' (R.F. 879 to 1060) f° 70, 112, 123 (Thuillier, 1972, fig. 9-11).

Painted during the artist's second visit to Rome (about 1642-1643 according to Thuillier, 1972, p. 312), this painting would appear to represent the plague of Athens as described in the accounts of Thucydides and Lucretius (id., pp. 313-314, notes 29 and 30 for the sources and related subjects). The theme of *plagues* has frequently been used since Raphael (engraving by Marcantonio) and, in the seventeenth century, Poussin *(the Plague of Asdod, 1630, Louvre)* like Mignard *(The Plague of Aegina,* engraved by G. Audran), developed, as has Poerson here, the diverse attitudes of man confronted with a scourge which overtakes him. Under the whip of a winged spirit, symbolising the evil which attacks it, humanity dies or buries its dead, weeps or prays, offers sacrifices on the altars and fights or resigns itself. The sequence of these 'events' which draw the eye of the spectator from the foreground, with its dying women, to the statue (of Aesculapius the God of healing ?) in the background, passing by the central figure of the old man pleading, belongs to the language of Poussin. A discrete quotation is noticeable in the background, where a man, perched upon the statue, distributes bread: this group is borrowed from the *Charity of Saint Cecilia,* a celebrated fresco executed in 1613-1614 for the Church of San Luigi dei Francesi in Rome by Domenichino, an artist whom Poussin in fact placed above all of his contemporaries for his 'correctness'.

29. Acis and Galatea

96.5 × 133.5 cm.
Paris, Musée du Louvre (inv. 7161; Catalogue 1974, no. 633, reproduced).

HISTORY: Collection of the 'jardinier' André Le Nôtre (1613-1700), 'dans le cabinet de sa maison au jardin des Tuileries' (Guillet de Saint-Georges, who noted that it 'a été gravé par le Pautre'). Presented by Le Nôtre, with his collection, to Louis XIV in September 1693. At Versailles in 1695, at Meudon and then again at Versailles from 1699 until the Revolution (Engerand, 1899).

EXHIBITIONS: 1961-1962, Canada, no. 60, reproduced; 1973, France, no. 25, fig. 10.

BIBLIOGRAPHY: Dézallier d'Argenville, *Abrégé ...,* 2nd ed. 1762, vol. IV, p. 24; Fontenay, *Dictionnaire des artistes,* 1776, vol. II, p. 291; Guillet de Saint-Georges, 'François Perrier' (without a date, but after 1672), in *Mémoires inédits ...,* 1854, vol. I, pp. 127-136, cf. p. 134; F. Engerand, 1899, p. 317; J. L. Vaudoyer, "Les collections de Le Nôtre', *R.A.A.M.,* vol. 34, 1913, pp. 350-364, cf. pp. 359-360, reproduced p. 361; J. Laran, 'Une vie inédite de François Perrier...', *A.A.F.,* 1913, pp. 186-200, cf. pp. 186 note 1, 199 and note 1; J. Magnin, *Le paysage français,* 1928, p. 14; A. Blunt, *Art and Architecture in France, 1500-1700,* Harmondsworth, 1953, p. 170, pl. 113 B; J. Thuillier, 1964, p. 68, reproduced in colour p. 67; E. Schleier, 'Affreschi di François Perrier a Roma', *Paragone,* no. 217, March 1968, pp. 42-54, cf. p. 52 note 4; J. Thuillier, 'Deux tableaux de François Perrier', *R.L.,* 1972, no. 4-5, pp. 307-314, cf. p. 308 note 3; E. Schleier, 'Quelques tableaux inconnus de François Perrier à Rome', *R.A.,* no. 18, 1972, pp. 38-46, cf. p. 43; J. Thuillier, 'Un chef-d'oeuvre de François Perrier au Musée des Beaux-Arts de Rennes: Les adieux de saint Pierre à saint Paul', *Bulletin des Amis du Musée de Rennes,* no. 3, 1979, pp. 52-65, cf. p. 60, fig. 11.

RELATED WORKS: Etching, in the opposite direction, by Jean Le Pautre (1618-1682), after the painting in the Louvre, then in the collection of Le Nôtre. Laran (1913, p. 199 note 1) claims that 'la gravure de ce tableau (of the Louvre), editée par N. de Poilly, est due à Perrier lui-même. Elle

ne figure pas dans le catalogue de R. Dumesnil'.

A replica with a few variations, by the artist according to Thuillier (1972), 102 × 132 cm., acquired in 1847 from Mme. de Roany, as 'Luca Giordano', by the Louvre (inv. 7162) was on loan, in 1892, to the Carcassonne Museum (D.65).

A painting of the same subject, with a different composition, in a private collection in 1938 (reproduced in Thuillier, 1979, p. 59, fig. 10). A painting of the same subject, oval, with large figures, 126 x 85 cm., in the Copenhagen Museum (Schleier, 1972, p. 43, fig. 14) has been rejected by Thuillier (1974, p. 65 note 13). A painting, 150 x 175 cm., in the Lewisburg Museum (Pennyslavania), published by R. Longhi (*Paragone,* no. 217, 1968, p. 54, pl. 43, cf. Rosenberg, 1982, p. 368, no. 11) is dated by him to the second Roman visit, which Schleier (1972, pp. 39, 43) and Thuillier accept (1979, p. 65 note 13).

According to Guillet de Saint-Georges, Perrier 'se faisait un plaisir de traiter fréquemment ce sujet de Galathée, qu'il traitait avec beaucoup d'industrie' (1854 edition, p. 134). He mentions three versions of it: the first (p. 131), which he places in his biography of the artist, before the second Roman visit, belonged to Dorat, councillor of the 'Grande Chambre', and passed through the collection of 'M. Lallemand qu'est du corps de l'Académie' (the painter Philippe Lallemand, who was received as an academicien in 1672); the second (p. 134) belonging to Le Nôtre is the Louvre painting; the third (p. 134) was then 'dans le cabinet de M. Blanchard, professeur de l'Académie' (the painter Gabriel Blanchard, the son of Jacques and nominated professor in 1670).

A version on canvas, 'H. 15 pouces, 6 lignes; L. 19 pouces, 6 lignes, (approximately 42 × 53 cm.) figured in the Prince de Conti sale, 8th April 1777, no. 589, sold for 185 *livres* to 'Peraut'.

Ovid's *Metamorpheses* (XIII, 750) are the source of this mythological theme, treated amongst others by Poussin around 1630 (Dublin, no. 34). The love of the God Acis for the nymph Galatea aroused the jealousy of the cyclops Polyhemus, who attempted to crush his rival with rocks. Acis only escaped death by transforming himself into a river.

The name of Lanfranco has often been mentioned regarding the subject of the painting. Nevertheless, his *Polyphemus and Galatea,* at the Palazzo Doria in Rome (approximately 146 × 195 cm.; catalogue 1982, p. 132, fig. 208) has, as Schleier remarks (1968) hardly any direct relationship with Perrier's work, except for the shadow of the veil cast obliquely over Galatea's face. Moreover, it is more than likely that this painting dates to the end of Perrier's life ('about 1647-1650 ?' Thuillier, 1976) rather than from his first stay in Paris in the 1630's (Schleier, 1972), where Lanfranco's influence was still strong.

Raphael's *Galatea* (1511) at the Farnesina, the almost inevitable reference for any artist treating this subject, is here recalled by the winged *putto* at the centre of the painting, which Poussin had already borrowed in his *Triumph of Neptune* in Philadelphia (circa 1634; cf. Rosenberg, 1982, no. 89). In turn, the figure flying in the sky with a torch is taken from Guido Reni's *Aurora,* (circa 1612-1614) at the Casino Rospigliosi. The frontal deployment of the marine triumph evokes a tradition which goes from Giulio Romano to Annibale Carracci to Guido Reni.

Perrier gives to this theme, so often repeated (including by the artist himself), an interpretation which is at the same time both powerful and poetic. His loose technique, his broad harmonies of blue and red, to which echo the finest nuances of pink and green, are united together in a marvellous inspiration, as in the flight of the white birds on the surface of the waves. Rejecting the monstruous detail, he hides the single eye of Cyclops behind a tuft of hair, but knows how to express the anguish of the latter who, abandoning Pan's pipes, turns towards Galatea with an imploring gesture.

Charles Poerson
Lorraine, 1609 (?) — Paris, 1667

Little is known of the life of this painter, who like La Tour, Mellin and Dauphin was a native of Lorraine, and we do not know if he even made a trip to Italy. Vouet's biographers record him among his pupils, a fact which his style alone would lead us to recognise.

He was in Paris in 1638, the year of his marriage. In 1651 he moved (like Baugin) from the Académie de Saint-Luc to the Académie Royale, where he became a professor and in 1658 rose to the position of Rector. His son, Charles-François (1653-1725), later became the Director of the French Academy at Rome.

He collaborated with Juste d'Egmont on the decoration of the Galerie des Hommes illustres *at the Palais Cardinal (where Champaigne and Vouet painted the principal figures) and with le Sueur on the Appartement des Bains of Anne of Austria at the Louvre. He was twice chosen to execute the* May of Notre-Dame: *in 1642* St. Peter's First Sermon in Jerusalem *(in situ) and in 1653* St. Paul on the Island of Malta *(lost). For the same church, along with Champaigne and Stella, he made cartoons for the famous series of tapestries depicting the* Life of the Virgin.

Midway between the lyricism of Vouet and the elegance of Stella, his style possessed a clear lucid character which sometimes recalls François Perrier, though it is more erudite. It was possible at one time to attribute to him the two pictures of Cincinnatus *at Le Mans, today given to Le Sueur (no. 23).*

30. Nativity

53 × 37 cm.
Signed, bottom right: *C. Poerson*
Paris, Musée du Louvre (R.F. 3928; Catalogue 1974, no. 648, reproduced).

HISTORY: Acquired at Meaux in 1935 by M. G.-P. Ryaux, antiquarian; presented by him in 1936 to the Louvre.

EXHIBITIONS: 1960, Paris: *Réserves,* no. 353.

BIBLIOGRAPHY: J. Lejeaux, 'Charles Poerson 1609-1667, and the tapestries of the *Life of the Virgin* in the Strasbourg Cathedral', *G.B.A.,* 1946-II, July, pp. 17-29, cf. pp. 19, fig. 1, 22, 28; J. Thuillier, 1964, p. 74; S. Savina, *Charles Poerson,* thesis (in preparation).

RELATED WORKS: A large wide painting (without the sky), signed, at the church of Montfort-l'Amaury. Tapestry at Strasbourg Cathedral (see entry).

This Nativity, one of the few definite works by Poerson, is closely linked to one of the fourteen tapestries of the *Life of the Virgin,* woven between 1638 and 1657 for the Cathedral of Notre-Dame in Paris, and today preserved in the Cathedral at Strasbourg. It is known that Poerson assisted in this enterprise and, though the 'cartoon' (full size), of this scene for the tapestry has not been found, like those of Stella and Champaigne, it is evident that it was also by his hand.

The differences between the tapestry and this small painting, however, are quite numerous, with only the angel seen from behind being virtually identical. The wide tapestry does not include the 'heavens', so luminous with their 'glory' peopled with angels, but it adds many figures of shepherds descending the staircase, with the angel with joined hands occupying the centre of the composition.

In width also, the painting at Montfort l'Amaury is much closer to that of the Louvre, and it is only barely distinguishable by its rejuvenation of Saint Joseph, the absence of the top portion and naturally the format, which is that of a church painting. One can thus assess how a fortunate composition, once established, could give rise to numerous variations of format and of purpose.

The small, well preserved canvas in the Louvre displays the slate-blue colouring, dear to the artist as it was to both Perrier and Stella, and, in common with the works of the latter, a search for distinction, perceptible in the nervous finish of the draperies and the wings, and in the elegance of the smiling figures.

31. The Assumption

255 × 211 cm.

Dublin, National Gallery of Ireland (cat. no. 1896; Catalogue 1981, p. 127, reproduced).

HISTORY: Cardinal Fesch sale, Rome, commenced 17th March 1845, catalogue by George, 1844, 3rd section, *Ecole Française*, p. 60, no. 396-1287 (as Charles-François Poerson). Acquired in Rome from Signor Aducci, in 1856, (id.).

BIBLIOGRAPHY: M. Wynne, 'Fesch paintings in the National Gallery of Ireland; *G.B.A.*, 1977-I, January, pp. 1-8, cf. pp. 2 and 5, reproduced; H. Quinlan, *Fifty French Paintings, National Gallery of Ireland*, Dublin, 1984, p. 7, reproduced in colour.

The attribution of this large altarpiece to Charles Poerson and (not to his son Charles-François) is entirely convincing. In it, one recognises the artist's taste for angels with long blue or rose-tipped wings (cf. no. 30), with the Magdalen, placed to the left, very similar to the mother portrayed in the centre of the *Judgement of Solomon* at Vire (reproduced in the *R.L.*, 1972, no. 4-5, p. 305). Conversely, it allows us to confirm the attribution to Poerson of the cartoon for the tapestry representing *The Wedding Feast at Cana*, now at the Hôtel de Ville at Perpignan (cf. Rosenberg, 1982, pp. 300-301), put forward by Jean Lejeaux ('La tenture de la vie de la Vierge de la Cathédrale de Strasbourg', *Bulletin de la Société des Amis de la Cathédrale de Strasbourg*, 2nd series, no. 6, 1951, reproduced, p. 7).

The composition, clearly arranged in two superimposed levels, recalls the great Bolognese paintings on this theme, back in favour with the Counter-Reformation, notably those by Annibale Carracci (Prado, Dresden, Bologna, and Rome, Santa Maria del Popolo) and Guido Reni (The Gesú at Genoa). This 'bolonisme' is, however, reviewed through the style of Vouet (who treated this subject in 1653, Musée de Rheims), and in a spirit of gravity close to that of a Champaigne.

Nicolas Poussin
Les Andelys, 1594 — Rome, 1665

Though he passed almost forty years in Rome and even though it was there that his greatest creations were achieved Nicolas Poussin was nonetheless the greatest French painter of the seventeenth century. In the baroque Rome of Bernini his art, strikingly original, influenced both the Italians (Pietro Testa, Andrea de Lione . . .) as much as the French who lived there, (Bourdon, Blanchet, Mignard, Le Brun, Loir, N. Coypel). The collectors who fought over his works were frequently French, (Richelieu, Chantelou, Pointel) and, even apart from his Parisian sojourn of 1640-1642, he was established as the principal touchstone of French painting. His concept of art as an intellectual activity, which nonetheless maintained 'délectation' – (enjoyment) as its chief aim – was to be the main preoccupation of the Académie Royale under Le Brun's direction, and Félibien made an enthusiastic reference to this fact in his eighth Entretien *(1685).*

Poussin did his apprenticeship at Rouen, where he studied with Quentin Varin, and at Paris with Georges Lallemand, both eminent representatives of 'mannerism'. His works from this period (notably the 'Death of the Virgin' c.1623, formerly in Notre-Dame) have disappeared.

After two vain attempts to reach Rome, he finally arrived there in 1624, passing through Venice on the way. The initial protection and patronage of the poet Marino, for whom he illustrated Ovid's Metamorphoses *(drawings, Windsor) was followed by that of Cardinal Barbarini, the nephew of Pope Urban VIII, who commissioned from him* The Death of Germanicus *(1628, Minneapolis) and also that of his secretary, Cassiano dal Pozzo. Poussin's contact with this learned group, enamoured of antiquity and philosophy, was instrumental in the development of his art and theories.*

Despite a number of excursions into the realms of large scale religious painting, of which his Martyrdom of St. Erasmus *(1628-1629) for St. Peter's in Rome was the principal example, he was never successful in this field and for the rest of his career Poussin devoted himself exclusively to the painting of 'tableaux de cabinet' (cabinet paintings). These were intended for cultured collectors who formed a select and faithful clientèle which allowed him complete freedom of expression. The initial, highly active period of his Roman sojourn was followed by an interval during which he was seriously ill and after which he married Anne Dughet (1630). This in turn was followed by a retiring and industrious existence which allowed the artist the scope of developing an oeuvre in which each composition was matured slowly, a practice which permitted him to say 'je n'ai rien négligé' ('I have neglected nothing'). From this period date the following works:* The Plague of Azdod *(1631, Louvre),* Young Pyrrhus Rescued *(1634, Louvre), the first two* Bacchanals *painted for Richelieu (1635-1636),* The Continence of Scipiò *(1640, Moscow) and the two* Landscapes *along with* St. John the Evangelist *(1640, Chicago) and* Saint Matthew *(1641, Berlin). For Cassiano dal Pozzo he painted the first series depicting the* Seven Sacraments *(the five pictures of 1641 at Belvoir Castle, another destroyed, and the* Baptism *of 1642 in Washington).*

At the end of 1640 Poussin reluctantly agreed to Louis XIII's insistences that he return to Paris. 'Voilà Vouet bien attrapé!' ('Behold, Vouet well ensnared!') the King is reported to have said on his arrival. In fact, the jealousy of Vouet, then all powerful in Paris, and that of his students, as well as the intrigues of others, forced Poussin to return to Rome following two years

devoted to work done for Cardinal Richelieu in 1641. This included: Moses and the burning Bush, (Copenhagen), and Time saving Truth from Envy and Discord, (Louvre); for the Noviciate of the Jesuits (The Miracle of St. Francis Xavier, Louvre) where his painting was placed between those of Vouet and Stella; for the Royal chapel at Saint-Germain-en-Laye (The Institution of the Eucharist, Louvre); and also for the Grande Galerie of the Louvre, which he was commissioned to decorate. This immense undertaking, – the only one of its type which he accepted – comprised murals by Fouquières and, on the vault, a complex interplay of real and trompe-l'oeil bas-reliefs, the latter recounting the story of Hercules, of which only the drawings remain. Under the pretext of going to collect his wife in Italy, Poussin left his assistants (Jean Lemaire and Rémy Vuibert) to continue the work and returned to Rome: for good.

This is the period of the second series of The Seven Sacraments painted between 1644 and 1648 for Paul Fréart de Chantelou (Edinburgh), larger in format and more severe in appearance than the first set. Poussin wished to show in these compositions, in their austere grandeur, the institutions of the Early Church by employing an exacting archaeological precision drawn from a study of sarcophagi and the liturgy. At the same time he broached stoic subjects, in 1648 painting Landscape with the body of Phocion carried out of Athens (collection of the Earl of Plymouth) and The Ashes of Phocion collected by his Widow (Walker Art Gallery, Liverpool). It was at this time that he painted his two Self-Portraits for Pointel (1649, Berlin) and Chantelou (1650, Louvre).

The 1650's saw him develop an interest for landscape in his work, following the example of Annibale Carracci and Domenichino and of Claude Lorrain and perhaps Dughet, his pupil and brother-in-law. From the Landscape with a Woman washing her Feet (1650, Ottowa) and the Pyramus and Thisbe, painted the following year (Frankfurt), contrasting humanity and its dramas with a Nature which surpasses it, he moved towards a 'pantheistic' concept of the world, in which the natural forces are personified. The Landscape with Orion (1658, New York) is the masterpiece of this cosmic vision, which one encounters again in his very last years in the Four Seasons (1660-1664, Louvre) and Apollo and Daphne, (1665, Louvre).

32. Nymph and Satyr drinking

73 × 59 cm.

Dublin, National Gallery of Ireland (cat. no. 816; Catalogue 1981, p. 129, reproduced).

HISTORY: Perhaps in the Robert Strange sale, London, Christie's, 7th February 1771, no. 20, purchased by Stephenson. Collection of the Duke of Sutherland circa 1836. Duke of Sutherland sale, London, Christie's, 11th June 1913, no. 34 (Bodkin) or 35 (Blunt), purchased for £147 by Mr. Alec Martin for Sir Hugh Lane. Bequeathed by Sir Hugh Lane, 1918.

BIBLIOGRAPHY: Th. Bodkin, 'Nicholas Poussin in the National Gallery, Dublin, I', Burlington Magazine, April 1932, pp. 174-186, cf. pp. 179-180 and pl. III B; Th. Bertin-Mourot, 'Addenda au catalogue de Grautoff depuis 1914', Société Poussin, cahier no. 2, 1948, no. and pl. XXIV; A. Blunt, Nicolas Poussin, Critical Catalogue, London, 1966, p. 138, under no. 200 ('Copies 2'); J. Thuillier, Tout l'oeuvre peint de Poussin, 1974, p. 89,

under no 39; D. Wild, Nicolas Poussin, Zurich, 1980, vol. II, pp. 258-259, no. R.29, reproduced ('Der Meister der Bacchanale').

RELATED WORKS: Version at the Prado (74 × 60 cm.; inv. 2318, carries the original numbers 491 and 1030), acquired in 1722 by Philippe V from the heirs of Carlo Maratta (Grautoff, 1914, vol. II, p. 86, no. 53, reproduced; R. Rey, Poussin, Peintures, Lausanne, 1960, reproduced in colour p. 29; A. Blunt, 1966, p. 138, under no. 200 ('copies 3'); J. Thuillier, 1974, no. 39a; Exhibition 1977-1978, Rome and Düsseldorf, no. 9. Version at Moscow (Pushkin Museum; at the Hermitage until 1930. 77 × 62 cm.; inv. 1401). Acquired by Catherine II in 1771 with the Crozat collection, this painting figures in L. A. Crozat catalogue of 1775 by Thiers and in the Pierre Crozat inventory of 1740 (cf. M. Stuffmann, G.B.A., 1968-II, p. 132, no. 165). It belonged at the beginning of the century to J.-B. Boyer

d'Aguilles (1645-1709), and had been engraved in the opposite direction by Jacques Coelemans in the *Recueil . . .* of this collection, Aix, 1705 (re-edited by Mariette in 1744; cf. G. Wildenstein, *G.B.A.,* 1962-II, p. 189, no. A.376, reproduced p. 180; Line engraving after this print by El. Lingée in Landon, *Vies et oeuvres . . . Nicolas Poussin,* vol. IV, 1811, pl. 45 [pl. CLXXI of the *Table*]). It is perhaps the painting described without dimensions in the inventory of the abbot Louis Lanthier, at Aix, in 1737 as *Le Satyre coudé,* valued at 200 *livres* (cf. J. Vallery Radot,

'Sur un tableau du Poussin, le 'Satyre buvant' du Musée de l'Ermitage', *Les Beaux-Arts, revue d'information artistique,* no. 4, 15th February 1926, pp. 52-53). Cf. Grautoff, 1914, p. 87, no. 54, reproduced; Blunt, 1966, p. 138, no. 200; Thuillier, 1974, no. 39b.

Copies at the Besançon Museum and Martin sale, Paris, 1802 (Blunt, 1966, 'copies, 1 and 4').

The figure of the satyr drinking (but from a horn and not a vase) is seen again in the *Childhood of Bacchus* at Chantilly (Blunt, 1966, no. 134).

The existence of three virtually identical versions of this composition has prompted art historians to prudence. Let us immediately indicate the versions among them: only that in Dublin shows a curved staff and a pan flute hanging on the tree, in that in Moscow the girdle of ivy on the satyr carries a small oblique branch. Grautoff (1914), followed by Thuillier (1974) catalogued the version in the Prado and that in Moscow, now in the Hermitage, which he considered as an autograph replica of the former. Blunt (1966) retains only the second and catalogues those in Dublin and in the Prado as copies. P. Rosenberg has exhibited (1977-1978) that in the Prado which he dates, in agreement with Thuillier, to 1626-1627 (that is to say earlier than Grautoff: 1632-1636 and earlier than Blunt dates the Russian picture: 1633-1635) and though he does not cite the Dublin version, he has generously informed us that he believes, as we do, that it is original.

The argument, often put forward against the possibility of such repetitions, according to which Poussin refused to copy himself, lies in the artist's own affirmation 'je n'aurai jamais du plaisir à refaire ce que j'ai déjà fait une fois', ('I would never get any pleasure in redoing that which I have already done once before'. Letter to Cassiano dal Pozzo, 17th January 1642: *Correspondence,* ed. Ch. Jouanny, *A.A.F.,* 1911, p. 115), which he made in respect of the *Seven Sacraments.* It is known that he made a second, entirely different, series for Chantelou to that which he painted for dal Pozzo, who had besides forbidden that his paintings be copied. . . Even more than for the *Nurture of Bacchus* (no. 33), Poussin, at the beginning of his Roman career, could well have repeated this small scene three times, as an attractive commercial venture. This fact is admitted today by many specialists (for example, Rosenberg, 1982, p. 303).

Regarding the handling, now jerky, now fluid, it is to be found in a whole series of works equally marked by the influence of Titian and often devoted to Bacchic subjects, such as the *Nymph Bestriding a Satyr* in Kassel, the *Nymph Bestriding a Goat* in Leningrad and the *Nurture of Bacchus* (no. 33).

33. The Nurture of Bacchus, *or* Small Bacchanal

97 × 136 cm.
Paris, Musée du Louvre (inv. 7295; Catalogue 1974, no. 687, reproduced: 'Poussin ?').

HISTORY: Collection of Louis XIV from 1683. At Versailles in the Cabinet de Monseigneur in 1695 and 1709 (Engerand, 1899). In the Appartement du Dauphin in 1720 (Monicart). Restored in 1749 (Engerand, 1899). Exhibited at the Luxembourg palace (id. and Boyer d'Argens, 1752). At the Louvre in 1785. Exhibited at the

Louvre on the opening of the Museum in 1793 (Catalogue no. 15).

EXHIBITIONS: 1934, Paris, no. 266; 1956-1957, Rome, no. 225, pl. 49; 1958, Stockholm, no. 38, pl. 18; 1960, Paris: *Poussin,* no. and pl. 29; 1961, Rouen, no. 77; 1964, Bordeaux, no. 50; 1968, Atlanta, p. 16, reproduced; 1973-1974, Paris, no. 81; 1977-1978, Rome, no. 11, reproduced in its entirety and detail pp. 135, 139; 1978, Düsseldorf, no. 11, reproduced.

BIBLIOGRAPHY: J.-B. de Monicart, *Versailles immortalisé*, 1720, vol. II, p. 376; Boyer d'Argens, *Réflexions critiques sur les différentes écoles de peinture*, 1752, p. 179; Dézallier d'Argenville, *Abrégé ...*, 2nd ed., 1762, vol. IV, p. 39; *Le Musée Français*, vol. II, 1805, 2nd section, text and plates without no.; Filhol and Lavallée, vol. IV, 1807, 41st issue, pp. 1-4, pl. I (no. 241); C. P. Landon, *Vies et oeuvres ... Nicolas Poussin*, vol. III, 1809 (1811), pl. 22 (pl. CLIV of the *Table of plates*, vol. IV, 1811, p. 11); C. P. Landon, vol. III, 1832, p. 59, pl. 31; J. Smith, 1837, p. 108, no. 206; A. Andresen, 1863, pp. 90-91, no. 363-364; L. de Veyran, 1879, 3rd series, 29th issue, reproduced; F. Engerand, 1899, pp. 315-316; Tuetey and Guiffrey, 1909, pp. 16, 380 (?); E. Magne, *Nicolas Poussin*, 1914, p. 198, no. 15; W. Friedlaender, *Nicolas Poussin*, Munich, 1914, pp. 50, 127, pl. 174; O. Grautoff, *Nicolas Poussin*, Munich and Leipzig, 1914, vol. I, p. 100, vol. II, p. 46, no. 25, reproduced; P. Jamot, 'Etudes sur Nicolas Poussin', *G.B.A.*, 1921-II, pp. 81-100, cf. p. 86; H. Lemonnier, 'L'enfance de Bacchus de Poussin au Musée Condé et au Louvre', *Beaux-Arts, revue d'information artistique*, 3rd year, no. 6, 15th March 1925, pp. 90-91 (pp. 30-31 of 'Bulletin des Musées'); J. Magnin, *Le paysage français*, 1928, p. 30; P. Marcel and Ch. Terrasse, *La peinture au Musée du Louvre, École française. XVII° siècle*, 1929, p. 42, reproduced pp. 36 and 37, fig. 42 and 43; W. Weisbach, 1932, pp. 150 fig. 50, 151; A. Gide, *Poussin*, 1945, pl. 12, reproduced in its entirety and details; P. Jamot, *Connaissance de Poussin*, 1948, pp. 22, 40, 64, pl. 17 and detail in colour pl. 115; F. S. Licht, *Die Entwicklung der Landschaft in den Werken von Nicolas Poussin*, Bâle and Stuttgart, 1954 (*Basler Studien zur Kunstgeschichte*, XI), pp. 103-104; G. Wildenstein, *Les graveurs de Poussin au XVII° s.*, 1957, p. 194, no. 129; Ch. Sterling, exhibition note, 1956-1957; M. Davies, *National Gallery Catalogues, French School*, London, 1957, pp. 170-173, under no. 39; A. Blunt, exhibition note, 1960 (1st and 2nd ed.); R. Rey, *Poussin, peintures*, 1960, pp. 35, 37, reproduced in colour; M. Alpatov, 'Poussin peintre d'histoire', *Colloque Poussin*, 1960, vol. I, p. 190; P. du Colombier, 'The Poussin exhibition', *B.M.*, July 1960, pp. 282-288, cf. p. 284; D. Mahon, 'Poussin's early Development: an Alternative Hypothesis', *B.M.*, July 1960, pp. 288-304, cf. pp. 297-298, note 76; M. Hours, 'Nicolas Poussin: Etude radiographique au Laboratoire du Musée du Louvre', *Bulletin du laboratoire du Musée du Louvre*, no. 5, November 1960, pp. 3-39, cf. pp. 22-23, reproduces the radiography; P. Rosenberg, exhibition note, 1961; A. Blunt, 'Poussin studies, XIII: Early falsifications of Poussin', *B.M.*, November 1962, pp. 486-498, cf. pp. 494, 497, fig. 23, 25, 26 ('Master of the clumsy Children'); D. Mahon, 'Poussiniana', *G.B.A.*, 1962-II, July-August, pp. 1-138, cf. pp. 29 note 87, 53, 132-133 note 397; W. Friedlaender, *Nicolas Poussin*, 1965, p. 124, colour plate, p. 125; A. Blunt, *The Paintings of Nicolas Poussin. A critical Catalogue*, London, 1966, p. 93, under no. 133, and p. 174, no. R. 64; D. Wild, 'Charles Mellin ou Nicolas Poussin', *G.B.A.*, 1967-I, January, p. 4; K. Badt, *Die Kunst des Nicolas Poussin*, Cologne, 1969, vol. I, pp. 298, 493, vol. II, pp. 78, 610 note 4; J. Thuillier, *Tout l'oeuvre peint de Poussin*, 1974, p. 89, no. 37, reproduced p. 88; G. Bazin (review by Thuillier, 1974), 'Chronique des Arts', supplement to *G.B.A.*, 1974-II, November-December, pp. 27-28; A. Blunt, (id.), *B.M.*, December 1974, p. 761; P. Rosenberg, introduction, p. 18, and exhibition note 1977-1978, Rome, reproduced in its entirety and detail; Id., exhibition note, 1978, Düsseldorf; A. Blunt, 'Poussin at Rome and Düsseldorf', *B.M.*, 1978-I, June, pp. 421-425, cf. p. 423; G. Isnard, *Le musée imaginaire du faux*, 1980, p. 120, reproduced; D. Wild, *Nicolas Poussin*, Zurich, 1980, vol. II, pp. 261-262, no. R. 27, reproduced in its entirety and detail.

RELATED WORKS: Engravings by Matthys Pool, in the opposite direction, dated: *Amsterdam, 1699* (reproduced in Wildenstein, 1957; according to Landon, 1809, the same engraver had left unfinished a larger plate of the same painting); by Pauquet and Dupréel in *Le Musée français*, 1805, re-used in Veyran, 1879; by Châtaigner and Niquet in Filhol and Lavallée, 1807; by Mme. Soyer in Landon, 1809; by C. Normand in Landon, 1832; by Maria Horthemeles.

Another version (75 × 97 cm.), incorrectly said to be unfinished, at the National Gallery in London (39) presents numerous variations: the sleeping bacchante does not figure in it, a winged cherub is standing behind the goat, the two children to the left are naked, the landscape is different (exhibition 1977-1978, Rome and 1978, Düsseldorf, no. 10, presented at Düsseldorf only).

This painting has long given rise to two problems, that of its exact subject matter, and more recently, that of its acceptance as belonging to the *oeuvre* of Poussin.

The title of *Bacchanal*, which it carries in the early inventories (and which for a long time led to the belief that it was one of the '*Bacchanales Richelieu*' of 1635) is retained by quite a few authors who refuse to see it as an *Education of Bacchus*. Included among these is the

author of the *Musée Français* (1805) who pushes the supposed logic of Poussin to the point where he denies him ever having painted an infant Bacchus drinking wine, a drink of which he was the inventor only at a later stage ..., and the authors Villot (catalogue 1853), Grautoff (1914), Marcel and Terrasse (1929) maintain, against all evidence, that the child is drinking milk. Conversely, Lavallée (1807), Landon (1809 and 1832), and more recently Friedlaender (1914 and 1965), Jamot (1921 and 1948) Lemonnier (1925), Rosenberg (1977-1978) accept the title *The Education (or Nurture) of Bacchus.*

In fact, the child crowned with vine leaves, like the two satyrs who nurture him, drinks from a gold cup the juice which the latter press out from a bunch of grapes. The inclusion of a goat conforms to Ovid's text (*Metamorphoses*, III, 315) according to which the Nymphs of Nysa nourished Bacchus with milk. Here, a child holds back the apparently irate animal (in the London version it is a winged cherub who leads a peaceful goat, pointing with his finger to the principal group as if to suggest a diet more appropriate to the unweaned infant!), and two overturned vases on the ground seem to indicate that the little Bacchus has abandoned the milk for the juice of the vine.

The effects of drunkenness are visible in the sleeping bacchante, the two embracing children to the left, and the bacchante with the lost look holding the thyrse, who dominates the central group. In the distance, to the right, a satyr can be seen playing the flute listened to by another bacchante, as wine engenders music as well as love.

The second question, that of the attribution, appears to have been resolved since the exhibition in 1978 at Düsseldorf where P. Rosenberg compared, for the first time, the London and Paris versions which confirmed that both were original. It should be recalled that, following the *Poussin* exhibition of 1960, Blunt (in the second edition of the catalogue) and Mahon (1960) expressed the first doubts on the authenticity of the Louvre painting, which Blunt, (1972 and 1966), attributed to a 'Master of the clumsy children' (forged from 'poussinesque' paintings or from those no longer attributed to Poussin by him, and which do not seem to form a very coherent group) before returning in the end (1978) to his initial idea: that of a painting by Poussin finished by another artist. D. Wild, having disagreed with Blunt's reticence, went a step further than the latter and invented a no less problematic 'Master of the Bacchanals'. On the other hand Grautoff (1914), Friedlaender (1914 and 1965), Badt (1964), and Thuillier (1974), uphold the authenticity of the work, which, according to Rosenberg (1977-1978), cannot be of the same date as the London version. One can, in effect, agree with him in thinking that that version (which he places, in agreement with J. Thuillier, to 1625-1626) is appreciably earlier than the Louvre painting.

After arriving in Rome in 1624, Poussin ardently admired Titian's *Bachanals* which he saw there, a factor which was to be a decisive influence on his work as is testified by the sleeping bacchante in the present painting. Though he had not, strictly speaking, 'repeated' the London composition in this work, it is nowadays thought that he did not refrain, during what was for him a somewhat difficult period, from painting many quite similiar versions of the same subject. Blunt himself accepts him as the author of the two versions of *Midas* at New York (1978, fig. 104) and there exist three signed versions of the *Nymph and Satyr drinking* at the Prado, (Rosenberg, 1977-1978, no. 9), at Moscow and at Dublin (see no. 32). The relative *'brutalité'* of the handling in these works which have often turned black through the reappearance of a dark preparatory ground, as in *Olympus and Marsyas* of the Louvre (circa 1630, reproduced in *Revue du Louvre*, 1969, no. 2, p. 87) is somewhat attenuated here, and the brushstrokes seem more fluid. Nonetheless it retains an astonishing rapidity of execution, as can be seen in the summary indication of the foliage in the middle ground, to the right, in which Blunt (1962, fig. 23) and Wild (1980, fig. p. 262) saw a sufficient argument to delete it from Poussin's *oeuvre*.

34. Acis and Galatea

98 × 137 cm.
Dublin, National Gallery of Ireland (cat. no. 814; Catalogue 1981, p. 129, reproduced).

HISTORY: Perhaps in England as early as the eighteenth century (Blunt, 1966, who quotes, hypothetically, the Bragge sale at Prestage's, 16th February 1750, lot 31 and John Knight sale, Philips, 17th March 1821, lot 24). Collection of the Earl of Spencer at Althorpe House, from 1831 (Blunt, who quotes Passavant, 1836) who sold it in 1856 to Sir John Leslie. Acquired from the descendents of the latter by Sir Hugh Lane, who bequeathed it to the Gallery in 1918.

EXHIBITIONS: 1932, London, no. 163 (*Commemorative Catalogue*, p. 33, no. 118, pl. XL); 1937, Paris, no. 111 (*Album* pl. 24); 1953, Brussels, no. 106; 1964, Dublin, no. 84; 1965, Dublin, no. 95; 1977-1978, Rome, no. 19, reproduced in its entirety and detail (and colour detail on the cover); 1978, Düsseldorf, no. 17, reproduced; 1981, Edinburgh, no. 7, reproduced.

BIBLIOGRAPHY: Lomenie de Brienne, *Discours sur les ouvrages des plus excellents peintres ...* ms. [1693-1695]: see Hourticq, 1937 and Thuillier, 1960; J. D. Passavant, *Tour of a german artist in England ...*, London, 1836, vol. II, p. 37, J. Smith, 1837, no. 239; A. Andresen, 1863, no. 386; O. Grautoff, *Nicolas Poussin*, Munich and Leipzig, 1914, vol. II, p. 258 ('perdu'); E. Magne, *Nicolas Poussin*, 1914, p. 197, no. 3; Th. Bodkin, 'Nicolas Poussin in the National Gallery, Dublin, I', *B.M.*, April 1932, pp. 174-185, cf. p. 180 and pl. IV A; L. Hourticq, *La jeunesse de Poussin*, 1937, pp. 142, 146; Ch. Sterling, exhibition note, 1937; P. Jamot, *Connaissance de Poussin*, 1948, pl. 130; Th. Bertin-Mourot, 'Addenda au catalogue de Grautoff depuis 1914', *Société Poussin*, 2nd cahier, 1948, pp. 43-54, cf. pp. 49-50 no. XXI and pl. XXI; W. Friedlaender and A. Blunt, *The Drawings of Nicolas Poussin, Catalogue raisonné*, vol. III, London, 1953, p. 36; G. Wildenstein, *Les graveurs de Poussin au XVIIè siècle*, 1957, p. 201; T. McGreevy, *Nicolas Poussin*, Dublin, 1960, reproduced; H. Bardon, 'Poussin et la littérature latine', *Colloque Poussin*, 1960, vol. I, pp. 123-132, cf. p. 127; J. Thuillier, 'Pour un *Corpus pussinianum*', *Colloque Poussin*, 1960, vol. II, pp. 39-238, cf. 214 and note 13; *The Connoisseur*, September 1960, p. 45; G. Kauffmann, 'Poussins Letztes Werk', *Zeitschrift für Kunstgeschichte*, 'vol. XXIV-1, 1961, pp. 101-127, cf. pp. 116 and fig. 114, p. 115; D. Mahon, 'Poussiniana', *G.B.A.*, 1962-II, July-August, pp. 1-138, cf. pp. 29, 53 note 164; A. Blunt, *Nicolas Poussin. A critical catalogue*, London, 1966, p. 89, no. 128; A. Blunt, *Nicolas Poussin, The A. W. Mellon Lectures in the Fine Arts 1958*, Washington 1967,

vol. II, pl. 31; D. R. Clark, 'Poussin and Yeats's "News for the Delphic Oracle",' *Wascana Review*, II, no. 1, 1967, pp. 33-44; K. Badt, *De Kunst des Nicolas Poussin*, Cologne, 1969, pp. 106, 514, fig. 63; J. Thuillier, *Tout l'oeuvre peint de Poussin*, 1974, p. 90, no. 46, reproduced p. 91 and colour pl. IX; J. White, 'Inaccessible Poussins', *Apollo*, February 1974, pp. 39-41, cf. p. 39; J. White, 'Sir Hugh Lane as a Collector', *Apollo*, February 1974, pp. 112-125, cf. p. 119 and pl. VI, 121; P. Rosenberg, exhibition note, 1977-1978 and 1978; A. Blunt, 'Poussin at Rome and Düsseldorf', *B.M.*, June 1978, pp. 421-425, cf. p. 421, 422; D. Wild, *Nicolas Poussin*, Zurich, 1980, vol. II, p. 38, no. 37, reproduced; *B.M.*, June 1982, p. 379; H. Bridgstocke, 'France in the Golden Age', *Apollo*, July 1982, pp. 8-14, cf. p. 12; H. Quinlan, *Fifty French Paintings, National Gallery of Ireland*, Dublin, 1984, p. 2, reproduced in colour.

RELATED WORKS: Engraving in the opposite direction by Antoine Garnier (1611-1694 with the dedication *Trahit sua quemque voluptas*', reproduced in Wildenstein, 1957, p. 201, no. 135, who dates it to about 1650-1660 and *Colloque Poussin*, 1960, vol. 1, fig. 245, and a line engraving after the latter by El. Lingée in C. P. Landon, *Vies et oeuvres ... Nicolas Poussin*, vol. 1, 1811, pl. 45 (pl. CXCI in the *Table of Plates*, vol. IV, 1811, ('Polyphème').

Drawing, 18.1 × 25.8 cm., Dublin, National Gallery of Ireland (cat. no. 2842; Bodkin, 1932, pl. IV B; Friedlaender and Blunt, 1953, no. A. 62; Travelling exhibition, United States, 1983, *Master European Drawings from the Collection of the National Gallery of Ireland*, pp. 112-113, reproduced). This watercoloured drawing, only has in common with the painting, the groups of the Tritons and Nereids; Polyphemus is to the right in a different posture and Galatea standing on a marine chariot in the form of a shell, with Acis beside her. It must therefore be a *Triumph* of Galatea.

Considered by Blunt (1953 and 1966) as a 'Copy of a lost drawing, but (...) more likely (...) the work of an imitator'; but accepted by Rosenberg (1977-1978) and K. Oberhuber, who believe it to be, not a preparatory drawing for the painting, but a later version of the subject (exhibition catalogue, 1983, U.S.A.).

The catalogue of the 1932 exhibition quotes 'another (drawing) at Chantilly'.

A copy of the left side, collection of Lebel-Ehrmann, Paris (Bertin-Mourot, 1948, p. 50, note 1; Blunt, 1960, 'copies 1'). A copy by Antoine Bouzonnet-Stella, in the inventory of his niece Claudine in 1697, '2 pieds environs' (Blunt, 1966, 'copies 2'). A copy in the Musée de Valenciennes (id. 'copies 3').

Along with the *Lamentation over the Dead Christ*, the deeply moving masterpiece of his last years (temporarily on exhibition in London), *Acis and Galatea* is the most celebrated of the Poussins at Dublin. In contrast to the two others (nos. 32, 35) they have never aroused controversy, so much is the evidence of genius imposed in these two pages which resound like two equally moving chants, one of love, the other of death.

The only hesitations have related to the title and the date. Since its entry into the collection, and up to about 1960, *Acis and Galatea* carried the title of the *Wedding of Thetis and Peleus*. However, this could not have been the painting of this subject painted in Paris in 1641-1642 for Cassiano dal Pozzo (*Correspondance de Nicolas Poussin*, ed. Jouanny, *A.A.F.*, 1911, p. 68; cf. Bertin-Mourot, 1948; Blunt 1966, p. 133 L. 70, lost), the Dublin painting being earlier by at least a dozen years to this period, which is that of the *Miracle of St. Francis Xavier* (Louvre) and the last *Sacraments* for dal Pozzo. Moreover, D. Wild, in a letter in the gallery files (17th June, 1975) corrected the title of the painting.

Not known to Grautoff, who refers to it only in its engraved version, the work is variously dated, between 1627, the period of the *Death of Germanicus* (Blunt, Thuillier) and 1631-1633 (Wild), while Mahon, followed by Rosenberg, place it in the middle of this period: late 1629-middle of 1631. It would thus be contemporary with *The Empire of Flora* at Dresden (1630), and *The Plague of Azdod* in the Louvre, painted in 1630-1631 in a dramatic key completely different to the idyllic picture at Dublin. This latter is in effect a vision of happiness: recounted by Ovid (*Metamorphoses,* XIII), the loves of the shepherd Acis and the Nereid Galatea are hidden from the cyclops Polyphemus — also enamoured of Galatea — by two *amorini* who deploy a large red awning. To the almost hesistant kiss of the young entwined couple, whose bodies are neatly arranged in a triangle, Poussin contrasts the vigorous embrace of the Tritons and Nereids who form, along with the *amorini* astride the dolphins, the traditional cortège associated with Galatea (cf. the painting by Perrier, no. 29). Polyphemus, turning his back, expresses his passion by playing his pan pipes: according to a principle, which he was to develop more and more, Poussin thus declines the different expressions of Love, from its birth to its most sensual manifestation to its sublimation through art. Taking up this subject again, at a much later date, in the *Landscape with Polyphemus* in the Hermitage (painted in 1649 according to Félibien, though Mahon places it about 1600), he gives it a completely different dimension, that of the harmony between Man and Nature.

35. The Holy Family with Saint Anne, Saint Elisabeth and the young Saint John, *called* The Virgin with ten Figures

79 × 106 cm.
Dublin, National Gallery of Ireland (cat. no. 925; Catalogue 1981, p. 129, reproduced).

HISTORY: Painted for Jean Pointel in 1649 (Félibien, 1685), the painting figured in the latter's posthumous inventory, 20-22nd December 1660, estimated at 400 *livres* (Thuillier and Mignot, 1978). Collection of Cerisier (or Serisier), another dealer friend of Poussin, at whose home G.L. Bernini saw the painting on the 10th August 1665 (Chantelou). Engraved in 1668. Figured in the collection of the Earls of Milltown (formed in the eighteenth century) at

Russborough, from 1826 (Wynne, 1974, caption to fig. 1), and in 1847 (exhibited at Dublin). Gift of Geraldine, widow of the 6th and last Earl of Milltown, in 1902. Restored in 1962.

EXHIBITIONS: 1847, Dublin; 1916, Dublin, no. 55; 1962, Bologna, no. 78; 1964, Dublin, no. 85.

BIBLIOGRAPHY: P. Fréart de Chantelou, *Journal de voyage du Cavalier Bernin en France*, ed. Lalanne, 1885, p. 90 (cf. ed. 1981, p. 103 and Thuillier, 1960, p. 127); A. Félibien, 4th section, 1685 (8th discussion), p. 299 (ed. 1725, IV, p. 59); F. Le Comte, vol. III, 1700, p. 37 (reprint 1972, p. 277); J. Smith, 1837, no. 81; A. Andresen, 1863, no.

139; W. Friedlaender, *Nicolas Poussin*, Munich, 1914, p. 120; O. Grautoff, *Nicolas Poussin*, Munich and Leipzig, 1914, vol. I, pp. 271-273, vol. II, pp. 208-209 (catalogue and another version reproduced); E. Magne, *Nicolas Poussin*, 1914, p. 213, no. 250; Th. Bodkin, 'Nicolas Poussin in the National Gallery, Dublin, I', *B.M.*, April 1932, pp. 174-185, cf. pp. 174 and 179, pl. II A ('School of Poussin'; numerous confusions in the text); W. Friedlaender, *The Drawings of Nicolas Poussin. Catalogue raisonné*, vol. I, London, 1939, pp. 22, no. D 2 (a) and 27 under no. 52; A. Blunt, 'The héroic and the ideal Landscape of Nicolas Poussin', *Journal of the Warburg and Courtauld Institutes*, VII, 1944, p. 161, note 3; A. Blunt, 'Poussin Studies IV: Two rediscovered late works', *B.M.*, February 1950, pp. 38-41, cf. p. 40; F. S. Licht, *Die Entwicklung der Landschaft in den Werken von Nicolas Poussin*, Bâle and Stuttgart, 1954, p. 157; G. Wildenstein, *Les graveurs de Poussin au XVII° siècle*, 1957, p. 93 under no. 55; Th. Bertin-Mourot, 'Poussin inconnu', *Société Poussin*, 2nd cahier, supplement, 1959, p. III; T. McGreevy, *Nicolas Poussin*, Dublin, 1960; A. Blunt, in exhibition catalogue, 1960, Paris: *Poussin*, under no. 86; A. Blunt, 'Poussin Studies XI: Some Addenda to the Poussin number', *B.M.*, September 1960, pp. 396-403, cf. p. 400; J. Thuillier, 'Pour un *corpus Pussinianum*', *Colloque Poussin*, 1960, vol. II, p. 127 (text of Chantelou) and note 15; D. Mahon, Réflexions sur les paysages de Poussin, *Art de France*, I, 1961, pp. 119-132, cf. p. 129 note 47; D. Mahon, exhibition note, 1962, Bologna; D. Mahon, 'Poussiniana', *G.B.A.*, 1962-II, July-August, pp. 1-138, cf. pp. 116-118 and 117 fig. 41; W. Friedlaender, *Nicolas Poussin*, 1965, pp. 60 fig. 57, 63; A. Blunt, *The Paintings of Nicolas Poussin. A Critical Catalogue*, London, 1966, pp. 43-44 no. 59; A. Blunt, *Nicolas Poussin. The A. W. Mellon Lectures in the Fine Arts, 1958*, Washington 1967, vol. II, pl. 208; M. Wynne, 'The Milltowns as Patrons ...', *Apollo*, February 1974, pp. 104-111, cf. pp. 108 fig. 11, 109; H. Hibbard, *Poussin: the Holy Family on the Steps*, London, 1974, pp. 88, 89 fig. 56; J. Thuillier, *Tout l'oeuvre peint de Poussin*, 1974, p. 105 under no. 164; A. Blunt, [review by Thuillier 1964], *B.M.*, December 1974, p. 761; C. Wright [id.], *Antologia di Belle Arti*, no. 1, March 1977, p. 177; D. Whitfield, 'Nicolas Poussin's *Orage and Temps Calme*', *B.M.*, January 1977, p. 9; J. Thuillier and Cl. Mignot, 'Collectionneur et Peintre au XVIIè: Pointel et Poussin', *R.A.*, no. 39, 1978, pp. 39-58, cf. pp. 48-49; D. Wild, *Nicolas Poussin*, Zurich, 1980, vol. II, p. 140 no. 150 reproduced; R. Verdi [review by Wild, 1980], *B.M.*, April 1982.

RELATED WORKS: Engravings (all in the opposite direction): by Claudine Bouzonnet-Stella, dated 1668, with the dedication: '*Ego Mater pulchrae dilectionis*' (Andresen, 1863, no. 139; Wildenstein, 1957, reproduced; Davies and Blunt, in *G.B.A.*, 1962, II, p. 210, no. 55; Thuillier, 1974, fig. 164a; Thuillier and Mignot, 1978, p. 49, reproduced); By Louis Moreau, before 1669 (Wildenstein, 1957, cited; reproduced in Bertin-Mourot, 1959, opposite p. III); By El. Lingée, line engraving after the two preceding engravings, in Landon, *Vies et oeuvres . . . Nicolas Poussin*, vol. IV, 1811, pl. 26 (pl. LXI *Table of plates*).

Drawing, ink and wash, 24 × 26 cm., Chantilly, Musée Condé (Friedlaender, 1939, p. 27, no. A8, pl. 74; cf. Bodkin, 1932, pl. II.B, and H. Malo, *Chantilly, Musée Condé, cent deux dessins de Nicolas Poussin*, 1933, fig. 15). This drawing which corresponds exactly to the painting, with the exception of the three children and the architecture to the right, is considered by Friedlaender (1939) to be a 'copy (...) after the picture' and by Blunt (1966, p. 43) 'a copy, probably after a lost drawing'; Wild holds the same opinion, 1980. A drawing at Stockholm, datable to circa 1649 (Friedlaender, 1939, p. 27, no. 52, and 1965, p. 63, fig. 61; Hibbard, 1974, p. 40, fig. 17; Wild, 1980, vol. II, p. 140) depicts a Virgin and Child Jesus in the same attitudes as the painting.

Copies: 84 × 108 cm., San Francisco, M. H. De Young Memorial Museum (exhibition 1960, Paris: *Poussin*, no. 86, reproduced). The reservations expressed by Blunt in the catalogue are justified by the mediocrity of the painting which, recognised as a copy, was hung in second rank (cf. J. Thuillier, 'L'année Poussin', *Art de France*, I, 1961, p. 339; Blunt, 1966, p. 43, 'copies 1'). 78 × 100 cm., private collection in Paris in 1914 (Friedlaender, 1939, mentions this version as being in the collection of Lerolle, who, we know possessed the *Madonna of the Steps*: is it by confusion? From 1932, Bodkin gave the same provenance to the Dublin painting, against all likelihood). Grautoff, who published and reproduced this painting (1914), gives the following history for it: passed in 1793 from the abbey of the Ferté-sur-Grosne, near Chalon-sur-Sâone (Saône et Loire) (all these names are distorted by Grautoff) in the collection of the mayor du Creusot, and remained in the family of his descendants until 1913, before passing into a Parisian collection. The photograph (by Lemare) reproduced by Grautoff shows that it consists of a copy (Blunt, 1966, p. 43: 'copies 2'). Bodkin (1932) refers to a copy in the Musée de Tours which seems to have never existed.

'Puis, voyant la *Vierge* a dix figures, j'ai (Chantelou) dit que tout me plaisait dans ce tableau hors la tête de la Vierge. Il (Bernini) a demandé de qui il était, demande qui m'a surpris: j'ai dit 'du Poussin', il a repondu qu'il ne l'eût pas cru, que ce n'était pas lui sans doute qui avait fait ces enfants'. ('Then seeing the *Virgin* with ten figures, I (Chantelou) said that everything in this painting pleased me apart from the head of the Virgin. He (Bernini) asked who was it by, a request which surprised me: I said 'by Poussin', he said that he would not have believed it, that it was unlikely that it was he who had made those infants'). This surprising dialogue between the great Italian sculptor and his French *Cicerone,* Chantelou, reported by the latter, shows to what extent Poussin's work could disconcert the most knowledgeable connoisseurs, only three months before the death of the artist. The intentional archaism of the painting, noticeable through the engravings, surprises even today, and perhaps explains certain reticences (Bodkin, 1932, though only expressed in the description accompanying the reproduction; Thuillier, 1974 and 1978; Wild, 1980). Blunt, who exhibited the San Francisco version in 1960, while noting in the entry for that picture that the one in Dublin was 'perhaps superior', clearly declared the latter as the original (*B.M.* 1960), and catalogued it only under this title (1966). Reaffirmed in 1974, this opinion goes back to that expressed in 1931 by Jamot (letter in the Gallery files) and Friedlaender (id., and 1939, 1965). For his part D. Mahon, pronounced vigorously in favour of the Dublin canvas in 1961 and has since twice reinforced this position in 1962, after the cleaning of the picture, underlining the high quality of the painting and the existance of a *pentimento* in the head of St. Anne, which is in fact visible to the naked eye: the white cloak which covers it making it smaller. These arguments appear to us entirely convincing, and the two other versions being manifestly copies, the Dublin canvas is evidently the painting executed for Pointel in 1649.

Let us remember that this merchant, quite friendly with Poussin, so much so that the artist was to send him his self-portrait (1649, Berlin), possessed no fewer than twenty pictures by the artist, which were listed in his inventory after his death in 1660 (published and discussed by Thuillier and Mignot, 1978), many of which belonged to the same years as the *Holy Family* in Dublin: *Moses saved from the Waters,* of 1647, *Eliezer and Rebecca* of 1648, the *Judgement of Solomon* of 1649, the *Landscape with Orpheus and Eurydice* about 1650, all in the Louvre, the *Storm* (Rouen) and *The Tranquil Landscape (Le Temps Calme,* Morrisson collection) of 1651.

To the acid colouring, which relates the painting to the *Judgement of Solomon,* is to be added the fact that the six infants are identical to those in two Holy Family pictures of a similar dating: that called *With a Bathtub* in the Fogg Museum (1650, *cf.* Rosenberg, 1982, no. 93) and that called *'with the eleven figures* painted for the Duc de Créqui in 1651, formerly at Chatsworth and at the Norton Simon Museum in Pasadena since 1981 (Mahon, 1962), which suffices to negate the remark of Bernini in 1665. . . . Regarding the head of the Virgin, which did not please Chantelou, it in fact expresses admirably, in its very unrealism, the serene meditation of the mother of Christ conscious of her mystical role. Her far away look — as in a statue — her immobility, her palid complexion, turning slightly crimson, between the crossed gazes of Joseph, Anne and Elizabeth and the homages rendered to her son by the small praying St. John and the little Angels offering flowers, place her outside of time. Like the *Holy Family of the Steps,* the masterpiece of this period in this type of composition, executed in 1648, *The Virgin with Ten Figures* derives from Raphael, notably the *Madonna of the Fish* in the Prado, it places the accent on the role of the Virgin as intercessor between God and humanity (*cf.* Hibbard, 1974).

Finally, one must note the importance of the landscape, a theme which Poussin himself studied more closely and developed from this period on (*Orpheus, Phocion*). It is very similar in its right hand portion to that in the *Holy Family* in the Fogg Museum with its

many structures, its blocks of stone in the foreground, it composes a grey monochrome setting which projects to the front the group of figures where the three primary colours and the white, sonorous tones which are echoed by the deep purple robe of the Virgin, dominate.

36. Coriolanus won over by his Wife and his Mother

119 × 199 cm.
Les Andelys, Musée municipal.

HISTORY: Collections of the Marquis de Hauterive (about 1584-1670) (Félibien, 1685); of the 'Fermier général' Bouret (Dézallier d'Argenville, 1757); of the 'Trésorier de la Marine' Simon-Charles Boutin from whom it was seized during the Revolution in 1794 (Furcy-Raynaud, 1912; Thuillier, 1960, II, p. 41). Musée du Louvre. Intended for the town of Andelys by consular decision on the 10th April 1800, it was sent in 1802 to the prefecture of the Eure at Evreux, then in 1832 to the Hôtel de Ville at Andelys (Hoog, 1969); for a while at the Palais de Justice of this town (exhibition 1961), then at the museum. Restored in 1964.

EXHIBITIONS: 1934, Paris, no. 271; 1961, Rouen, no. 85; 1977-1978, Rome, no. 37 reproduced in its entirety and detail; 1978, Düsseldorf, no. 36, reproduced.

BIBLIOGRAPHY: G. B. Bellori, *Le vite de'pittori, scultori ed architetti moderni ...*, Rome, 1672, p. 450 (cf. ed. Boréa, 1976, p. 466 and Thuillier, 1969, p. 87); A. Félibien, *Entretiens ...*, 4th section, 1685, p. 399, (8th *Entretien*; ed. 1725, vol. IV, p. 152); Lomenie de Brienne, (ms.), 1693-1695: see Hourticq, 1937 and Thuillier *(Corpus)* 1960; F. Le Comte, vol. III, 1700, p. 38; Dézallier d'Argenville, *Abrégé ...*, 1745, vol. II, p. 254; ed. 1762, vol. IV, p. 39; C. P. Landon, *Vies et Oeuvres ... Nicolas Poussin*, vol. III, 1809 (1811), pl. 23 (pl. CXXXVIII de la *Table des planches*, vol. IV, 1811, p. 9: 'La colère de Coriolan'); H. Fuseli, *Lectures on Painting . . .*, London, 1820, pp. 74, 144, 163; J. Smith, 1837, p. 93, no. 173; A. Andresen, 1863, p. 80, no. 322-325; M. Furcy-Raynaud, 'Les tableaux et objets d'art saisis chez les émigrés et condamnés et envoyés au Muséum Central', *A.A.F.*, 1912, p. 259; W. Friedlaender, *Nicolas Poussin*, Munich, 1914, p. 80, 126; O. Grautoff, *Nicolas Poussin . . .*, Munich and Leipzig, 1914, vol. I, p. 136, vol. II, p. 110, no. 68, reproduced p. 111; E. Magne, *Nicolas Poussin*, Brussels and Paris, 1914, p. 199; P. du Colombier, *Poussin*, 1931, p. 7, pl. 22; L. Hourticq, *La jeunesse de Poussin*, 1937, p. 43; A. Blunt, *The French Drawings in the Collection of his Majesty the King at Windsor Castle*, Oxford and London, 1945, p. 53, under no. 280; W. Friedlaender, *The Drawings of Nicolas Poussin. Catalogue Raisonné*, London, vol. II, 1949, p. 13, no. A.31, and pl. 121; W. R. Merchant: 'A Pousin "Coriolanus" in Rowe's 1709 Shakespeare', *Bulletin of the John Rylands Library*, Manchester, XXXVII, 1954, p. 13; F. S. Licht, *Die Entwicklung der Landschaft in der Werk von Nicolas Poussin*, Bâle and Stuttgart, 1954, p. 117; G. Wildenstein, *Les graveurs de Poussin au XVII°s*, 1957, p. 174, no. 113; A. Blunt, exhibition catalogue, *Poussin*, Paris, 1960, p. 117; under no. 87; *Nouvelles de l'Eure*, May 1960, no. 5 ('Les Andelys, Patrie de Nicolas Poussin'), reproduced in colour; H. Bardon, 'Poussin et la Littérature latine', *Colloque Poussin*, 1960, vol. I, pp. 123-132, cf. p. 128; J. Thuillier, 'Tableaux attribués à Poussin dans les inventaires révolutionnaires', ibid., 1960, vol. II, pp. 27-44, cf. p. 41 no. 29; Id., 'Pour un *Corpus Pussinianum*', ibid., 1960, vol. II, pp. 49-238, cf. p. 224 (text by Lomenie de Brienne); P. Rosenberg, exhibition note, 1961; D. Mahon, 'Poussiniana', *G.B.A.*, 1962-II, July-August, pp. 1-138, cf. pp. 119 note 350, 134; W. Friedlaender, *Nicolas Poussin*, 1965, p. 64; A. Blunt, *The Paintings of Nicolas Poussin. A Critical Catalogue*, London, 1966, pp. 106-107 no. 147; A. Blunt, *Nicolas Poussin, The A. W. Mellon lectures in the Fine Arts 1958*, Washington, 1967, vol. I, pp. 161, 171, vol. II, pl. 174; M. Hoog, 'Notes sur la politique du Premier Consul à l'égard des musées de Province', *A.A.F.*, 1969, pp. 353-363, cf. p. 353 note 1; J. Thuillier, *Nicolas Poussin*, Novarre, 1969, pp. 87 (text of Bellori), 131-132, pl. 85 (after restoration); K. Badt, *Die Kunst des Nicolas Poussin*, Cologne 1969, vol. I, pp. 61, 66, 71, 74; J. Thuillier, *Tout l'oeuvre peint de Poussin*, 1974, p. 109, no. 183, reproduced; P. Rosenberg, exhibition note, 1977-1978 Rome and 1978 Düsseldorf; D. Wild, *Nicolas Poussin*, Zurich, 1980, vol. I, pp. 127, 204, vol. II, p. 142, no. 152, reproduced; M. Fumaroli, 'Muta Eloquentia: la représentation de l'éloquence dans l'oeuvre de Nicolas Poussin', *B.S.H.A.F.*, 1982 (1984), pp. 29-48, cf. pp. 38-39, reproduced p. 39, fig. 11.

RELATED WORKS: A small anonymous copy was inventoried in 1693 in the collection of Claudine Bouzonnet-Stella (J. J. Guiffrey, in *N.A.A.F.*, 1877, p. 37; Ch. Sterling, in *Colloque Poussin*, 1960, vol. I, p. 272).

Engravings by Etienne Baudet, at Rome, after

1665 (Andresen, 1863, no. 323; cf. Thuillier, 1969, p. 131); by Benoit and Gérard Audran, in two plates (Chalcographie du Louvre, no. 1222; Andresen, no. 322; cf. Damiron, in *Colloque Poussin*, 1960, vol. II, p. 13); by B. Picart, after the engraving of Audran (Andresen, no. 324); by an anonymous engraver, at 'Giacomo Billy in

Roma', (id., no. 325); by Mme. Soyer in Landon (1809).

Drawing (copy of a drawing by Poussin, or an original drawing in ink over chalk outine ?), Windsor Castle, inv. 11891 (Blunt, 1945, p. 53, no. 280; Friedlaender, 1949, p. 13, no. A.31, reproduced pl. 121).

Despite his victory over the Volscians, Gnaeus Marcius Coriolanus, a Roman general, was refused the consulship and banished by the Tribune of the plebeians. To take his revenge he became leader of these enemy people, and besieged Rome. After many appeals, his mother Volumnia and wife Veturia begged him not to take up arms against his own country and assuaged his pride. The story (which ends with the assassination of Coriolanus by the Volscians), is told by Titus-Livy (*Histories,* II, 40) and Plutarch (*The Life of Coriolanus,* XII, 134), and also inspired a tragedy by Shakespeare (about 1607). Poussin makes of it the 'most ingenious' (Bellori) subject of one of his least known paintings, (despite its importance): sent by the Louvre in 1802 to the artist's birthplace, it has in fact only figured in a few exhibitions, two of which were organised by P. Rosenberg in 1961 and 1977.

The frieze-like composition, which gives greater emphasis to the more important figures, is reminiscent of *The Death of Germanicus* (1627, Minneapolis) though here, the eloquence of the gestures is pushed to extremes. The exhortations of Veturia, and even those of her child, which she holds in her arms, and of Volumnia at the centre of the painting, provoke the submission of Coriolanus, who symbolically returns his sword to its sheath. It is the heart of the action, made manifest by the diagonal of the sword opposing the arms of the two women. Nonetheless, it is not these last who look at Coriolanus, but a figure standing at the extreme left of the composition, a woman in arms, with naked breast, whose ornate helmet is a pendant to his own: she is the allegory of Rome, visible to him alone, who recalls him to his duty. At her feet, Fortune, leaning on her wheel, lies on the ground, signifying the state of abandon in which Rome finds itself when deserted by its defenders (Bellori). A dual 'commentary' is provided by the four imploring Roman women, to the left (where M. Fumaroli, 1982, identifies, standing turned towards Rome, Valerie, who provoked the encounter) and to the right by Coriolanus' companions in arms, one of whom contemplates the attitude of their leader, the other trys to understand him. The moral of the painting, Pride held to ridicule which through filial piety renounces its vengence, and reverts to patriotic sentiments, can thus be clearly 'read' and through the interplay, at once intellectual and formal of the 'representation', it assumes an exemplary force.

The almost brutal 'primitivism' of the work, which in itself is in keeping with the evocation of early Roman history, implies a long period of maturation of reflection on the dramatic effectiveness of forms, all of which denies the acceptance of a precocious dating (about 1635 to 1639) as proposed by Grautoff (1914). The relationship of the work with the second series of the *Sacraments* has led to its being dated to the middle (Mahon, 1962) or to the end (Blunt, 1966) of the 1640's. Most probably it should be placed to about 1650-1652, to the time of the *Fronde des Princes* in France, the civil war to which it may make an allusion (Thuillier, 1974), and it should be linked stytisically, as does P. Rosenberg (1977-1978), to the *Moses saved from the Water* in the Schreiber collection, painted, according to Félibien, in 1651, and to *The Woman taken in Adultery* of 1653 at the Louvre. It can no longer be seen (as has Blunt, quoted by Rosenberg, 1961) as the pendant to the *Continence of Scipio* at Moscow (116 × 150 cm.) which we now know was painted as early as 1640.

37. The Death of Sapphira

122 × 199 cm.

Paris, Musée du Louvre (inv. 7286; Catalogue 1974, no. 680, reproduced).

HISTORY: Collection of J. Fremont, seigneur de Venne, according to the dedication on the engraving by Jean Pesne, prior to 1685; the first name, latinised and abreviated to 'Jan', can only be Jean. Félibien (1685) wrote 'Froment de Veines', and the variations go from 'Fornant de Veynes' (Smith, 1837) to 'Jean Froment de Veine' (Rosenberg, 1977-1978). Sold for 5,500 *livres* in 1685, by the artist and art dealer Louis Hérault, to Louis XIV, at the same time as the *Judgement of Solomon,* 5,000 *livres.* At the Château Neuf of Meudon in 1706 and 1709; at the 'Surintendance des Bâtiments' at Versailles in 1760 and 1784 (Engerand, 1899). Restored in 1792 (Tuetey and Guiffrey, 1909). Exhibited in the Louvre at the opening of the Museum in 1793 (cat. no. 459).

EXHIBITIONS: 1960, Paris: *Poussin,* no. and pl. 106; 1961, Rouen, no. 89; 1964-1965, Dijon, Lyons, Rennes, no. 35 (with *erratum*); 1977-1978, Rome, no. 38, reproduced in its entirety and detail; 1978, Düsseldorf, no. 37, reproduced, pl. in colour p. 73; 1982, Peking, Shanghai, no. 8, reproduced; 1983-1984, Paris, no. 205, reproduced 287.

BIBLIOGRAPHY: G. B. Belori, *Le Vite ...,* Rome, 1672, p. 454 (cf. Boréa edition, 1976, pp. 470-471 and Thuillier, 1969, p. 89); A. Félibien, *Entretiens ...,* 4th section, 1685, p. 399 (8th 'entretien'), ed. 1725, vol. IV, p. 152; F. Le Comte, vol. III, 1700 (1st section) p. 38 (reprinted 1972, p. 277); Dézallier d'Argenville, *Abrégé ...,* 2nd ed. 1762, vol. IV, p. 39; Filhol and Lavallée, vol. X, 1815, 115th issue, pp. 1-2, pl. I (no. 685); C. P. Landon, *Vies et Oeuvres ... Nicolas Poussin,* vol. IV, 1811, pl. 32 (and *Table of plates,* p. 8, pl. CXVIII); H. Laurent, vol. I, 1816, section 'Histoire', text and pl. without no.; C. P. Landon, vol. III, 1832, pp. 38-39, pl. 18; J. Smith, 1837, pp. 80-81, no. 149; A. Andresen, 1863, pp. 58-59, nos. 217-221; L. de Veyran, 10th series, 1877, 96th issue, reproduced; J. J. Guiffrey, *Comptes des Bâtiments du Roi,* vol. II, 1887, columns 587 and 664; E. Bonnaffé, 1884, p. 116; F. Engerand, 1899, p. 304; Tuetey and Guiffrey, 1909, pp. 16, 76, 315, 404; W. Friedlaender, *Nicolas Poussin,* Munich, 1914, pp. 88-89, 126; O. Grautoff *Nicolas Poussin,* Munich and Leipzig, 1914, vol. I, p. 277, vol. II, p. 232 no. 149, reproduced; E. Magne *Nicolas Poussin,* 1914, p. 211 no. 220; P. Alfassa, 'Poussin et le paysage', *G.B.A.,* 1925-I,

May, pp. 265-276, cf. pp. 272, 274; A. F. Finberg, *The Life of J. M. W. Turner,* Oxford, 1939, p. 89 (text of Turner); A. Gide, *Poussin,* 1945, no. 31, reproduced in its entirety and detail; P. Jamot, *Connaissance de Poussin,* 1948, p. 81; A. Blunt, "Poussin Studies IV: Two rediscovered Late works', *B.M.,* 1950, pp. 38-41, cf. p. 40, and fig. 9; F. S. Licht, *Die Entwicklund der Landschaft ...,* Bâle, 1954, p. 145; G. Wildenstein, *Les graveurs de Poussin du XVIIe siècle,* 1957, pp. 122-123, no. 75; L. Réau, vol. III, 3, 1958, p. 1088; A. Blunt, exhibition note, 1960; M. Hours, 'Nicolas Poussin. Etude radiographique ...', *Bulletin du laboratoire du Musée du Louvre,* no. 5, November 1960, pp. 3-39, cf. pp. 27-29, fig. 19, 21 (radiography reproduced); P. Rosenberg, exhibition note, 1961; D. Mahon 'Poussiniana', *G.B.A.,* 1962-II, July-August, pp. 1-138, cf. p. 120; W. Friedlaender, *Nicolas Poussin,* 1965, pp. 67-68, fig. 68; A. Blunt, *Nicolas Poussin. A Critical Catalogue,* London 1966, pp. 58-59 no. 85; A. Blunt, *Nicolas Poussin. The A. W. Mellon Lectures in the Fine Arts 1958,* Washington, 1967, vol. I, pp. 301-303, vol. II, pl. 220-221; J. Thuillier, *Poussin,* Novarre, 1969, pp. 89 (text of Belori), 133 and pl. 89-90; K. Badt, *Die Kunst des Nicolas Poussin,* Cologne, 1969, vol. I, pp. 368, 569, vol. II, pl. 170; J. Thuillier, *Tout l'oeuvre peint de Poussin,* 1974, pp. 108-109, no. 191, reproduced and colour pls. LI-LIII; A. Pigler, 1974, vol. I, p. 388; D. Wild, *Nicolas Poussin,* Zurich, 1980, vol. I, pp. 162-163, reproduced in colour, p. 163, vol. II, p. 166 no. 179, reproduced; P. Rosenberg, exhibition note, 1977-1978 and 1978; M. Vasselin and J. P. Cuzin, exhibition note, 1983-1984; M. Fumaroli, 'Muta Eloquentia ...', *B.S.H.Á.F.,* 1982 (1984), pp. 29-48, cf. p. 43 and 42, fig. 17.

RELATED WORKS: Engraving by Jean Pesne, with the dedication: '. . . ex Musaeo Jan. Fremont D. de Venne', therefore prior to 1685 (reproduced in Wildenstein, 1957, who itemizes a second state subsequent to the painting entering the royal collection, and the various copies of this engraving: anonymous engraver, at Vallet, in Paris; by F. Andriot; by L. Audran). Line engraving by Mme. Soyer in Landon, 1811. Engraving by Queverdo and Bovinet in Filhol and Lavallée, 1815. Engraving by R. U. Massard in Laurent, 1816, re-used in Veyran, 1877. Line engraving by C. Normand in Landon, 1832.

Drawing in the collection of Jacob Isaacs, London (exhibition 1960, Paris, no. 230). Drawings in the Musée Fabre, Montpellier, and in the Musée d'Orleans (?).

The *Acts of the Apostles* tell us that, soon after the Pentecost and the first miracles of Saint Peter, the apostles received gifts from the populace which took care of all their needs.

Ananias and his wife Sapphira had thus brought their offering, though withholding for themselves part of the money which they claimed to have fully paid. Saint Peter successively proved them both guilty of lying and, for wishing to deceive God, Ananias, then Sapphira, each fell dead on the instant (Acts, V, 1-11).

A great admirer of Raphael, Poussin with this painting rivals the celebrated *Death of Ananias* which Raphael executed for the tapestry of *The Acts of the Apostles* at the Vatican. For Raphael's tripartite design, Poussin has substituted a composition on a single plane contrasting the moral sternness of the Apostles with the weakness of the first christians: these latter, surrounding the woman struck dead, express diverse feelings: ranging from compassion for the victim to terrified distrust towards the judges, from astonishment to flight. The architectural structure, one of the most 'scenographic' ever conceived by Poussin, is a landscape of stone, the tragic rigour of which is called for by the nature of the drama which takes place there. At the centre of the composition, in the middle-distance, a man gives alms to a beggar, and this simple gesture of charity acts as a counterpoint to the avarice for which Sapphira is punished at that same moment.

Strongly coloured in its figures, to sustain the grey of the architecture, this painting is of the same dimensions as the *Woman taken in adultery* painted for Le Nôtre in 1653 (Louvre), and to which it has often been compared, the one portraying forgiveness, the other punishment. Its precise date is unknown: Félibien places it between the works of 1646 and 1653, which Grautoff also retains; Blunt and Thuillier date it to 1654-1656, Wild to 1653-1654, while Mahon and Rosenberg both agree on dating it to about 1652, and so making it the first of the three 'town-scapes', prior to *The Women taken in Adultery* of 1653 and to the *Saint Peter and Saint John healing the Cripple* of 1655 (New York).

Antoine Rivalz

Toulouse, 1667 — Toulouse, 1735

A pupil of his father Jean-Pierre Rivalz (1625-1706), who knew Poussin in Rome, Antoine Rivalz spent a short time in Paris, where he took lessons at the Académie Royale, before moving to Rome, where he lived for twelve years or so (c.1688-1701). There he frequented the studios of Carlo Cignani, Giacinto Brandi and Cirro Ferri. A protégé of Cardinal Albani, the future pope Clement XI, in 1694 he won a second prize at the Academy of St. Luke. After his return to Toulouse, where he founded an academy in 1726, he was made 'peintre de la Ville' there from 1705 until his death. He had Pierre Subleyras as a pupil.

Best known today for his realist portraits (The Apothecary, Toulouse) Rivalz was first and foremost a great history painter. His provincial location meant that he was only loosely in touch with the evolution of painting in Paris and the works of this contemporary of Antoine Coypel (born in 1661) made use of the Caravaggesque heritage (The Death of Cleopatra, Narbonne and Dijon, Musée Magnin) as much as the lessons of Poussin (no. 38) and Le Brun. Like Bourdon, and above all like Blanchet, another painter who settled in the provinces on his return from Rome, Rivalz, far from Paris, developed a highly original art, which did not choose between classicism and baroque, but passed from one to the other, sometimes even fusing the languages as in his striking Allegory in homage to Poussin, engraved in 1700 (Wildenstein, Les Graveurs de Poussin au XVIIe siècle, 1957, p.3, fig. 1), which recalls the prints of Pietro Testa.

38. Cassandra dragged by her Hair out of the Temple of Pallas —*sketch*

53.5 x 65.2 cm.
Dijon, Musée des Beaux-Arts (J. 58; Catalogue 1968, no. 197, 'Ecole de Louis David, *Les Horaces et les Curiaces*').

HISTORY: An inscription by the hand of Albert Joliet, on the back of the frame, notes: 'Horaces et Curiaces par David' and the provenance: 'Vente du Mesnil, Brazey, 1902' and 'no. 36' (of this sale ?). Don Albert Joliet, 9th September 1925 (attributed to David). Identified in 1978.

BIBLIOGRAPHY: A. Schnapper, 'Morceaux choisis d'époque Louis XIV', in *La donation Suzanne et Henri Baderou au Musée de Rouen, peintures et dessins de l'Ecole*

française, 1980 (*Etudes de la Revue du Louvre*, no.1), pp.53-58, cf. p.58 and fig.20.

RELATED WORKS: Preparatory drawing, squared, 37 x 50 cm., Toulouse, Musée Paul-Dupuy (inv. 134; Catalogue by R. Mesuret, 1958, no. 132, reproduced). Another drawing, 41 x 54 cm., acquired in 1981 by this museum with an important group of drawings by the artist, is reproduced in *La Chronique des Arts*, supplement to *G.B.A.*, March 1982, p.7, no. 37.

Painting of final version, 97 x 135, Rouen, Musée des Beaux-Arts (Schnapper, 1980, p.58, fig.19).

In the second book of Virgil's *Aeneid*, Aeneas tells of the capture of Troy and describes Cassandra, the daughter of Priam, dragged out of the sanctuary of Pallas by the Greeks, among them Ajax, and defended by Corebes and other Trojans. Rivalz, who in Rome painted a *Death of Priam*, intended for his father, devoted to this composition two drawings full of vigour and the sketch, exhibited here, which were all preparatory to the painting at the Musée de Rouen. Without as yet being able to exactly determine its date, this work, incontestably by Rivalz, bears witness to his complex culture, which was nurtured by

Roman memories and characterised by references to Poussin (the figure of Cassandra). The originality of its composition, with its great voids, its clearly legible action which is in effect reminiscent of David's *The Oath of the Horatii*, did not permit it to be placed in Lemoyne or Watteau's epoch. It is remarkable that the Dijon sketch was kept hidden under an attribution to the School of David, just as the Rouen painting was under the name of the Neo-classical Suvée at a sale in 1977, where Henri Baderou identified it before offering it to the Museum.

This double error is in itself revealing:- on one hand it testifies yet again to the Neo-classical debt towards the seventeenth century, and on the other, it proves that the classical tradition of the seventeenth century was kept alive even though the dominant taste had changed at the time, and not just among the provincials like Rivalz, as is seen in the case of the Parisian Henri de Favanne (1668-1752), his exact contemporary (Schnapper, 1980).

Jacques Stella

Lyons, 1596 — Paris, 1657

Son of the painter François Stella, of Flemish origins (Stellaert), Jacques Stella passed the first twenty years of his life at Lyons. Possibly he was the student of Horace Le Blanc, who had returned from Italy around 1610 and who was then the most renowned painter in the city. He himself stayed in Florence for a number of years, beginning in 1616, where he worked for the Grand Duke of Tuscany and where he may have met Poussin. It was in Rome, where he spent twelve years (1623-1634) that he began a long friendship with the latter who in 1639 painted for him the Venus arming Aeneas *now in Rouen. Contrary to his traditional reputation, however, Stella was not in any way an imitator of Poussin.*

The success of his religious decorations and above all of his small, highly finished paintings, frequently on marble or lapis-lazzuli, in the Florentine fashion, or on copper, earned him the favour of Collectors and the protection of Cardinal Barbarini (who gained his release from prison) and we know that he even considered establishing himself in Spain where he had been called by Philip IV.

He returned to France in the company of the Ambassador, Le Maréchal de Créqui, in 1634, passing through Venice and Lombardy, stopping on the way in Lyons in 1635 (The Adoration of the Angels, Lyons) where he returned on a number of occasions, in 1639, 1642 – and finally reached Paris where Richelieu retained him in his service (works at the Palais Cardinal and at the château of Richelieu) with the title of 'Peintre du Roi', a pension of 1,000 livres and rooms in the Louvre. He also received the Ordre de Saint-Michel, *an exceptional honour for a painter.*

*His activity as an engraver (dating from his stay in Florence where he must have known Callot) and as a designer of illustrations is considerable, notably with the frontispieces for editions printed by the Imprimerie Royale at the Louvre (*Oeuvres de saint Bernard, *1640, engraved by Mellan) and the very celebrated* Pastorales *engraved by his niece Claudine Bouzonnet-Stella.*

When Sublet de Noyers, Superintendant of Buildings, had the Noviciate Church of the Jesuits decorated, the three altarpieces were entrusted to Poussin, then in Paris (1640-1642), Vouet and Stella, who thus found himself placed on the same level as the two most illustrious painters of the time: his Christ among the Doctors *is preserved in the Church of Notre-Dame at Les Andelys, the birthplace of Poussin, whose* St. Francis Xavier *is now in the Louvre. The altarpiece by Vouet, destroyed, was engraved (M. Fumaroli reproduced the three works in Rosenberg, 1982, p.15.*

Though he did not do large scale decorations, as Vouet and Blanchard had done, Stella participated, along with Champaigne and Poerson, on the tapestries depicting The Life of the Virgin *for Notre-Dame (the cartoon for the* Marriage of the Virgin *is at Toulouse). He also worked for numerous Parisian and provincial churches. His large religious pictures, with their cold colouring, their rigorous plasticity, and their voluntary restraint, contrast with the decorative exuberance of Vouet and tie him closely to La Hyre and Le Sueur.*

It has often been noted how much his paintings prefigure Neo-classicism: this is evidently because they were the admired models of David's generation. Stella had, besides, often tackled classical subjects: beginning in 1621, in Florence, he painted Lucius Albinus and the Vestal Virgins *(Hermitage, Leningrad; reproduced by J. Thuillier in* Colloque Poussin, *1960, vol. I.*

fig. 65) which calls to mind Benjamin West or Bénigne Gagneraux, and his Judgement of Paris *of 1650 (Hartford; reproduced in Rosenberg, 1982, no. 102), derived from Raphael, was an ancestor to Girodet.*

39. Cloelia crossing the Tiber

137 × 100 cm.
Paris, Musée du Louvre (inv. 7970; Catalogue 1974, no. 777, reproduced).

HISTORY: Royal collection at the Palais de Saint-Cloud before the Revolution (Lavallée, 1804, p.3). At Versailles in 1802. At Paris, Galerie du Sénat. At the Palais de Saint-Cloud in 1804, in the apartment of General Duroc, governor of the palace (it was then called 'de l'ancienne collection de Saint-Cloud', cf. Meyer, 1969); still there in 1816. In 1839 passed to Fontainebleau. Returned to the Louvre in July 1967. Relined in 1952 and restored in 1983-84.

EXHIBITIONS: 1948, no. 114; 1956-1957, Rome, no. 287; 1961, Rouen, no. 123.

BIBLIOGRAPHY: *Le Musée Français*, vol. 1, 1803, 3rd section, text and pl. without no.; Filhol and Lavallée, vol. II, 1804, 20th issue, pp. 1-3, pl. I (no. 115); L. de Veyran, 2nd series, 1877, 16th issue, reproduced; Ch. Sterling, exhibition note, 1956-1957; J. Thuillier, "Poussin et ses premiers compagnons français à Rome", *Colloque Poussin*, 1960, vol. I, pp. 72-116, cf. p. 109 note 138; P. Rosenberg, exhibition note, 1961; J. Thuillier, 1964, p. 68, reproduced in colour p. 64; P. Rosenberg, 1966, p. 124, under no. 124; G. Bernier, 'La rénovation de la grande Galerie', *L'oeil*, no. 166, October 1968, p. 12, fig. 2; D. Meyer, 'Les tableaux de Saint-Cloud sous Napoléon 1er', *A.A.F.*, 1969, pp. 241-271, cf. pp. 254, 268; M. Praz, *Mnémosyne*, 1970, p. 117, reproduced; A. Pigler, 1974, vol. II, p. 380.

RELATED WORKS: Engraving by Massard the elder in *Le Musée Français*, 1803, re-used in Veyran, 1877; by Villerey in Filhol and Lavallée, 1804.

Among the characteristics of the heroism which marked the beginnings of the Roman Republic, that of Cloelia figures alongside those of Mucius Scaevola and Horatius Cocles (two subjects painted by the young Le Brun, Mâcon and Dulwich College). During the fighting which brought Rome into conflict with Tarquin, the dethroned Etruscan king who was attempting to regain power with the help of Porsena, a truce occured between the two camps during which the consul Valerius Publicola handed over to the Etruscans twenty hostages chosen from the most noble Roman families. Cloelia, one of the ten young girls designated, took advantage, while bathing, to cross the river Tiber with her companions to return to the Roman camp in violation of the peace treaty. Publicola returned them to the Etruscans, but Porsenna, taken by Cloelia's courage, gave freedom and a horse to her and half of her companions. An equestrian statue in her honour was erected in Rome, above the *Via Sacra*.

Stella's painting follows Plutarch's narrative *(Life of Publicola XXV)*, according to whom 'some say that Cloelia crossed (the river) by horse, reassuring and encouraging the others who swam across by her side' rather than that of Titus-Livy *(Roman History, II, 13)* who states that Cloelia swam across the river. In the seventeenth century, this story found new favour with Madeleine de Scudery's novel, *La Cloelie* which appeared in ten volumes from 1654 to 1661, celebrated among the society of the *'précieuses'* (the famous *'Carte du Tendre'* appears in it).

Painted about 1635-1645, according to P. Rosenberg (1966), Stella's painting also adorns the Roman story with the charms of a refined preciousness:- though he observes 'Une parfaite imitation de l'antique' ('a perfect imitation of the antique', Lavallée, 1804) in his study of the clothes, the very elaborate hairstyles, and in the proud expression of Cloelia as she helps her faltering companions, in the purity of the 'greek' profiles, his painting has besides the grace of a 'women bathers' as represented in the mannerist tradition. The figures are of an importance unusual in Stella's *oeuvre*, with the landscape

reduced to a tree and the evocation of Rome represented by the Antonine Column . . . The recent cleaning of the painting has restored its chromatic finesse, playing with cold and clear harmonies, which are tempered to the right by the beautiful reflection lighting up the figure of a young girl. Monumental in its composition, it bears up to — and calls for — a closer examination, by the very subtle description of details in the costume (braids, hair ribbons): this elegance and the discrete eroticism, allied with an apparent coldness, are distinctive characteristics of Stella's style, who here gives us one of the most perfect examples of the Parisian 'Attic' manner.

Jean Tassel

Langres, c.1608 — Langres, 1667

For a long time confused with his father Richard, who lived until 1660, Jean Tassel is today recognised as one of the most original of the provincial artists of the seventeenth century. He was among those who wished to know Italy and he is recorded in Rome in 1634. Charles Sterling has underlined that this was the period when Sébastien Bourdon was also there, a factor which imposed a rapprochment between these two painters who shared a remarkable diversity of expression. Like Bourdon, he was subjected to the influence of both Pieter van Laer, which is testified to by his 'Bambocciate' such as The Marauding Soldiers (Langres) and of classicism as represented by Poussin. His art, however, seems to have drawn on all sources, from Venice to Bologna to Naples etc., and after his return to France (after 1647) he nourished his abundant production as much with his Italian memories as with the models offered by engravings. He also kept himself informed of the Parisian art of his time, imitating Vouet and La Hyre, while not hesitating to appropriate virtually an entire composition engraved by Claude Mellan to create his Guardian Angel (Dijon).

Equally tackling altarpieces (Adoration of the Magi, Dijon), small devotional pictures, genre scenes and portraits, Tassel's provincial clientèle, which extended to Champagne and Burgundy, was diverse. The most fascinating of these works was the portrait of Catherine de Montholon (Dijon, reproduced in colour in Thuillier, 1964, p. 26), the mother superior of the Ursulines at Dijon, which once decorated the convent there.

With this composite culture and this multiform activity, Tassel possessed a style which was very much his own: the contrasting light, of a Carravaggesque essence, falls on the long sharp edged draperies, the warm colours beautifully moving between the ochres and greys, the use of a startling red.

40. The Rape of Helen

127 × 93 cm.
Paris, Musée du Louvre (R.F. 3969; Catalogue 1974, no. 797, reproduced).

HISTORY: Private collection in London. Collection of Vitale Bloch, Holland. Purchased from the latter by the Louvre in 1936, on the initiative of Paul Jamot. Restored in 1983.

EXHIBITIONS: 1955, Dijon, no. 24, pl. XIII; 1960, Paris: *Réserves*, no. 364; 1973, France, no. 30, fig. 3.

BIBLIOGRAPHY: Ch. Sterling, 'Richard Tassel et Jean Lys', *La Renaissance*, no. 516, May-June 1936, pp. 36, 37 fig. 7; Ch. Sterling, exhibition preface, 1955, pp. 16, 21; P. M. Auzas, 'L'influence du Guide dans la peinture française au XVII° siècle', *Actes du XIX° Colloque international d'Histoire de l'Art, Paris 1958*, 1959, p. 360; H. Ronot, 'A la découverte d'un peintre langrois du XVII° siècle: Jean Tassel', *Médecine de France*, no. 158, January 1965, p. 24, reproduced p. 27; F. Gebelin, *L'époque Henri IV-Louis XIII*, 1969, p. 158; P. Rosenberg and S. Laveissière, 'Jean Tassel dans les musées français', *R.L.*, 1978, no. 2, pp. 122-123, cf. pp. 126, 132.

The rape of Helen, wife of Menelaus, by Paris (to whom Venus had promised the love of the most beautiful woman as a reward for a judgement in her favour), was both an intrigue of love and a pretext for the Trojan war. Guido Reni treated this subject as a *scène galante* (1631, Louvre) while Tassel has here chosen for his theme the agitation of the battle opposing Greeks and Trojans. Here, Helen is abducted brutally, like the Sabines of

Poussin, like Prosperine by Pluto, like Oreithyia by Boreas, in a dramatic composition where the diverging diagonals combine with the dispersal of the light to create movement. The monuments raise their vertical silhouettes against the sky and the rearing horse (directly copied from those of Montecavallo at Rome), which two soldiers are holding back, generate tension towards the top of the painting. The baroque conception of this picture, always considered as the most 'Bolognese' of Tassel's works, is not exempt from 'Poussinian' references: one is reminded of Poussin's *The Companions of Rinaldo* (New York) where the two warrior's with swords raised and seen from the back, are close to those of Tassel.

The artist (as attested by his entire *oeuvre*) had no scruples about fusing the most diverse influences together. But in its seeming disorder, *The Rape of Helen* answers in fact to a carefully reasoned composition, in which the spatial recession is balanced by the frontal aspect of the two principal combatants, between whom the heroine of the scene emerges, (it is after all the basic design of David' *Sabines*! . . .). The execution, like the expressions, is in keeping with the nature of the subject, in its concern for a fundamentally classical coherence.

Simon Vouet
Paris, 1590 — Paris, 1649

A major figure of the French seventeenth century, Simon Vouet had the most brilliant of careers. Very precocious, he found himself in England while still very young, then in Constantinople, from whence he reached Venice and then Rome, in 1614, where he remained for thirteen years. There he rapidly became one of the principal representatives of the international Caravaggesque movement, alongside Valentin and Vignon. His renown is testified to by his nomination, in 1624, as head of the Roman Academy of Saint Luke and by the commission, in the same year, for a large altarpiece for St. Peter's in Rome (together with Valentin and Poussin he was the only Frenchman to receive this honour). He decorated chapels in Rome (San Francesco a Ripa, San Lorenzo in Lucina), the Chartreuse in Naples, and in 1620-1621 he worked for the Doria family at Genova.

Pensioned by the King of France in 1618, he was recalled to Paris in 1627, with the title 'Premier peintre du Roi' and entrusted with the decoration of the Royal mansions and charged with providing designs for the new Tapestry Factories. His studio was the largest and most important in the capital and a great many artists passed through it, among whom Mignard, Le Sueur and Le Brun are the best known, though they also included, most notably, Dorigny, Poerson, Dauphin (all represented in this exhibition), Aubin Vouet, his brother, Nicolas Chaperon and Louis and Henri Testelin who were a few of his more remarkable pupils; François Perrier was at one time his assistant.

Vouet was entrusted with most of the large scale decorations undertaken both in Paris and in many of the dwellings in its environs: the Galerie des Hommes illustres at the Palais Cardinal, for Richelieu (at the same time as Champaigne), the galleries of the Hôtels Bullion and Séguier amongst others, the châteaux of Chilly and of Wideville, the palaces at Saint-Germain-en-Laye and Fontainebleau. The churches of Paris were adorned with his great altarpieces, many of which are still extant (Saint-Merry, Saint-Eustache, Saint-Martin-des-champs). Such activity was only possible thanks to the assistance of a very active studio. His best students, such as Le Sueur, worked in his style, so much so that their work can sometimes be confused with that of the master.

Vouet's success was due to the new language which he brought with him to France. His own style, from the end of his Italian period, evolved towards a clearer manner, benefitting from the examples of the Venetians and the Bolognese. The generosity of forms, the éclat of his colours, the impression of happy plenitude which emanates from his works, instantly seduced Parisian society on his return in 1627. They saw in him the restorer of French painting, the one who introduced the Italian 'grand goût' ('taste') which was destined to sweep away the old-fashioned 'manière' in which a George Lallemand would have persisted in following. . . . Vouet's reign lasted almost a quarter of a century, and his influence in France and abroad was immense. Neither the reputation of Blanchard, the finest colourist, nor the vogue of hyper-classicism represented by La Hyre, Stella, Champaigne or Le Sueur during the years 1640-1650, nor the brief Parisian sojourn of Poussin between 1640-1642, could overcome Vouet's supremacy. His art, (in which one may criticise his negligence and facility) was in effect suited to fulfilling all the requirements of painting, from the decoration of an entire salon to the provision of designs for devotional prints. His compositions worked marvellously in tapestries, while the engravings of

Dorigny, Tortebat (his sons-in-law) and Daret gave them a wide diffusion and even sculpture, as in the work of Jacques Sarrazin, adopted his designs. We must add that he was an admirable portraitist, notably in pastels, a technique he taught to Louis XIII.

Vouet should, therefore, be judged, not only on the quality of certain works (often very high, as are those exhibited here), but as much for his exceptional success as well as for the creation of a style. Le Brun, after being his student, was to give the most complete example, in France, of this type of character, the inheritor of the Renaissance, the universal artist.

41. The Four Seasons

Diameter: 113 cm.
Dublin, National Gallery of Ireland (cat. no. 1982; Catalogue 1981, p. 175, reproduced).

HISTORY: Engraved by Dorigny in 1645. Collection of W. P. Odlum at Huntington, Portarlington. Acquired from Mr. Neville Orgel in London in 1970 (Shaw Fund).

BIBLIOGRAPHY: W. R. Crelly, *The paintings of Simon Vouet*, New Haven, 1962, p. 254, no. 233 (lost painting; catalogues the engraving as: 'Allégorie de la Fécondité [?]'); *La Chronique des Arts*, supplement to *G.B.A.*, 1971-I, February, p. 133 no. 613, reproduced; W. R. Crelly, 'Two Allegories of the Seasons by Simon Vouet and their Iconography', *Studies in Honor of H. W. Janson*, New York, 1981, pp. 401-424, cf. p. 403 fig. 4; H. Quinlan, *Fifty French Paintings. National Gallery of Ireland*, Dublin, 1984, p. 5, reproduced in colour.

RELATED WORKS: Engraving in the opposite direction by M. Dorigny, with 'privilège royal' of 1645 and the dedication: '*Quod Natura negat, potuit praestare tabella / Frugibus et sertis jungere frigus iners*' (Crelly, 1962, not reproduced).

A painting now of oval composition, 140 × 129 cm., but probably originally rectangular, entered the Art Gallery and Museum of Glasgow (no. 218) in 1854 as Carle Van Loo, represents the same subject. Published as Vouet by Crelly (1981, fig. 1-3) who judges it to be much earlier than the Dublin painting, it is certainly the work of his pupil Dorigny according to P. Rosenberg (verbal communication). An anonymous painting reproducing this composition in the opposite direction, where Adonis, Flora and Ceres appear to be portraits, passed through a sale in Paris at the Hôtel Drouot on the 18th March 1985, room 4, no. 4, diameter 64 cm., (reproduced in the catalogue as 'Ecole flamande du XVIIe. siècle').

The iconography of this *tondo*, and of the similar picture at Glasgow, has been studied at length by Crelly (1981). The four seasons are depicted, Winter represented by Adonis, the young hunter with the incipient beard, draped in a blue cloak and accompanied by his dog. Spring is represented by Venus (made similar to Flora) who crowns him with flowers. Summer is shown by Ceres holding strands of corn while Autumn is represented by the infant Bacchus, decked with grapes and frightened by the dog. The myth of Adonis, born from a myrrh tree, is that of fertility: his stay for a part of the year, with Proserpine, the Goddess of the Underworld, corresponds to Winter, when the work of Nature is under ground. In Spring, Adonis rejoins Venus, and it is their happy reunion, underlined by an exchange of amorous glances, which Vouet has represented. The engraving by Dorigny confirms this interpretation which makes the semi-naked Adonis the symbol of Winter (so often represented by a shivering old man), with his latin distich which Crelly (1981, note 71) translated as: 'What nature denies, a picture has been able to show: The Union of Sluggish cold with fruits and Wreath of flowers'. M. J. O'Meara (letter in Gallery files, 1970) relates that the expression *Frigus iners* is borrowed from Ovid (*Metamorphoses*, VIII, 790).

The original destination of this picture is not known. Perhaps it was to go over a chimney, a place traditionally reserved for subjects related to fire (*The Forge of Vulcan* for example), but where it was also conceivable to place a figure of Winter, the season when fires are lit. Its dating is no more certain: evidently painted during the artist's Parisian

period, from 1627 to 1649, it could be placed to about 1635, the period when Vouet decorated the Hôtel de Séguier and the Hôtel de Bullion, and painted for the latter the *Martyrdom* and *Apotheosis of Saint Eustache* (The Church of Saint-Eustache, Paris, and the Musée at Nantes). It can also be compared to the *Apollo and the Muses* in the museum at Budapest.

42. Time overcome by Love, Venus and Hope

187 × 142 cm.
Bourges, Musée du Berry (D. 959. 2. 1).

HISTORY: (?) Sale at Paris, 11th December 1941, no. 59, 'attribué à Simon Vouet'. Allocated to the Louvre by 'Récupération artistique' after the Second World War (M.N.R. 594). Lent to the Bourges museum in 1959.

EXHIBITIONS: 1961, Rouen, no. 136, pl. 20; 1980-1981, Paris: *Saint Louis*, no. 66, reproduced in colour p. 66.

BIBLIOGRAPHY: Dézallier d'Argenville, *Voyage pittoresque de Paris*, 1752, ed. 1778, p. 219; L.-V. Thiery, 1787, p. 128; A. Lenoir, (1794), ed. 1865, p. 76 no. 74; A. Lenoir, *Archives du Musée des Monuments français*, vol. II, 1886, pp. 76, 80, 280; J. Wilhelm, 'La Galerie de l'hôtel de Bretonvilliers', *B.S.H.A.F.*, 1956, pp. 137-150, cf. p. 138; P. Rosenberg, exhibition catalogue, 1961; W. R. Crelly, 'A Painting from the Royal collection of France: Simon Vouet's Allegory of the Victory', *Bulletin of the Jon Herron Art Institute*, The Art Association, Indianapolis, vol. XLVIII, no. 1, March 1961, pp. 4-18, cf. p. 14; W. R. Crelly, *The Painting of Simon Vouet*, New Haven, 1962, pp. 111-112, 152-153 no. 12, fig. 135; Vergnet-Ruiz and Laclotte, 1962, p. 256; Y. Picard, *La Vie et l'oeuvre de Simon Vouet*, vol. II, *Simon Vouet premier peintre de Louis XIII, (1628-1649)*, s.d. 1964, pp. 40, 60, pl. 59; C. Van Hasselt, in the exhibition catalogue of: *Le dessin français dans les collections hollandaises*, Paris, Institut

Néerlandais, 1964, under no. 24; J.-F. Méjanès, in the exhibition catalogue of *Le Cabinet d'un grand amateur, P. J. Mariette*, Paris, Louvre, Cabinet des Dessins, 1967, pp. 162-163, under no. 274; P. Rosenberg, exhibition catalogue, *Dessins français des XVII° et XVIII° siècles dans les collections américaines*, Toronto, Ottawa, San Francisco, 1972, under no. 151; P. Rosenberg, 'Simon Vouet', in *Le Larousse des grands peintres*, 1976, p. 426 and colour plate; J. M. Bruson and F. Reynaud, exhibition note 1980-1981; P. Rosenberg, 1981-1982, p. 58, under no. 72; P. Rosenberg, 1982, p. 339, under no. 121; R. Fohr, 'Pour Charles Dauphin' *M.E.F.R.M.*, XCIV, 1982, no. 2, pp. 979-994, cf. pp. 985, 988 and fig. 6.

RELATED WORKS: Engraving in the opposite direction by Michel Dorigny, dated 1646, with the dedication: '*Spes Amor atque Venus Saturno Vellere plumas / Certant, raptorem diripiuntque suum*'.
Drawing for *Time*, Darmstadt, Hessisches Landsmuseum (Hz. 95; Méjanès, 1967, no. 274; Rosenberg, 1981-1982, p. 57, reproduced). A drawing of a flying figure (male) in a posture close to *Fame* in the Bourges painting, Heino, Hannema Foundation, has been considered as a study for this painting (Van Hasselt, 1964, pl. 21; Méjanès, 1967). Another drawing, Ottawa (6318), in a very different posture, has also been related to it (Rosenberg, 1972, no. 151, fig. 6), and the same for the head of an old man in the Louvre (R.F. 28180; cf. Méjanès, 1967).

Is this masterpiece, dating from Simon Vouet's Parisian period, the painting decorating the overmantle at the Hôtel Bretonvilliers which was referred to by Dézallier d'Argenville in 1752? The author's description, which gives its decorative context, seems to imply this, (1778 edition, p. 219): 'Ensuite est un Cabinet peint par *Vouet*. Sur la cheminée se voit' l'Espérance, avec l'Amour et Venus qui veulent arracher les ailes de Saturne. Michel Dorigny a gravé ce morceau. Le Temps paraît au plafond, accompagné de plusieurs Divinités et d'enfans dans des carrés ou compartiments' ('Next is a Cabinet painted by *Vouet*. On the chimney is Hope, with Love and Venus who wish to tear off Saturn's wings. Michel Dorigny has engraved this piece. Time appears on the ceiling, accompanied by many deities and children in squares or compartments'). The decoration of this Hôtel (where Bourdon intervened at a later stage) by Vouet, is dated to 1640-1643 (Bruson and Reynaud, 1980-1981). It is known that during the Revolution, the decorations were removed from the Hôtel, after the reports of Lemonnier and Moreau the Younger on the

30th July 1793 (Lenoir, 1886 edition, p. 76): 'Dans l'appartement occupé par le citoyen Desforges, ils ont remarqué surtout un trés beau plafond de Simon Vouet, avec quatre petits ronds attenant à ce même plafond; sur la cheminée de ladite chambre, un autre tableau de Vouet (...) Il est trés urgent de faire enlever les objects ci-dessus désignés. ...' ('In the appartment occupied by the citizen Desforges, they especially noticed a very beautiful ceiling by Simon Vouet, with four small roundels adjoining the same ceiling; on the chimney of the said room, is another painting by Vouet. ... It is most urgent to have the objects designated above, removed ...'). The inventory of the objects detached and transported to the 'dépôt provisoire des Petits Augustins' ('provisional depot of the Petits Augustins') from the 10th August to the 16th September 1793 (ibid., p. 80) lists 'un plafond et quatre compartiments, peints par Simon Vouet. — Un tableau sur toile, peint dans la manière de ce maître' ('a ceiling and four compartments, painted by Simon Vouet —A picture on canvas, painted in the style of the master') and the inventory of the paintings 'déposées provisoirement dans le Musée de la rue des Petits-Augustins' ('Provisionally deposited in the Museum in the Rue des Petits Augustins' ibid., p. 280 and Crelly, 1962, pp. 152-153.) indicates with this provenance: '969. Un plafond sur bois représentant le *Triomphe de Vénus* (sic) par Vouet. — 970. Quatre parties du même plafond représentant des *Enfants*, par le même. — 971. Le *Temps vaincu par les Grâces*, sur toile, par le même'. (969. A ceiling on panel representing the *Triumph of Venus* by Vouet. — 970. Four sections of the same ceiling representing the *Children* by the same hand. 971. *Time overcome by the Graces*, on canvas, by the same hand).

However, Alexander Lenoir (1794) in his catalogue of the 'II Vendemiaire an III' (2nd October 1794), states that this painting 'ne pas être l'original' ('is not the original'), which remark follows his doubts expressed in 1793 ('dans la manière de ce maitre' — In the style of this master). Should one believe that the Bourges painting, undoubtedly original, was removed before 1793 and replaced by a copy, or that Lenoir was mistaken? The fact that the painting included in the 1941 sale was only attributed to Vouet is not conclusive enough to imply the existance of two versions.

Whatever the case, Dézallier d'Argenville's description (though omitting the two flying figures) is precise enough, as is its reference to the engraving, to confirm that the Bourges painting corresponds to that of the Hôtel Bretonvilliers. One can recognise Saturn (Time) whose wings are torn off by Hope on the right (identified by her symbolic anchor) and Love on the left, while Venus, in the centre, crowned with roses, pulls at his hair. Flying over this group, Fame, with her two trumpets leans on another winged female figure whose right hand holds a sceptre (?), crowns and necklaces, and lets fall a shower of gold pieces over Love: this figure must represent *Abundance*.

Broadly arranged on a plan, like a bas-relief, the composition in which the figures link together according to a vast rhythm, culminate in the triumphant Fame, proclaiming the victory of Love over Time. This theme, which Vouet had treated in an entirely different manner in 1627 (Prado), was associated on the ceiling to that of 'Time revealing Truth' (according to Thiery, 1787, Dézallier is more vague, and the 1793 inventory sees it, on the contrary as a *Triumph of Venus*; cf. the painting by Dauphin, no. 11).

43. Abundance

170 × 124 cm. (with additions to the top and bottom).
Paris, Musée du Louvre (inv. 8500; Catalogue 1974, no. 909, reproduced).

HISTORY: Inventoried in the royal collection for the first time in 1706; in 1709 at the Cabinet de la Surintendance at Versailles (Engerand, 1899). Exhibited in October 1750 at the Luxembourg Palace (id. cf. again A. N. Dézallier d'Argenville, 1778), then in the Galerie d'Apollon at the Louvre (A. J. Dézallier d'Argenville, 1762). At the Louvre in 1785 (Engerand, 1899).

EXHIBITIONS: 1951, Pittsburgh, no. 60, reproduced; 1953, New Orleans (then 1954, New York, Wildenstein Gallery); 1956-1957, Rome, no. 316, pl. 58; 1967-1968, California (not numbered).

BIBLIOGRAPHY: A. J. Dézallier d'Argenville, *Abrégé* ... 2nd ed., 1762, vol. IV, pp. 17-18; A. N. Dézallier d'Argenville, *Voyage pittoresque de Paris*, 1752, 6th ed., 1778, p. 332; F. Engerand 1899, p. 299-300, no. 16; Tuetey and Guiffrey, 1909, p. 379; P. Marcel and Ch. Terrasse, *La Peinture au musée du Louvre. Ecole Française. XVII° siècle*, 1929, pp. 3, 5, reproduced p. 3 fig. 4; W. Weisbach, 1932, p. 54 fig. 11; Ch. Sterling, exhibition note 1956-1957; J. F. Revel "Les tois V", *Connaissances des Arts*, January 1958, reproduced p. 72; R. L. Manning, 'Some important Paintings by Simon Vouet in America', *Studies in the History of Art, dedicated to William E. Suida*, London 1959, p. 294 note 1; W. R. Crelly, 'A Painting from the Royal Collection of France: Simon Vouet's *Allegory of the Victory*', *Bulletin of the Jon Herron Art Institute*, The Art Association of Indianapolis, vol. XLVIII, no. 1, March 1961, pp. 4-18, cf. p. 11 fig. 4; W. R. Crelly, *The Painting of Simon Vouet*, New Haven, 1962, pp. 87-89, 201 no. 111 A; R. Klessman, 'Ein neuerworbenes Gemälde von Simon Vouet', *Berliner Museen*, XIII, 1963, pp. 32-39, cf. pp. 35, 36, fig. 3; J. Thuillier, 1963, p. 198, reproduced in colour p. 195 and detail p. 190; Y. Picard, *La vie et l'oeuvre de Simon Vouet*, vol. II, *Simon Vouet premier peintre de Louis XIII, (1628-1649)*, s.d. [1964], pp. 10, 57 no. 18, reproduced pl. 17; M. Laclotte, *Musée du Louvre. Peintures*, 1970, p. 23, reproduced in colour; R. Ward Bissel, *Orazio Gentileschi and the poetic tradition in caravaggesque Painting*, The Pennsylvania State University Press, University Park and London, 1981, p. 78, fig. 195; M. Laclotte and J.-P. Cuzin, 1982, reproduced in colour p. 34; M. Fumaroli, *Introduction* to Rosenberg, 1982, p. 6, reproduced.

It is not certain that this painting comes from the Château-Neuf at Saint-Germain-en-Laye, as is suggested by many authors (among them Crelly, 1962), and the Louvre catalogues. It would even appear to have never been there; in contrast to two other paintings in the Louvre whose fate was linked with it: *Faith* and *Victory* (inv. 8498 and 8499), inventoried at this château in 1709-1710 (Engerand, 1899, p. 298, nos. 9-10). In 1768, they decorated the ceiling of the Chambre du Roi along with a *Venus testing an Arrow* now at the Musée de Nancy. Yet this last painting and its pendant (*Love threatening Venus with an arrow*, Nancy) were in the Cabinet des tableaux at Versailles in 1709-1710 and later at the Château de la Muette (Engerand, 1899, p. 299, nos. 14-15). We know, however, (Crelly, 1962, pp. 86-87) that Vouet had painted 'quatre tableaux au plafond de la chambre de le Reine au Château-Neuf de Saint Germain' ('four paintings on the ceiling of the Queen's room in Château-Neuf at Saint-Germain'), listed in the artist's inventory of 1639-1640 as not yet paid for. Considering their location they must have consisted of ceiling subjects, such as the four *Virtues* engraved in 1638 and now at Versailles (Crelly, 1962, nos. 150 A-D and fig. 109-112).

The subject of the painting shown here has been interpreted by A. N. Dézallier d'Argenville (1778) as 'La victoire tenant dans ses bras Louis XIII encore enfant' ('Victory holding Louis XIII in her arms — [sic. for Louis XIV, born in 1638 at Saint-Germain-en-Laye] — still a child'): was it the child's blue ribbon which made him mistake the figure for the young King, wearing the ribbon of the Order of the Holy Ghost?

In fact, although the woman is crowned with laurel leaves (which explains why she was called 'Victory') and holds neither the imperial crown nor the sceptre which Ripa, in his *Iconology*, assigns as attributes to Abundance, the meaning of this allegory, surrounded by vases and precious objects, is clear. Though hardly noticeable, there are two details which clarify the interpretation. The legend of Apollo and Daphne, inscribed on the silver vase, relates that the chase after fugitive beauty is futile. Moreover, the ribboned child with finger pointing to the sky, answers to the one on the left who, with a slightly sad expression, displays a handful of jewels, under the amused smile of Abundance. Finally, the book lying on the ground indicates that the possession of knowledge no more than of love or Fortune, does not make one truly rich.

By its monumental stance and its twisted pose, this figure recalls the distant memory

of Raphael's *Virtues* and Michelangelo's *Sibyls* (Crelly, 1962). Bissel (1981) aptly relates it to Gentileschi's *Public Felicity Triumphant over Dangers* painted circa 1624 for the Luxembourg Palace.

Dated to the 1630's by Crelly, the painting, when compared to *Loth and his Daughters* (1633) at the Musée de Strasbourg, appears to be later, about 1640 according to Ch. Sterling (1956-57).

Exhibitions cited in abbreviated form:

1821, London, British Institution.

1832, London, British Institution.

1847, Dublin, Royal Irish Institution.

1883, Edinburgh, *Loan Exhibition of works by old Masters and Scottish National Portraits.*

1916, Dublin, Royal Irish Institution.

1918, Dublin, National Gallery of Ireland, *Pictures by old Masters given (...) by the late Sir Hugh Lane.*

1925, Paris, Petit Palais: *Le paysage français de Poussin à Corot.*

1929, Maisons-Laffitte: *Dessins français du milieu du XVII° siècle.*

1932, London, Royal Academy: *Exhibition of French art, 1200-1900.*

1934, Paris: *Réalité:* Orangerie des Tuileries, *Les peintres de la Réalité en France au XVII° siècle* (catalogue by Ch. Sterling).

1934, Paris, Musée des Arts décoratifs: *Artistes français en Italie de Poussin à Renoir.*

1937, Paris, Palais national des Arts, *Chefs d'oeuvre de l'art français.*

1948, Paris, Orangerie des Tuileries: *La peinture lyonnaise du XVI° au XIX° siècle.*

1949, Paris, Musée des Arts décoratifs: *Egypte-France.*

1949-1950, London, Royal Academy: Landscape in French Art (Catalogue by B. Dorival).

1951, Amsterdam, Rijksmuseum: *Het Franse Landschap.*

1951, Pittsburgh, Carnegie Institute: *French Painting 1100-1900.*

1952, Paris, Orangerie des Tuileries: *Philippe de Champaigne* (Catalogue by B. Dorival).

1953, Brussels, Palais des Beaux-Arts: *La femme dans l'art français.*

1953, New Orleans, Isaac Delgado Museum of Art: *Masterpieces of French Painting through Five Centuries (1400-1900).*

1955, Dijon, Musée des Beaux-Arts; *Les Tassel, peintres langrois du XVII° siècle.*

1956, France, travelling exhibition: *Le paysage français de Poussin aux Impressionnistes* (Catalogue by M. Hoog).

1956-1957, Rome, Palazzo delle Esposizioni: *Il Seicento europeo. Realismo, Classicismo, Barocco,* (entries on the French paintings by Ch. Sterling). Reprinted in 1968.

1957, Nancy, Musée des Beaux-Arts: *Autour de Claude Gellée, de Paul Brill à Joseph Vernet.*

1958, London, Royal Academy: *The Age of Louis XIV* (with an album of plates).

1958, Paris, Petit Palais: *Le XVII° siècle français. Chefs d'oeuvre des musées de province* (Catalogue by M. Laclotte).

1958, Stockholm, Nationalmuseum: *Fen Sekler Fransk Konst (Cinq siècles d'art français).*

1959, Berne, Kunstmuseum, *Das 17. Jahrhundert in der Französische Malerei* (Catalogue by B. Lossky).

1960, Paris: *Réserves:* Musée du Louvre, *Exposition de 700 tableaux de toutes les écoles antérieurs à 1800 tirés des réserves.*

1960, Paris: *Poussin.* Musée du Louvre: *Nicolas Poussin* (Catalogue by A. Blunt).

1960, France, travelling exhibition (Rennes, Tours, Besançon, Nancy): *Le paysage en Orient et en Occident.*

1960-1961, Recklinghausen, Städtische Kunsthalle: *Synagoga. Kultgeräte und Kunstwerke.*

1960-1961, Washington, Toledo. New York: *The Splendid Century, French Art 1600 to 1715.*

1961, Rouen, Musée des Beaux-Arts: *Nicolas Poussin et son temps. Le classicisme français et italien contemporain de Poussin* (Catalogue by P. Rosenberg).

1961-1962, Canada (Montreal, Ottawa, Québec, Toronto): *Héritage de France. La peinture française de 1610 à 1760.*

1962, Bologna: *L'ideale classico del Seicento in Italia e la pittura di paesaggio.*

1963, Versailles, Musée national du Château: *Charles Le Brun 1619-1690 Peintre et dessinateur* (Catalogue by J. Thuillier, paintings and J. Montagu, drawings).

1964, Bordeaux, Galerie des Beaux-Arts: *Le femme et l'artiste de Bellini à Picasso.*

1964, Dublin, National Gallery of Ireland: *1864-1964: Dublin Centennary Exhibition.*

1964, London, Hayward Gallery: *The Art of Claude Lorraine.*

1964, Newcastle-upon-Tyne, Laing Art Gallery: *The Art of Claude Lorraine.*

1964-1965, Dijon, Lyons, Rennes: *Peinture classique du XVII° siècle français et italien du Musée du Louvre.*

1965, Dublin, National Gallery of Ireland: *W. B. Yeats. A Centenary Exhibition.*

1965, Jerusalem, The Israël Museum: *Les Maîtres anciens et la Bible.*

1966, Tokyo, National Museum: *The Grand Century in the Public Collections of France.*

1967-1968, California (San Diego, Los Angeles, Sacramento, Santa Barbara): *French Painting from French Museums, XVII-XVIII century.*

1968, Atlanta, The High Museum: *The Taste of Paris from Poussin to Picasso.*

1973, France, travelling exhibition (Tours, Limoges, Poitiers): *Le XVII° siècle français. Tableaux du Louvre* ('Petit journal' illustrated by P. Rosenberg and M.-C. Sahut).

1973-1974, Paris, Musée du Louvre: *Copies, Répliques, Pastiches* ('Petit journal').

1977-1978, Rome, Villa Médicis, Académie de France: *Nicolas Poussin* (Catalogue by P. Rosenberg).

1978, Düsseldorf, Städtische Kunsthalle: *Nicolas Poussin* (id.).

1978, Tokyo, National Museum of Western Art: *European Landscape Paintings.*

1979, Paris, Musée du Louvre: *L'enlèvement des Sabines de Poussin* ('Petit journal' by A. Arikha and M.-C. Sahut).

1979-1980, Beauvais, Musée départemental de l'Oise: *Hommage à Maurice Boudot-Lamotte. Donation M. J. Boudot-Lamotte* (Catalogue by M.-M. Aubrun).

1980-1981, Paris: (*Ile Saint-Louis*), Musée Carnavalet et Mairie annexe du 4e arrondissement: *Ile Saint-Louis* (Catalogue by J.-M. Bruson and F. Reynaud).

1980-1981, Paris: *Patrimoine:* Grand Palais: *Cinq ans d'enrichissement du Patrimoine national. 1975-1980. Donation, Dations, Acquisitions.*

1981, Edinburgh, National Gallery of Scotland: *Poussin. Sacraments and Bacchanals.*

1982, Peking and Shanghai: *250 ans de peinture française. De Poussin à Courbet (1620-1870).*

1983, Munich, Haus des Kunst: *Im Licht von Claude Lorrain* (Catalogue by M. Roethlisberger).

1983-1984, Dunkirk, Musée des Beaux-Arts: *Acquisitions, dons et restaurations de 1967 à 1973* (Catalogue by J. Kuhnmunch).

1983-1984, *Paris, Grand Palais: Hommage à Raphaël. Raphaël et l'art français.*

Bibliography

Titles cited in abbreviated form. (Where not indicated, the place of publication is Paris).

A.A.F.: *Archives de l'Art français,* published by the Société de l'Histoire de l'Art français depuis 1851. *A.A.F. Documents:* the first 6 volumes of this collection (1851-1852 to 1858-1860).

ANDRESON, 1863: A. Andresen, *Nicolaus Poussin. Verzeichnis der nach seinen Gemälde gefertigten gleichzeitingen und späteren Kupferstiche etc.,* Leipzig, 1863.

B.M.: *The Burlington Magazine,* London.

BONNAFFÉ, 1884: E. Bonnaffé, *Dictionnaire des amateurs français au XVII° siècle,* 1884.

BRIERE and COMMUNAUX, 1924: G. Brière and E. Communaux, 'Emplacements actuels des tableaux du musée du Louvre catalogués par F. Villot, Tauzia et retirés des galeries. Ecole française', *B.S.H.A.F.,* 1924, pp. 273-355 (reprinted in part, 1925, 83 pp.).

B.S.H.A.F.: *Bulletin de la Société de l'Histoire de l'Art français.*

Catalogue 1974: P. Rosenberg, N. Reynaud, I. Compin, *Musée du Louvre. Catalogue illustré des peintures. Ecole française XVII° et XVIII° siècles,* 2 vol., 1974.

Colloque Poussin, 1960: Nicolas Poussin. Ouvrage publié sous la direction d'André Chastel (...) [Colloque tenu à] Paris, 19-21st September 1958, 2 vol., 1960.

DÉZALLIER d'ARGENVILLE, *Abrégé ...,* 1762: A. J. Dézallier d'Argenville, *Abrégé de la vie des plus fameux peintres ...,* (1st ed.: 1745), 2nd ed., 4 vol., 1762 (re-issue, Geneva, 1972).

DIMIER, 1926 and 1927: L. Dimier, *Histoire de la peinture française du retour de Vouet à la mort de Le Brun. 1627 à 1690,* Paris and Brussels, 2 vol., 1926-1927.

ENGERAND, 1899: F. Engerand, *Inventaire des tableaux du Roy rédigé en 1709 et 1710 par Nicolas Bailly ...,* 1899.

ENGERAND, 1900: F. Engerand, *Inventaire des tableaux commandés et achetés par la Direction des Bâtiments du Roi (1709-1792),* 1900.

FÉLIBIEN, *Entretiens . . . 1666-1668:* A. Félibien, *Entretiens sur les vies et les ouvrages des plus excellens peintres anciens et modernes,* 5 tomes in 2 vol., 1666-1668.

FILHOL and LAVALLÉE, 1804-1815: *Galerie du Musée Napoléon,* published by Filhol, engraver, and compiled by Joseph Lavallée, dedicated to S. M. l'empereur Napoléon 1er, 10 vol., 1804-1815.

G.B.A.: *Gazette des Beaux-Arts.*

GUIFFREY and MARCEL: J. Guiffrey, P. Marcel, *Inventaire général des dessins du Musée du Louvre . . . Ecole française,* since 1907.

HASKELL and PENNY, 1982: F. Haskel and N. Penny, *Taste and the Antique. The Lure of classical Sculpture, 1500-1900,* New Haven and London, 1982.

LACLOTTE, 1957: M. Laclotte, 'Le peinture du Grand Siècle', *L'oeil,* no. 36, December 1957, pp. 40-51.

LACLOTTE and CUZIN, 1982: M. Laclotte and J.-P. Cuzin, *Le Louvre. La peinture européenne,* 1982.

LANDON, 1829-1832: C. P. Landon, *Annales du Musée (...) Ecole française ancienne,* 3 vol., 1829, 1830, 1832.

LAURENT, 1816-1818: H. Laurent, *Le Musée Royal ...,* 2 vol., 1816-1818.

LAVALLÉE: See Filhol and Lavallée.

LE COMTE, 1699-1700: F. Le Comte, *Cabinet des singularitéz d'architecture, peinture et sculpture ...,* 3 tomes (in 2 parts each), 1699 (vol. I-II)-1700 (vol. III), re-issue Geneva, 1972.

LENOIR [1794], 1865: A. Lenoir, 'Catalogue historique et chronologique des peintures et

tableaux réunis au Dépôt national des Monuments français, 11 vendémiaire an III' [2 October 1794], *R.U.A.*, vol. XXI, 1865.

M.E.F.R.M.: *Mémoires de l'Ecole française de Rome. Moyen-Age-Temps modernes.*

Mémoires inédits ..., 1854: Mémoires inédits sur la vie et les ouvrages des membres de l'Académie royale de peinture et de sculpture, published (...) by L. Dussieux, E. Soulié, Ph. de Chennevière, P. Mantz and A. de Montaiglon, 2 vol., 1854.

MIREUR, 1911-1912: H. Mireur, *Dictionnaire des ventes d'art ...,* 7 vol., 1911-1912.

Le Musée Français, 1803-1809: Le Musée Français, Recueil complet de tableaux, sculptures, et bas-reliefs qui composent la collection nationale, avec l'explication des sujets (...) by S. C. Croze-Magnan (vol. I-II, 1803-1805), [then by] T. B. Emeric-David and E. Q. Visconti (vol. III-IV, 1807-1809), 4 vol., 1803-1809, not paginated, plates unnumbered.

N.A.A.F.: *Nouvelles Archives de l'Art français* (title used by the *A.A.F.* from 1872 to 1885).

PIGLER, 1974: A. Pigler, *Barockthemen. Ein Auswahl von Verzeichnissen zur Ikonographie des 17. und 18. Jahrhunderts,* Budapest, 3 vol., 1974.

Procès verbaux de l'Académie ...: Procès verbaux de l'Académie royale de Peinture et de Sculpture, 1648-1792, published by A. de Montaiglon, vol. I, 1875.

R.A.: *Revue de l'Art* (from 1968).

R.A.A.M.: *Revue de l'Art ancien et moderne.*

R.d.A.: *La Revue des Arts* (since 1951; from 1961: see *R.L.*).

RÉAU, 1955-1959: L. Réau, *Iconographie de l'art chrétien,* 3 tomes in 6 vol., 1955-1959.

R.L.: *La Revue du Louvre et des Musées de France* (since 1961).

ROSENBERG, 1966: P. Rosenberg, *Rouen, Musée des Beaux-Arts. Tableaux français du XVI° siècle et italiens des XVII° et XVIII° siècles* (Inventory of French public collections, 14), 1966.

ROSENBERG, 1981-1982: P. Rosenberg, (entries on drawings of the XVII-XVIII centuries) in *French Master Drawings from the Rouen Museum. From Caron to Delacroix,* travelling exhibition, United States (Washington, New York, Minneapolis, Malibu), 1981-1982.

ROSENBERG, 1982: P. Rosenberg, exhibition catalogue of *La peinture française du XVII° siècle dans les collections américaines,* Paris, Grand Palais, 1982 (then New York and Chicago, 1982).

R.U.A.: *Revue universelle des Arts.*

SCHNAPPER, 1967: A. Schnapper, *Tableaux pour le Trianon de marbre,* Paris and The Hague, 1967.

SMITH, 1837: J. Smith, *A Catalogue raisonné of the works of the most eminent Dutch, Flemish and French Painters,* London, 9 vol., 1829-1837, vol. VIII, [N. Poussin, Cl. Lorrain, Greuze], 1837.

THIERY, 1787: L.-V. Thiery, *Guide des amateurs et des étrangers voyageurs à Paris,* 2 vol., 1787.

THUILLIER, 1963: J. Thuillier, *La peinture française de Fouquet à Poussin,* Geneva, 1963.

THUILLIER, 1964: J. Thuillier, *La peinture française de Le Nain à Fragonard,* Geneva, 1964.

TUETEY and GUIFFREY, 1909: A. Tuetey and J. Guiffrey, 'La commission du Muséum et la création du Musée du Louvre (1792-1793)', *A.A.F.,* 1909, 482 pp.

VERGNET-RUIZ and LACLOTTE, 1962: J. Vergnet-Ruiz and M. Laclotte, *Petits et grands musées de France,* 1962.

VEYRAN, 1877: L. de Veyran, *Le Musée du Louvre. Collection de 500 gravures au burin,* 10th series, 1877 (issued in installments, this work reused the plates published in *Le Musée Français,* 1803-1809 and Laurent, 1816-1818).

WEISBACH, 1932: W. Weisbach, *Französische Malerei des XVII. Jahrhunderts,* Berlin, 1932.

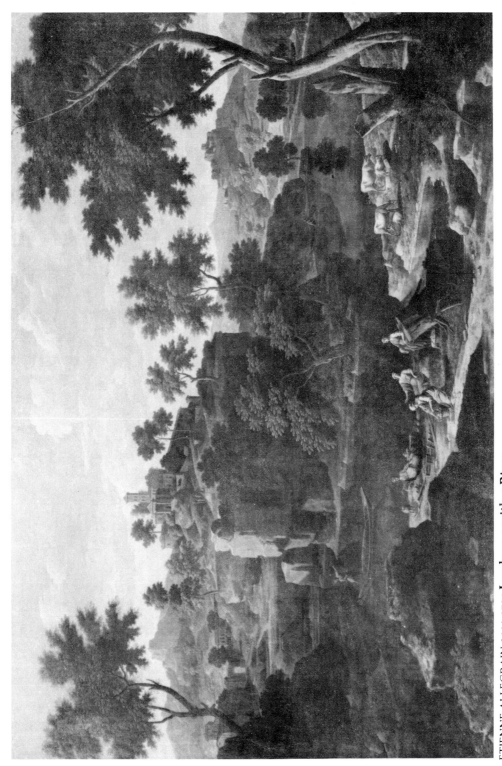

1 ETIENNE ALLEGRAIN 1644-1736 **Landscape with a River**
Musée du Louvre, Paris

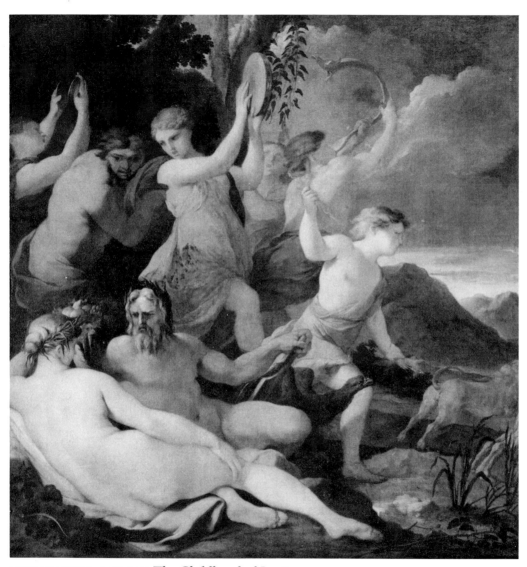

2 LUBIN BAUGIN c.1612-1663 **The Childhood of Jupiter**
Musée des Beaux-Arts, Troyes

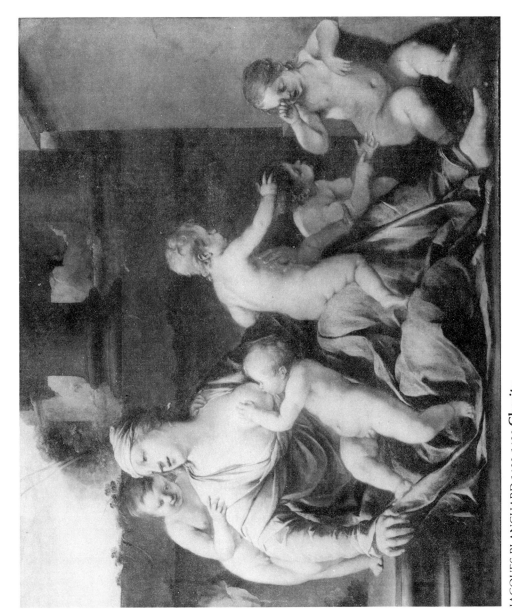

3 JACQUES BLANCHARD 1600-1638 **Charity**
Musée du Louvre, Paris

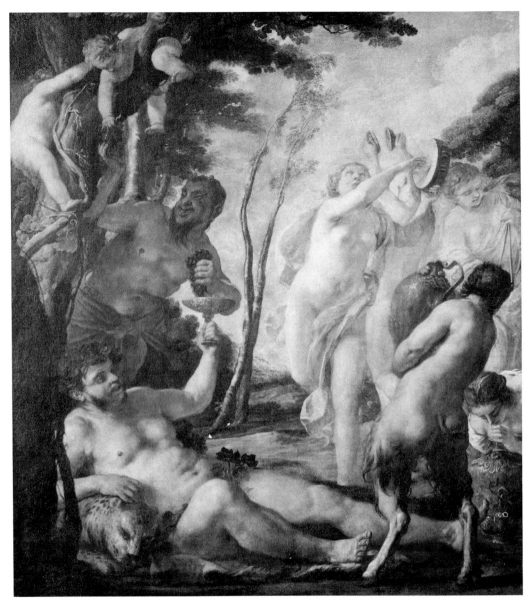

4 JACQUES BLANCHARD 1600-1638 **Bacchanal** 1636
Musée des Beaux-Arts, Nancy

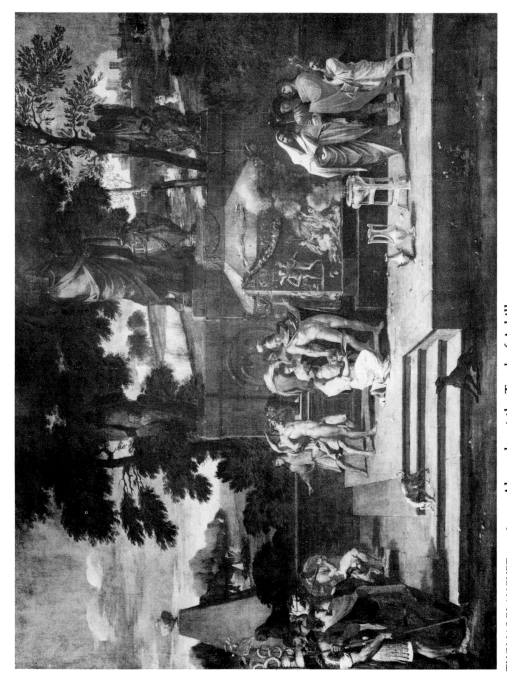

5 THOMAS BLANCHET 1614?-1689 **Alexander at the Tomb of Achilles**
Musée du Louvre, Paris

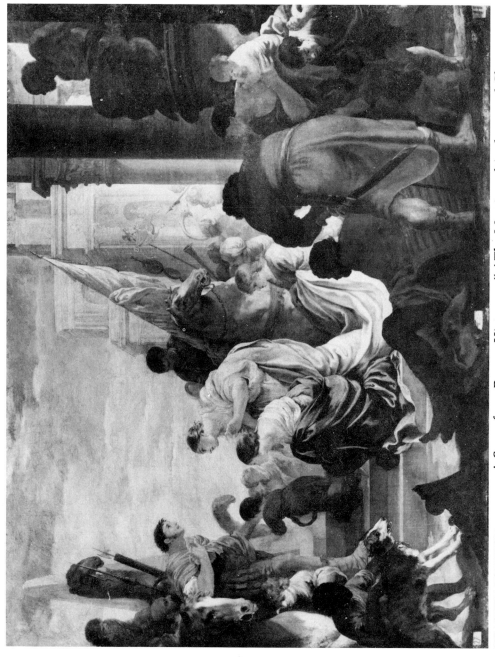

6 SEBASTIEN BOURDON 1616-1671 **A Scene from Roman History,** *called* **The Meeting of Anthony and Cleopatra**
Musée du Louvre, Paris

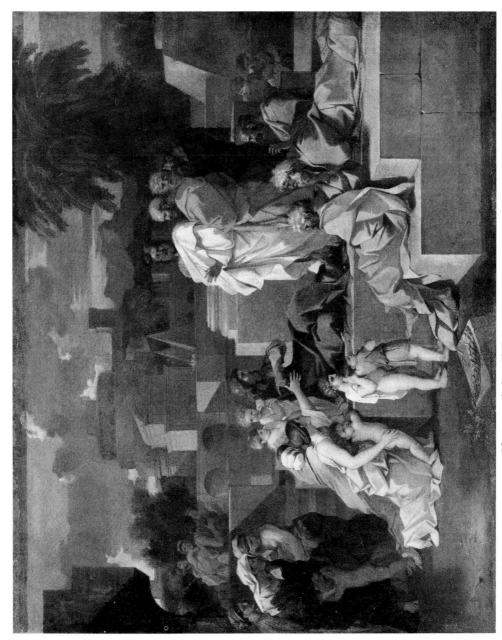

7 SEBASTIEN BOURDON 1616-1671 **Christ and the Children**
Musée du Louvre, Paris

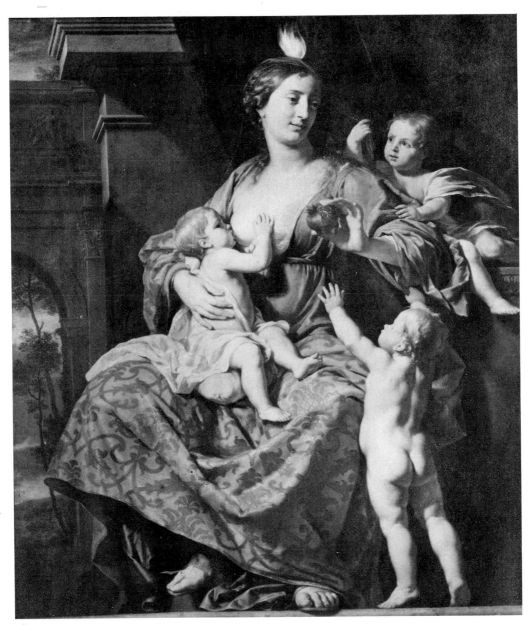

8 PHILIPPE DE CHAMPAIGNE 1602-1674 **Charity**
Musée des Beaux-Arts, Nancy

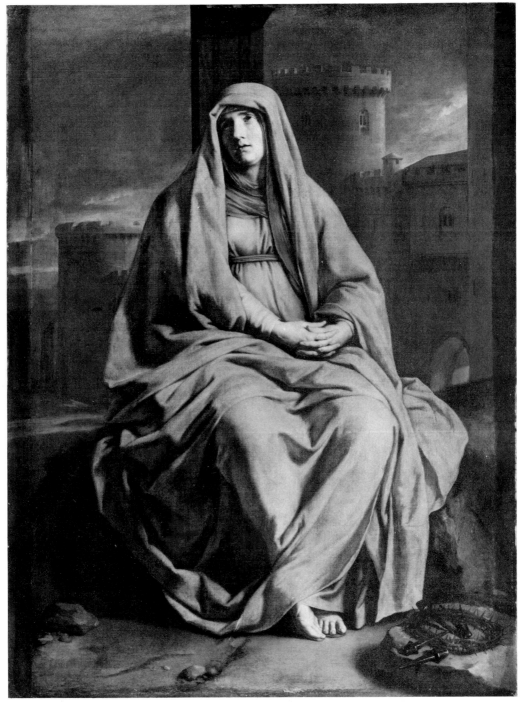

9 PHILIPPE DE CHAMPAIGNE 1602-1674 **The Virgin of Sorrows at the Foot of the Cross**
Musée du Louvre, Paris

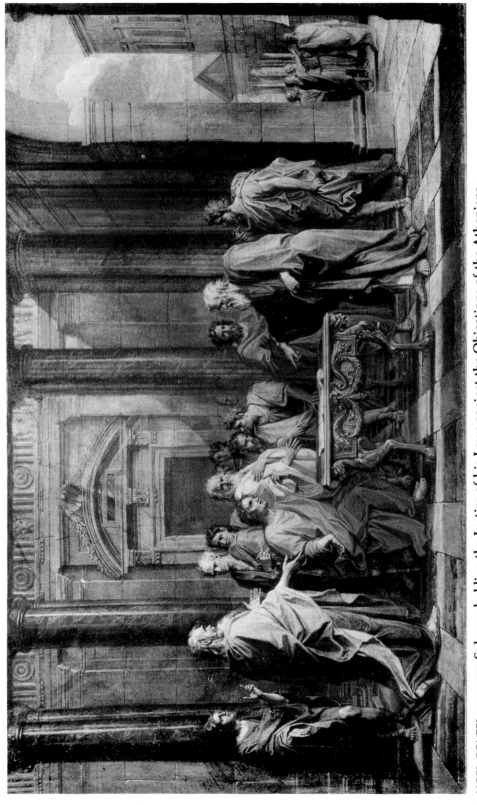

10 NOEL COYPEL 1628–1707 **Solon upholding the Justice of his Laws against the Objections of the Athenians**
Musée du Louvre, Paris

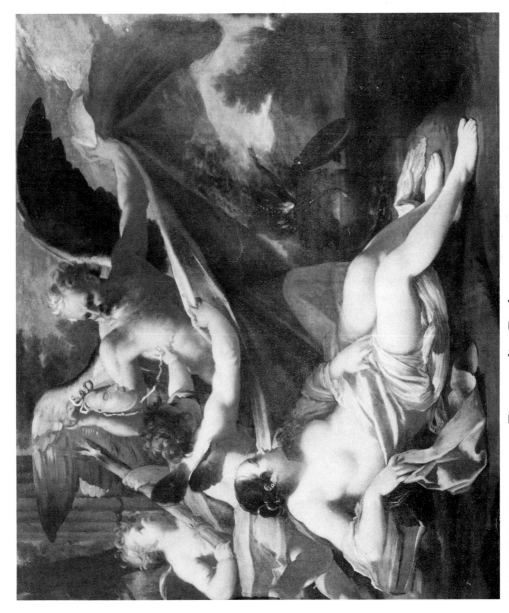

11 CHARLES DAUPHIN c.1620-c.1677 **Time revealing Truth**
Musée Historique Lorrain, Nancy

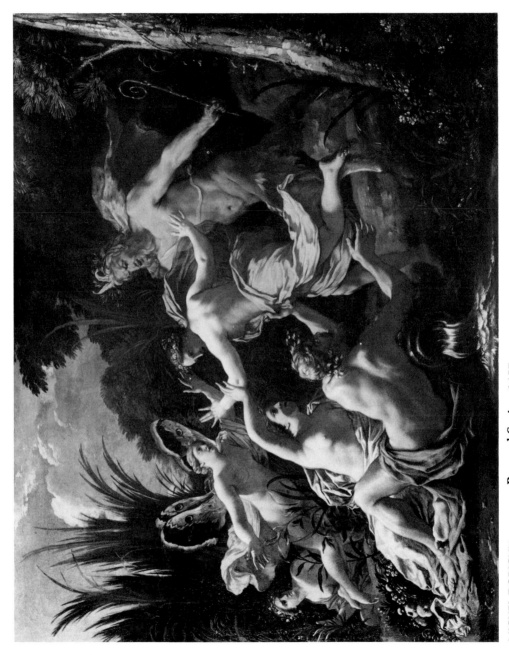

12 MICHEL DORIGNY 1617-1665 **Pan and Syrinx** 1657
Musée du Louvre, Paris

13 GASPARD DUGHET 1615-1675 **Landscape with Shepherds**
Musée du Louvre, Paris

14 CLAUDE GELLÉE called LE LORRAIN c.1602–1682 **Landscape with Paris and Oenone,** called **Le Gué (The Ford)**
Musée du Louvre, Paris

15 CLAUDE GELLÉE called LE LORRAIN c.1602–1682 **Juno confiding Io to the Care of Argus**, 1660
National Gallery of Ireland, Dublin

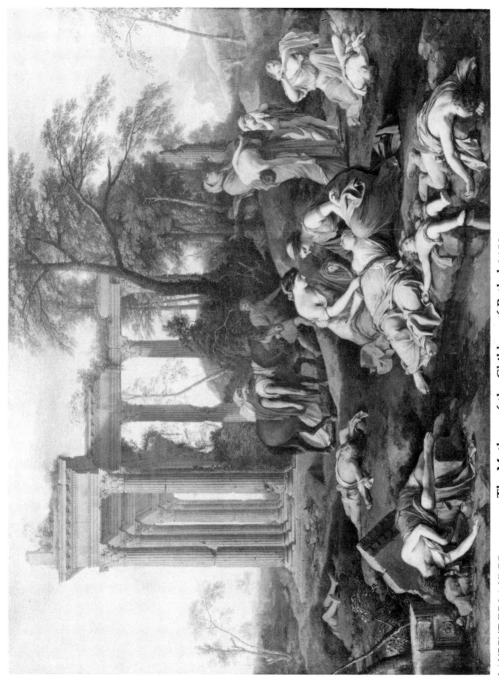

16 LAURENT DE LA HYRE 1606-1656 **The Mothers of the Children of Bethel** 1653
Musée des Beaux-Arts, Arras

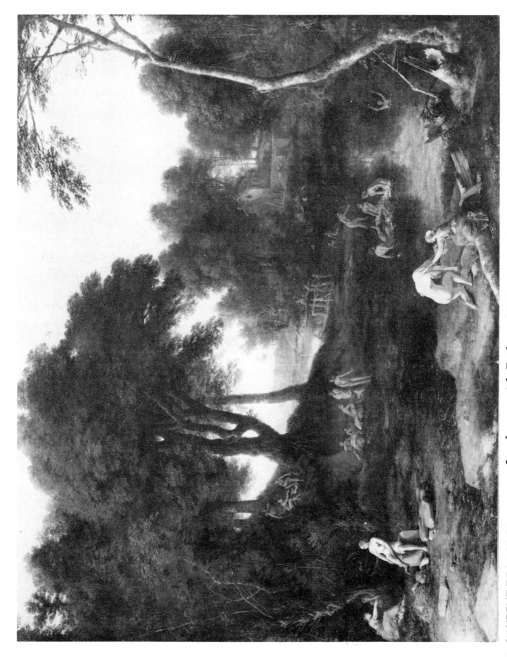

17 LAURENT DE LA HYRE 1606-1656 **Landscape with Bathers** 1653
Musée du Louvre, Paris

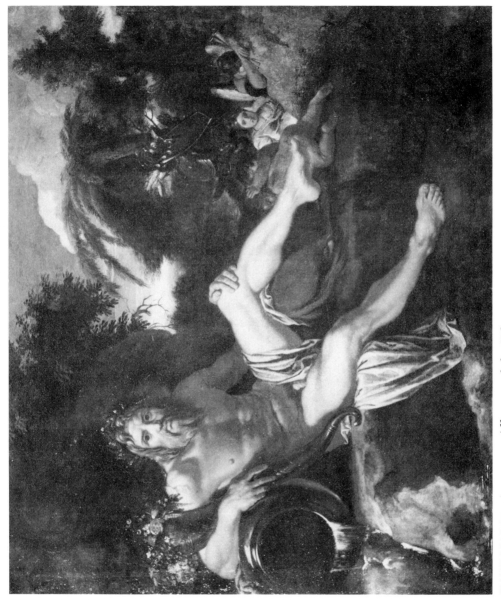

18 CHARLES LE BRUN 1619-1690 **Allegory of the Tiber**
Musée Departmental de l'Oise, Beauvais

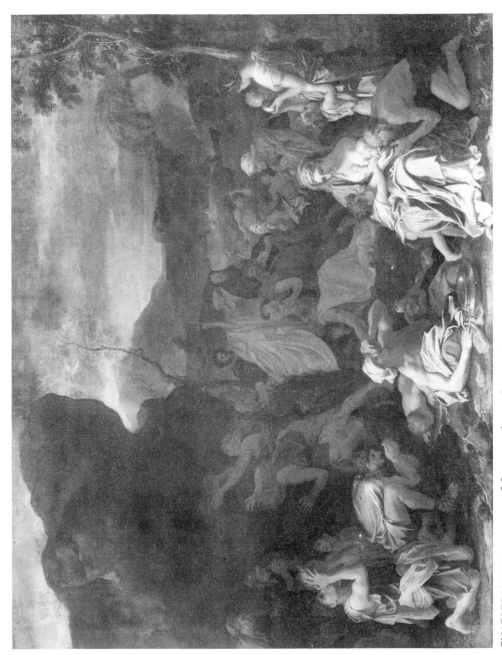

19 CHARLES LE BRUN 1619-1690 **Moses striking the Rock**
Musée du Louvre, Paris

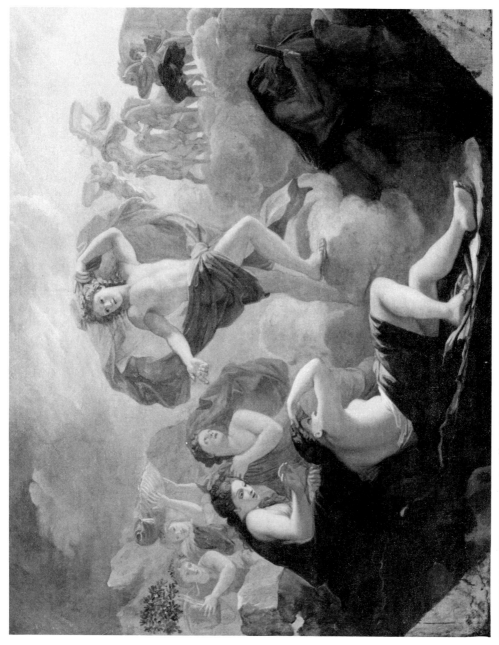

20 CHARLES LE BRUN 1619-1690 **Apollo taking Leave of Tethys**
National Gallery of Ireland, Dublin

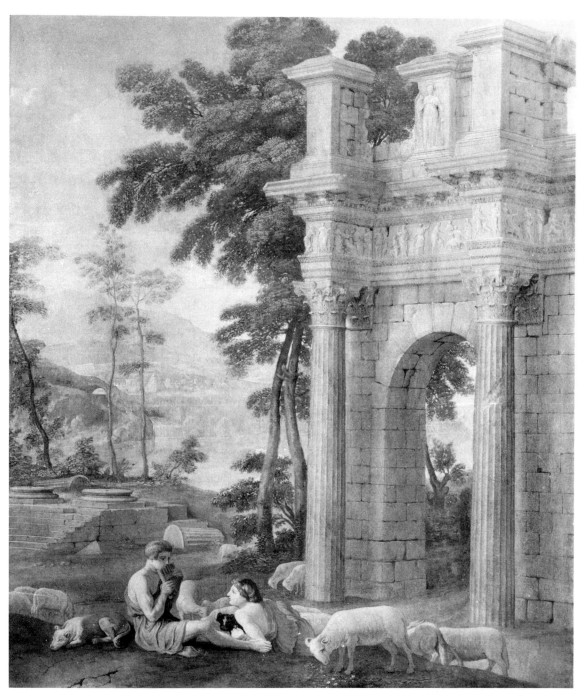

21 JEAN LEMAIRE called LEMAIRE-POUSSIN or LE GROS LEMAIRE 1598-1659 **The Childhood of Bacchus** *also called* **The Childhood of Romulus**
National Gallery of Ireland, Dublin

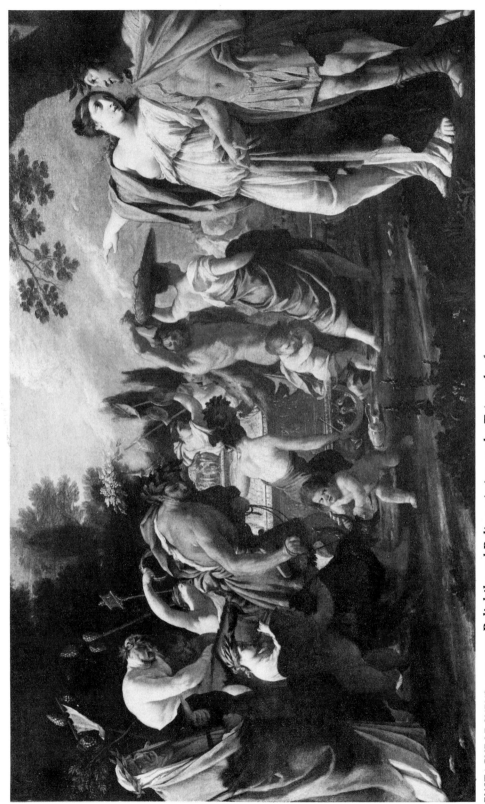

22 EUSTACHE LE SUEUR 1616-1655 **Poliphilo and Polia assisting at the Triumph of**
Bacchus
Musée de Tessé, Le Mans

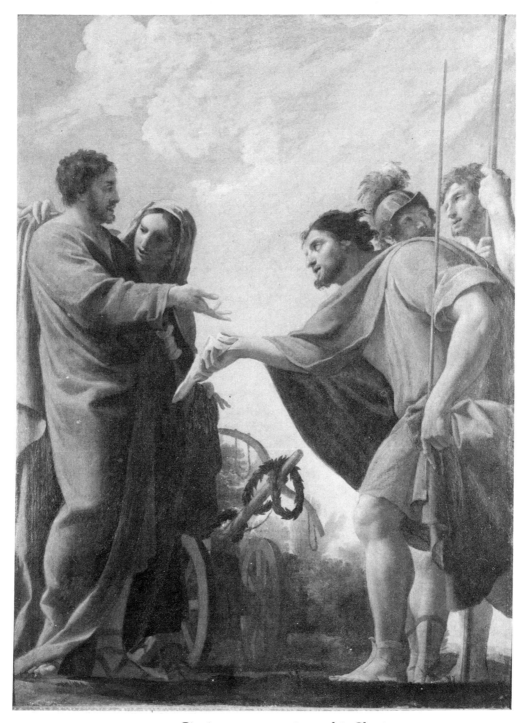

23　EUSTACHE LE SUEUR 1616-1655 **Cincinnatus returning to his Chariot**
Musée de Tessé, Le Mans

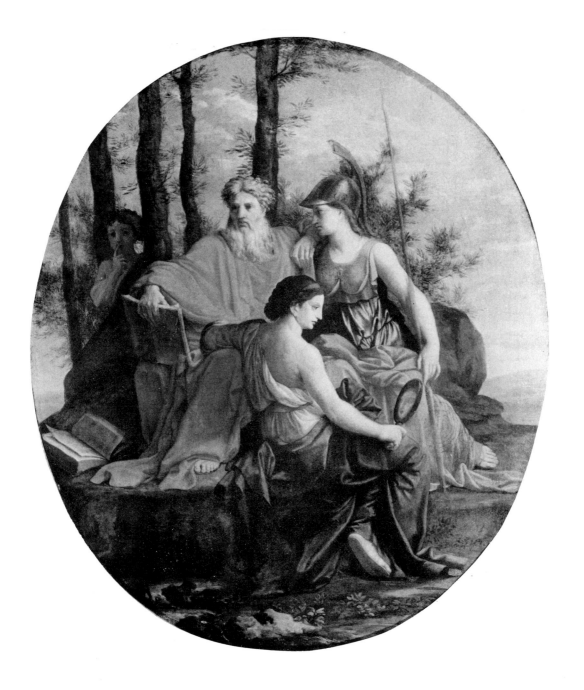

24 EUSTACHE LE SUEUR 1616-1655 **Allegory of the Perfect Minister**
Musée des Beaux-Arts, Dunkirk

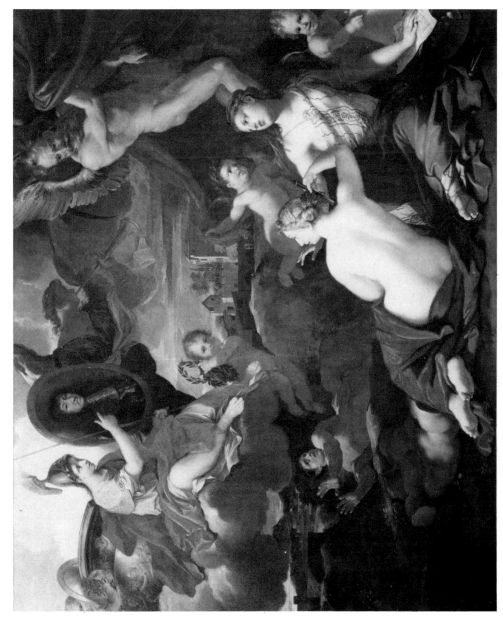

25 NICOLAS LOIR 1624-1679 **The Progress of the Graphic Arts under the Reign of Louis XIV**
Musée Vivenel, Compiègne

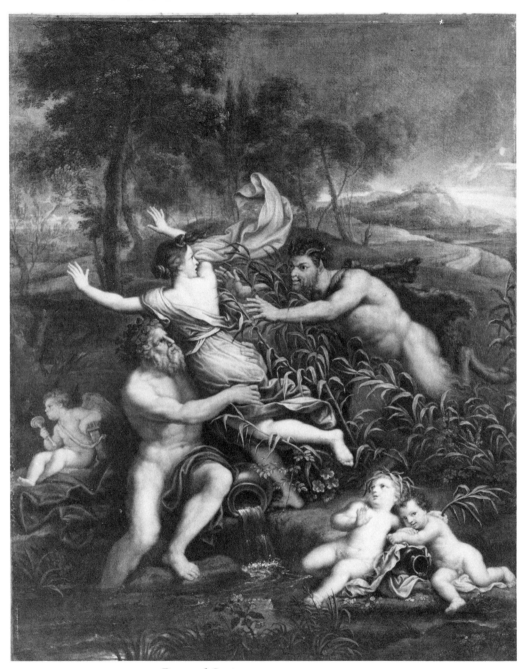

26 PIERRE MIGNARD 1612-1695 **Pan and Syrinx**
Musée du Louvre, Paris

27 PIERRE PATEL c.1605-1676 **Josabeth exposing Moses on the Nile**
Musée du Louvre, Paris

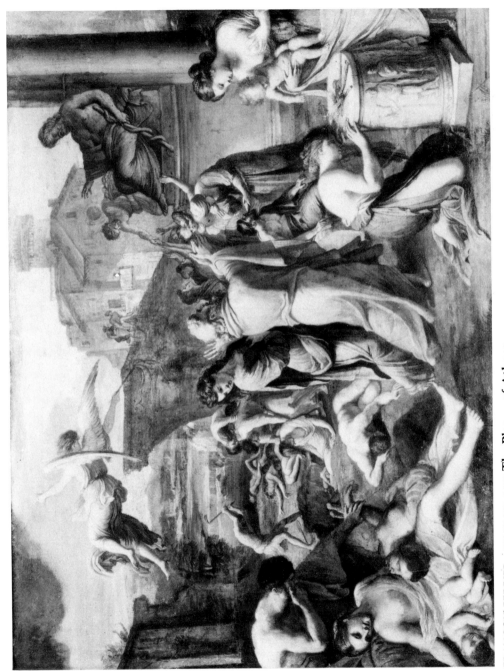

28　FRANÇOIS PERRIER c.1590/1600-1650 **The Plague of Athens**
Musée des Beaux-Arts, Dijon

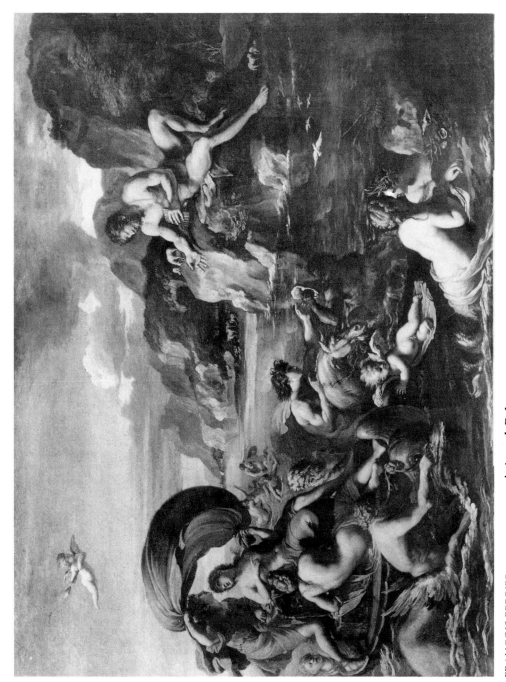

29 FRANÇOIS PERRIER c.1590/1600-1650 **Acis and Galatea**
Musée du Louvre, Paris

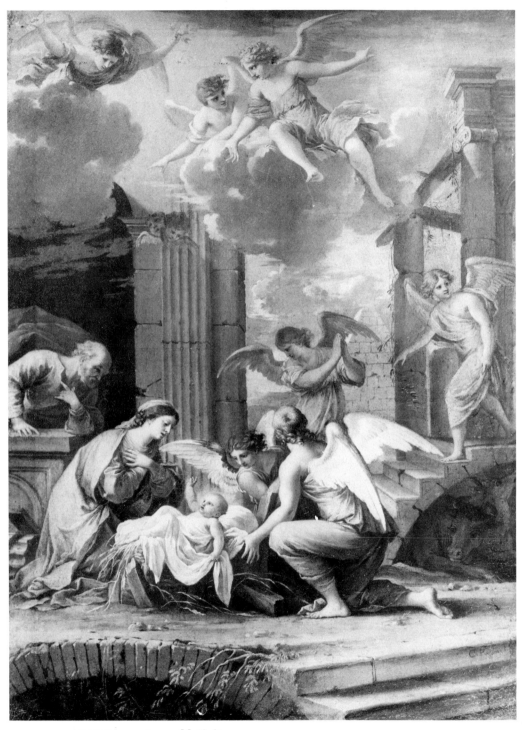

30 CHARLES POERSON 1609 ?-1667 **Nativity**
Musée du Louvre, Paris

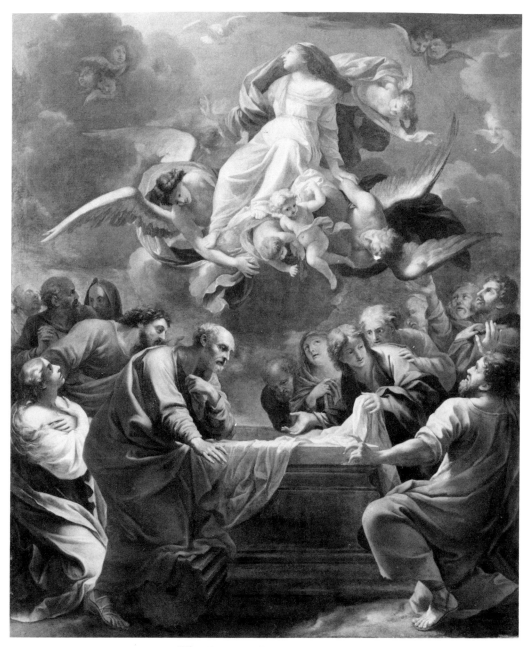

31 CHARLES POERSON 1609?-1667 **The Assumption**
National Gallery of Ireland, Dublin

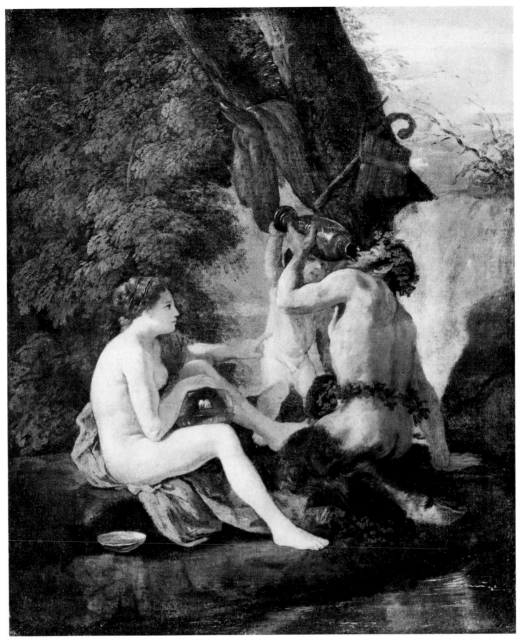

32 NICOLAS POUSSIN 1594-1665 **Nymph and Satyr drinking**
National Gallery of Ireland, Dublin

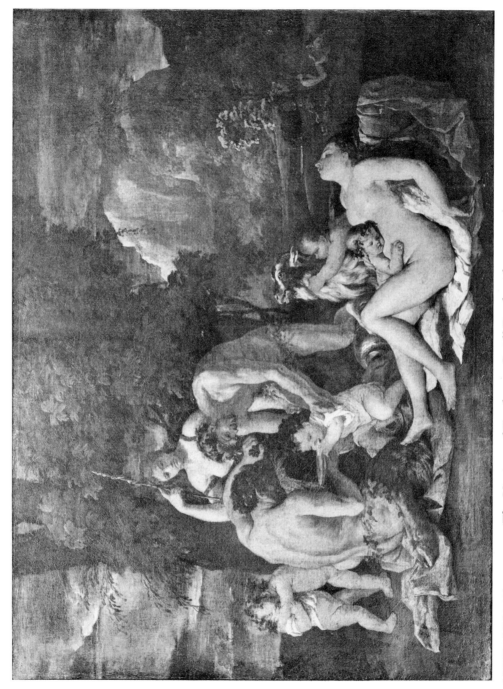

33 NICOLAS POUSSIN 1594-1665 **The Nurture of Bacchus** *or* **Small Bacchanal**
Musée du Louvre, Paris

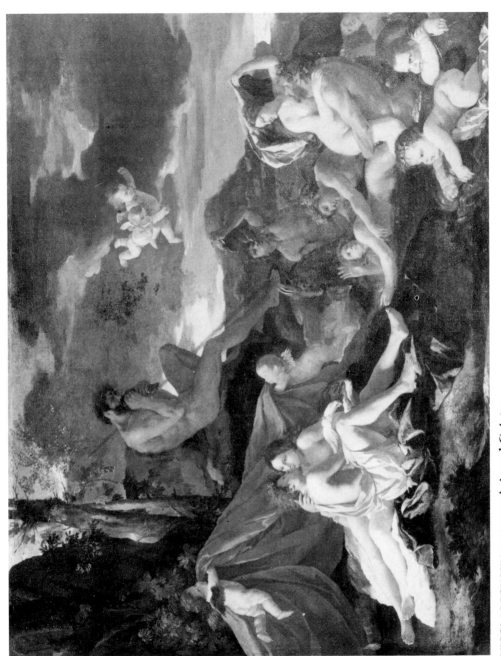

34 NICOLAS POUSSIN 1594-1665 **Acis and Galatea**
National Gallery of Ireland, Dublin

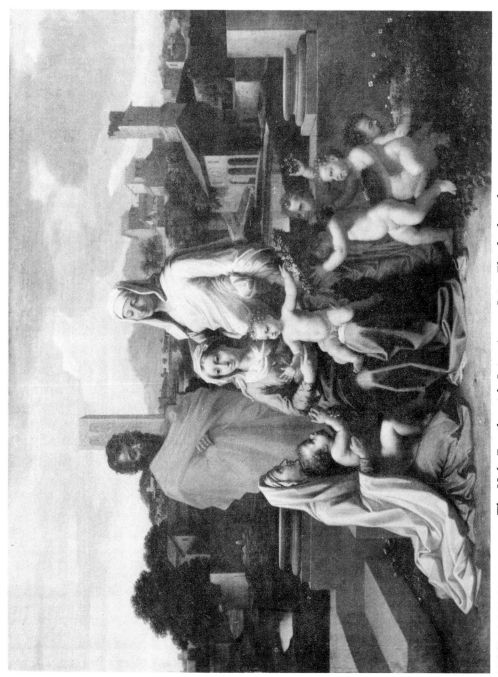

35 NICOLAS POUSSIN 1594-1665 **The Holy Family with Saint Anne, Saint Elisabeth and the young Saint John,** *called* **The Virgin with Ten Figures**
National Gallery of Ireland, Dublin

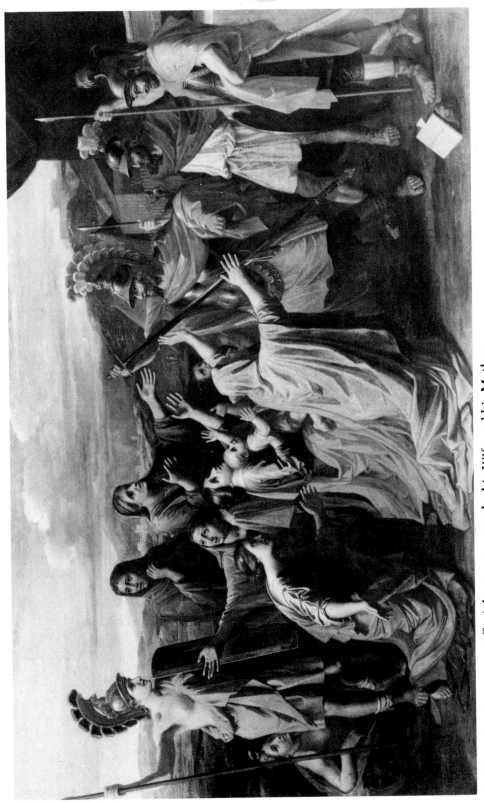

36 NICOLAS POUSSIN 1594-1665 **Coriolanus won over by his Wife and his Mother**

Musée Municipal, Les Andelys

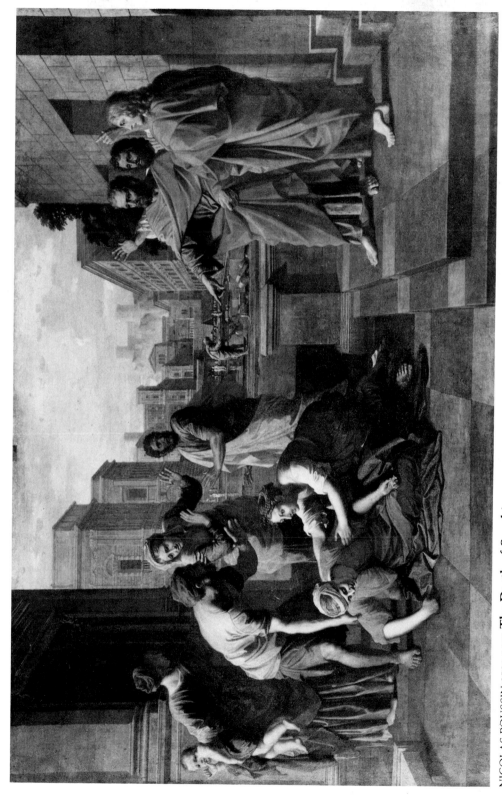

37 NICOLAS POUSSIN 1594-1665 **The Death of Sapphira**
Musée du Louvre, Paris

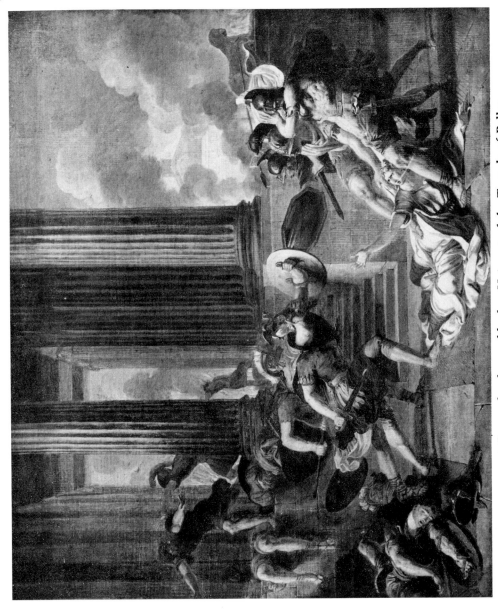

38 ANTOINE RIVALZ 1667-1735 **Cassandra dragged by her Hair out of the Temple of Pallas**

Musée des Beaux-Arts, Dijon

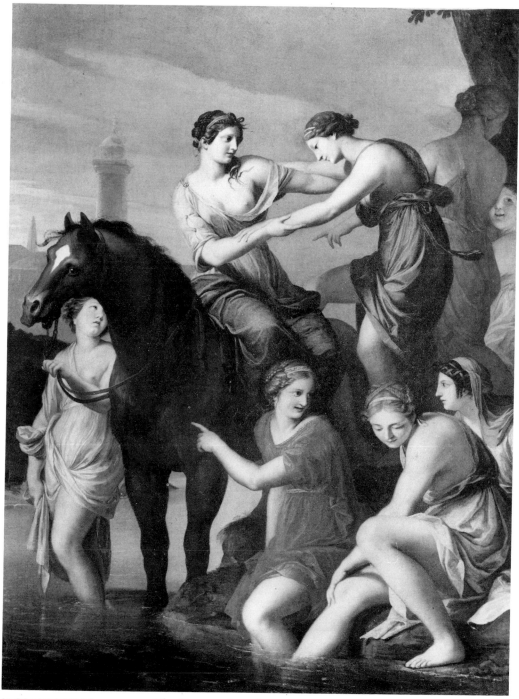

39 JACQUES STELLA 1596-1657 **Cloelia crossing the Tiber**
Musée du Louvre, Paris

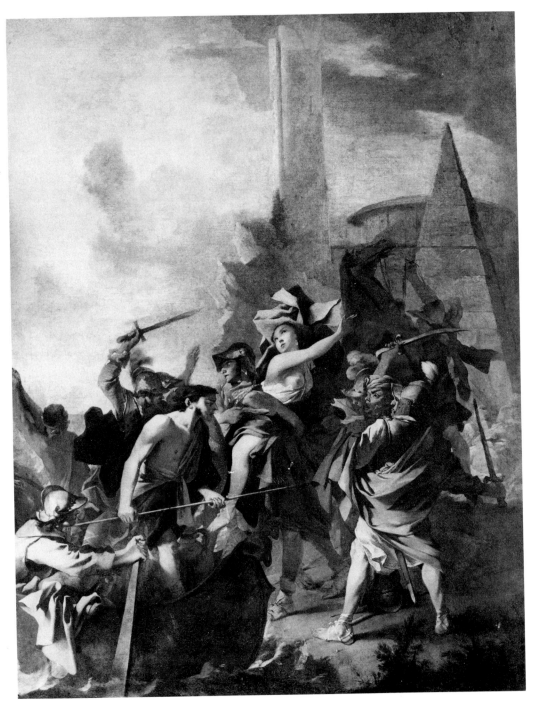

40 JEAN TASSEL c.1608-1667 **The Rape of Helen**
Musée du Louvre, Paris

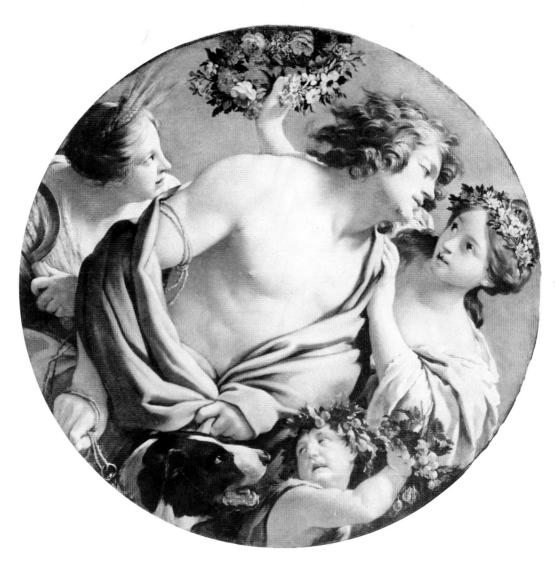

41 SIMON VOUET 1590-1649 **The Four Seasons**
National Gallery of Ireland, Dublin

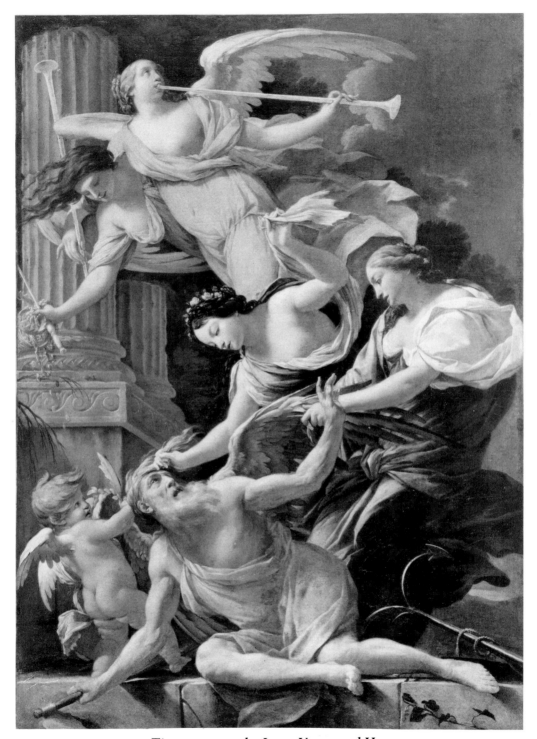

42 SIMON VOUET 1590-1649 **Time overcome by Love, Venus and Hope**
Musée du Berry, Bourges

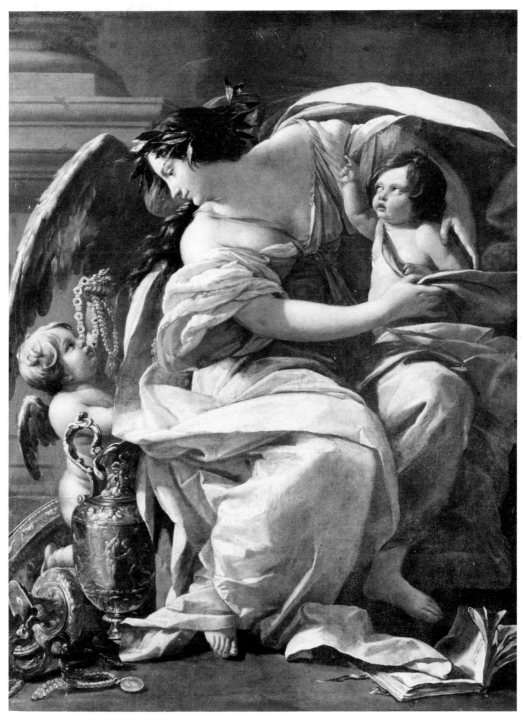

43 SIMON VOUET 1590-1649 **Abundance**
Musée du Louvre, Paris